for

Gabriele Helms
(1966 to 2004)

and for

David Vella Grace
(2004-)

On the art of Being Canadian

**Brenda and David McLean
Canadian Studies Series**

UBC Press is proud to publish
the Brenda and David McLean Canadian Studies Series.
Each volume is written by a distinguished Canadianist appointed
as a McLean Fellow at the University of British Columbia, and reflects
on an issue or theme of profound import to the study of Canada.

W.H. New, *Borderlands: How We Talk about Canada*

Alain C. Cairns, *Citizens Plus: Aboriginal Peoples and the Canadian State*

Cole Harris, *Making Native Space:
Colonialism, Resistance, and Reserves in British Columbia*

John F. Helliwell, *Globalization and Well-Being*

Julie Cruikshank, *Do Glaciers Listen?
Local Knowledge, Colonial Encounters, and Social Imagination*

ON THE art OF BEING CANADIAN

Sherrill Grace

UBCPress · Vancouver · Toronto

20 19 18 17 16 15 14 13 12 11 10 09 5 4 3 2 1

LIBRARY AND ARCHIVES CANADA CATALOGUING IN PUBLICATION

Grace, Sherrill E.
On the art of being Canadian / Sherrill Grace.

Includes bibliographical references and index.
ISBN 978-0-7748-1578-9 (bound);
ISBN 978-0-7748-1579-6; ISBN 978-0-7748-1580-2 (e-book)

1. National characteristics, Canadian, in art. 2. Nationalism and the arts — Canada.
3. Arts, Canadian — 20th century. 4. Arts, Canadian — 21st century. I. Title.

FC95.5.G72 2009 700.971 C2009-904155-3

UBC Press gratefully acknowledges the financial support for our publishing program of
the Government of Canada through the Book Publishing Industry Development Program
(BPIDP), and of the Canada Council for the Arts, and the British Columbia Arts Council.

This book has been published with the help of a grant from the Canadian Federation
for the Humanities and Social Sciences, through the Aid to Scholarly Publications
Programme, using funds provided by the Social Sciences and Humanities Research
Council of Canada, and with the help of the K.D. Srivastava Fund.

1006548158

Printed and bound in Canada by Friesens
Set in Electra by Artegraphica Design Co. Ltd.
Text design: Irma Rodriguez
Copy editor: Deborah Kerr

UBC Press
The University of British Columbia
2029 West Mall
Vancouver, BC V6T 1Z2
www.ubcpress.ca

Contents

Illustrations / ix

Acknowledgments / xi

Introduction:
On Being Canadian / 3

1
Creating a Northern Nation / 15

2
Theatres of War: Battle Fronts and Home Fronts / 55

3
Inventing Iconic Figures / 106

Epilogue:
Listening for the Heartbeat of a Country / 154

Notes / 160

Bibliography / 175

Index / 188

Illustrations

1 Frederick Varley, *Portrait of Vincent Massey* (1920) / 6

2 Andrew Danson Danushevsky, "Jean Chrétien, 1985, Self-Portrait" (1985) / 9

3 Charles Pachter, *The Mistook North* (1984) / AFTER 16

4 Don Proch, *Magnetic North Mask* (2000) / AFTER 16

5 Gerardus Mercator's map of the Arctic (1589) / 21

6 Rudy Wiebe's map *Inuit View to the South* / 22

7 Nordicity map, *Where Is the North?* / 23

8 Map of Canada showing Nunavut / 24

9 William Blair Bruce, *The Phantom Hunter* (c. 1888) / AFTER 26

10 Lawren Harris, *Winter Comes from the Arctic to the Temperate Zone* (c. 1935) / AFTER 26

11 Benoit Aquin, "Le verglas #16, Boucherville" (1998) / 27

12 Owen Beattie's photograph of John Torrington / AFTER 38

13 Dominique Gaucher, *Abstractionist Rescued from Certain Depth 2* (2006) / AFTER 38

14 John Palmer, photographs of Mother Canada and the Vimy Memorial / AFTER 56

15 Frederick Horsman Varley, *For What?* (1918) / AFTER 56

16 Map of the western front, 1917 / 61

17 Maps of Second World War theatres of war / 62

18 Alex Colville, *Infantry, near Nijmegen, Holland* (1946) / AFTER 66

19 Charles Comfort, *Via Dolorosa, Ortona* (c. 1944) / AFTER 66

20 Charles Comfort, *Route 6 at Cassino, Italy* (1944) / 71

21 Benjamin West, *The Death of General Wolfe* (1770) / 73

22 C.R.W. Nevinson, *War in the Air* (1918) / 83

23 Eric Peterson as Billy Bishop in *Billy Bishop Goes to War* / 84

24 "Remember Hong Kong!" a Second World War recruiting poster / 86

25 Photograph of Louis Riel in 1885 / 113

26 Chester Brown, page from *Louis Riel* (2003) / 115

27 Marcien Lemay, *Louis Riel* (1968) / 122

28 John Boyle, *Batoche—Louis David* (1975) / AFTER 122

29 Jane Ash Poitras, *Riel Reality* (2000) / AFTER 122

30 Joe Fafard, *Emily Carr and Friends* (2005) / AFTER 126

31 Emily Carr, *Self-Portrait* (1938-39) / AFTER 126

32 Joy Coghill in *Song of This Place* / 130

33 Tom Thomson, *Self-Portrait after a Day in Tacoma* (1902) / AFTER 134

34 Tom Thomson, *The Jack Pine* (c. 1916-17) / AFTER 134

35 Brenda Wainman-Goulet, *Tom Thomson* (2005) / 139

36 Panya Clark Espinal, *First Snow* (1998) / 141

37 Mina Benson Hubbard on her Labrador trail (1905 and the 2005 centenary) / 146

38 Mina in *Mina et Leonidas Hubbard: L'amour qui fait voyager* (2007) / 149

Acknowledgments

From 2003 to 2005, it was my privilege to hold the Brenda and David McLean Chair in Canadian Studies at the University of British Columbia. The duties of the chair are to teach two senior seminars in the Canadian Studies Program and to deliver three public lectures. I gave my lectures in March 2005 and have revised them for this monograph. Chair holders before me have included some of the most distinguished scholars of Canada from my generation, and each one of them is, and was, an inspiring lecturer, but it is Brenda and David McLean who had the vision and generosity to grasp the significance of Canadian studies for future generations and who have given us, and posterity, an invaluable gift through these lectures and monographs.

Although a published book provides tangible and lasting form for the lectures and for my research over those years, it cannot capture all the lived joys and challenges, all the face-to-face interaction, and all the lively debate that made holding the McLean Chair such a delight for me. Thus, though I begin with my thanks to the McLeans, I must also thank my students in both seminars for their enthusiasm, insights, and lively discussions. I will not name each of them, but I hope they will read this little book and keep in touch with me as they continue to carry their dedication to this country into their future careers.

It is especially important to thank the many artists, from young poets to veteran painters and filmmakers, for their permission to quote from or reproduce their works, and it is a particular pleasure to thank Kate Braid

and Karen Connelly for allowing me to quote so extensively from their work. If these artists did not do what they do so well, there would be no "art of being Canadian." One of my long-standing debts is to Canadian geographer Louis-Édmond Hamelin, and it is once more a pleasure to thank him for his knowledge about the North and for his inspiration. Among the many others I wish to thank is John O'Brian, who, as chair of the Canadian Studies Program at UBC, advised and assisted me at every turn and whose vast knowledge of the Canadian cultural scene has guided me on many occasions. Working with you, John, has always been fun. Other colleagues have also provided support, ideas, and suggestions for music or poems or paintings: Richard Cavell, Stephen Chatman, Donna Coates, Michelle La Flamme, Bill New, Doug Udell (and the staff of the Douglas Udell Gallery), Jerry Wasserman, Dominique Yupangco, and still others who have listened patiently while I struggled to articulate and clarify ideas. To all I owe my appreciation because thinking in solitude is thinking that is limited; it is only in the exchange of ideas that we learn.

This book is dedicated to two wonderful people — one for the past and one for the future. The colleague and friend whom I remember with special feeling and to whom this book is dedicated is Dr. Gabriele Helms. Gabi and I had discussed many of the ideas I would develop for this book, and we were planning to work together on the Canadian representation of war. My only regret about this volume is that she died before I could benefit further from her reflections on what it means, in Gabi's case for an immigrant as well as a scholar, to become and be Canadian. My grandson, David, was born in 2004 and still has much to learn about being Canadian; I dedicate this book to him with the hope that his future and the future of his country will be full of promise.

Finally, it is a pleasure to acknowledge the support over many years of the Social Sciences and Humanities Research Council of Canada and of individuals such as Margery Fee, Laura Moss, Jean Wilson, and the editors

at UBC Press, Darcy Cullen and Holly Keller, for their support of this project at various stages. I also extend my heartfelt thanks to Geneviève Gagné-Hawes for her amazing help with illustrations and permissions. And, as so often in the past, it is a joy to thank my family: John, who shares my passion for the North and for Canadian painting; Elizabeth, who has also gone north and succumbed to the temptations of Canadian art, theatre, and literature; and Malcolm, with whom I can always discuss the history and exigencies of war.

On the art of Being Canadian

To be creative is, in fact, Canadian.
— *Margaret Atwood*

The identity of a nation has no fixed essence and
supplements this lack with the labour of continuous self-representation.
Nationhood is formed by telling stories, manufacturing fictions,
and inventing traditions in a ceaseless and selective process
of inclusion and exclusion, remembering and forgetting.
— *Sue Malvern*

If this is your land, where are your stories?
— *Edward J. Chamberlin*

On Being Canadian

Oh Canada.
 I try so hard with you
 but nothing explains
 your terrible polite immensity,
 your merciless wind, your deaths,
 which are my own.
Not to suggest that a country is a family

but stating it unequivocally
a country *is* a family
 and this is mine,
 my country
 my family.

I come back to them now
 as water always comes back.
It is the dead
 who teach us how to live,
well or badly, it is the dead
 who teach us how to swim,
well or badly, it is the dead
 who walk among us
 but cannot spell our names.
— *Karen Connelly,* "OH, CANADA"

I began my 2005 McLean Lectures, and now begin this book, with Karen Connelly's poem "OH, CANADA" because it is by a young Canadian woman writing in this century, and because it responds, in so many ways, to Vincent Massey's questions in his 1948 book *On Being Canadian*: "What sort of person do we wish our young Canadian to be?" Massey asked. "What will he be like if he embodies the best in the Canada around him?" (184). Massey's book has given me part of my title, but Connelly's poem, written in 2003 and first published in 2004, demonstrates the contemporary relevance of my title, as well as confirming my belief that *the art of* Canada continues to tell us what "being Canadian" means.

When he was writing in 1948, Massey was not thinking about the arts in quite the interdisciplinary way I am or even as he would come to do over the next decade of his life. He was concerned about education — a liberal arts education in schools and universities — because he believed that such an education would produce good Canadian citizens. From today's perspective, it is easy to describe Massey's ideas as elitist and conventional, and it is easy to criticize his personal love of pomp and ceremony, his loyalty to the British Empire, his wealth, his centralized view of power, and his rhetorical flourishes. It is easy but not altogether wise, if for no other reason than because a liberal arts education is still the foundation of contemporary Canadian life in ways that technical training or scientific education alone can never be. But there are other reasons for taking the man and his ideas on the arts seriously. Vincent Massey (1887-1967), Canada's first native-born governor general (from 1952 to 1959), had a vision of Canada to which he was prepared to devote his time and energy. He placed great emphasis on the role of culture (by which he meant theatre, classical music, architecture, history, and painting) in defining the nation, and eighteen years before writing *On Being Canadian*, he had articulated his reasons for believing that art and nationality must go together. In "Art and Nationality in Canada," a speech he gave to the

Royal Society of Canada in 1930, he explained why the arts were so important to the country, and he called on artists "to arouse us from our lethargy" (67) concerning our own history and landscape while at the same time warning his audience that "a national art cannot flourish without a public which is both honest and loyal" (71).

Early in my planning for the McLean Lectures, I knew I wanted to begin with Massey because, for better or worse (and much of it *is* better), he has had a profound and lasting influence on the state of the arts in this country.[1] It was the report of the Massey-Lévesque Commission (chaired by Massey with Georges-Henri Lévesque as a key committee member), formally called *Report: Royal Commission on National Development in the Arts, Letters and Sciences, 1949-1951*, that warned against "a national independence which would be nothing but an empty shell without a vigorous and distinctive cultural life" (18), and it was this Royal Commission that described Canadian independence in terms of the North, the arts, and a strong military for national defence. Moreover, it was the Massey-Lévesque Commission that called for the creation of the Canada Council, which came into existence in 1957 with Lévesque at the helm. The commission's report also paved the way for numerous future studies and commissions that would follow, such as the much criticized Appelbaum-Hébert Report of 1982, the Fraticelli Report on gender inequity in Canadian theatre professions (1982), and the Canadian Arts Consumer Profile (1993-94) — all funded by the federal government.[2] By the 1990s Canadians had come a long way from Massey's vision, and the very term "Arts Consumer Profile" must have sent him whirling in his grave.

By invoking him here in these pages, I am, as it were, *calling him up* (see Figure 1), but if he does put in a spectral appearance, I hope he will approve my linking of the arts with his "being Canadian" because I too believe in the value of the liberal arts in education, in the importance of national independence, and in the need for a loyal and informed public.

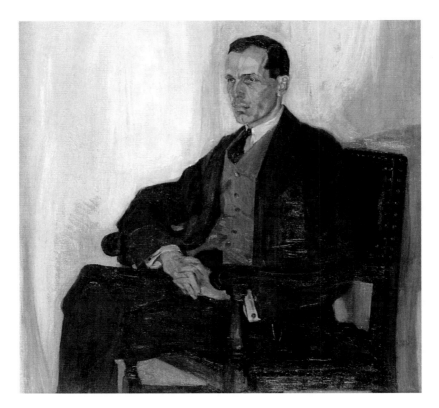

FIGURE 1 Frederick Varley, *Portrait of Vincent Massey* (1920), oil on canvas, 120.6 x 141.0 cm. Charles Vincent Massey (1887-1967) was a life-long patron of the arts and the first Canadian-born governor general of Canada (1952-59). Frederick Horsman Varley (1881-1969), a First World War war artist and founding member of the Group of Seven, painted a number of powerful portraits of which this is a striking example. Permanent collection of Hart House, University of Toronto; reproduced with the permission of the Justina M. Barnicke Gallery.

Like Massey, albeit without his attachment to the British monarchy, I am a cultural nationalist. Nevertheless, I hope that, as one of Karen Connelly's "dead / who teach us how to live," he will hold his tongue as I set about pushing the boundaries on *the art of* being Canadian beyond what he would have accepted, simply by virtue of being a female academic and

by foregrounding female artists. As Canadians now know so well, Earle Birney was quite wrong when he said we had no ghosts, but I prefer Massey's to be quiet.

Although my thinking for the lectures and for this book has been influenced by Vincent Massey's work and life, and by recent studies of him, his phrase and my expansion of it raise several questions: How does one *be* Canadian? What qualifies as "being Canadian"? Who, then, is Canadian (and who is not)? What do the arts and our artists show or tell us about being Canadian or about being ourselves? How do they do this work of cultural and national identification, assuming they do? And to what degree do our many cultural institutions and policies determine, control, and shape the arts, artists, and aspects of cultural production (dissemination, accessibility, visibility, canonization) that instruct us in the art of being Canadian? These are sweeping, ultimately political, questions for which I have no tidy answers, but I raise them because they trouble and fascinate me, because I believe they are important — at least as important as any answers — and because these questions will surface time and again in the following pages. But if I do not have answers, I do have, or make, assumptions, two of which are fundamental. I take for granted that the arts matter and that they exert considerable power in, as well as bringing great pleasure to, our lives. Moreover, I assume that, collectively, they have and continue to represent, illustrate, narrate, shape, and inform identity, our personal identities and the identities of any number of social groups or physical places to which we might belong — a city, a province, a region, and the country. Here are two brief examples as preliminary illustrations of what I assume: one is rather arcane — not easily accessible and thus little known — the other is more visible; one is very serious and the other rather less so; both work overtly with ideas of identity through autobiography/biography and familiar Canadian imagery; both also manage to gesture toward the three defining subjects I

have chosen for these lectures: the North, the two world wars, and a set of iconic figures.

My first example is Joyce Wieland's 1976 film *The Far Shore*, her only feature film and one that creates a story about Tom Thomson in a portrait of the artist as moral arbiter for Canadian identity. Setting her story against the background of a post—First World War Canadian heartland (Toronto and the "north country" just beyond the city), Wieland pits her Tom character and his lover Eulalie — a beautiful French Canadian pianist who is unhappily married to a crass anglophone entrepreneur and Toronto developer — against the violent and corrupting forces of mining speculation, resource exploitation, greed, and cultural commodification. The villains in this film are also racist and sexist; Wieland has loaded her dice. However, in her national allegory of Canadian identity, Wieland's good artists seem to lose out to the crass developers because she is stuck with the Tom Thomson story, and in that story the artist must die. When Tom and Eulalie flee north in the service of art, love, country, and free- dom, they are killed by the sniper shots of the returned soldier turned developer.

My second example is Andrew Danson Danushevsky's richly ambigu- ous portrait photograph of Jean Chrétien (see Figure 2). This cleverly staged portrait of Chrétien, created in 1985 while the future Canadian prime minister (1993-2003) was waiting on the political sidelines, might not be visible today were it not for its prominence in an article from the March 2004 *National Post* in which Julia Dault describes a McMichael gallery exhibition called Identities: Canadian Portraits. Dault's headline is "How We See Ourselves," and she privileges the Chrétien piece for contemporary political reasons because, in 2003, Chrétien had just left office with the sponsorship scandal about to erupt. In the 1980s, when this photograph was created, he was known for his interest in the Canadian North through his ministerial appointments with Indian Affairs and

FIGURE 2 Andrew Danson Danushevsky, "Jean Chrétien, 1985, Self-Portrait" (1985), black-and-white photograph, 55.9 x 57.1 cm. Danushevsky's provocative photograph of the Right Honourable Jean Chrétien, Liberal prime minister of Canada from 1993 to 2003, was featured in a 2004 exhibition of Canadian portraiture at the McMichael Canadian Art Collection. Collection of the artist; reproduced with permission.

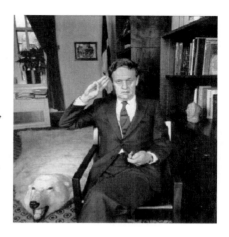

Northern Development (1968-74) and with Energy, Mines, and Resources (1982-84). This ironic, humorous image has a lot to say about being Canadian and about *the art and artfulness* of being Canadian: right on cue, we have our nordicity represented by that polar bear and our military endeavours signalled through a salute. But wait! The whole scene is a clever pose: the bear is just a rug (could it be a souvenir from Chrétien's work with Northern Development?), the salute is Chrétien's familiar Boy Scout salute (given while seated, which is scarcely respectful, and directed *at* the viewer/voter), and he is posed holding the camera's shutter release cable in a scene staged for the viewer's consumption and bewilderment. Can it be that the politician returning our gaze intends to insult or mock us? Whether or not the man in the photograph will become an icon, only time will tell, and whether or not Canadians endorse his script for being Canadian — after all, we did buy it in 1993 and for quite a while following that — he appears to know the precise Canadian props with which to stage his performance. And the arts reporter *seems* to be going along with the show. Dault's subtitle reads "Portraiture Communicates the Personal as Well as the Collective Sense of Identity."[3]

At first glance, perhaps, these images and media seem totally different and without connection. As works of art, however, they suggest a great deal about both the *art of* being Canadian and about *being Canadian* between the early 1970s, when Wieland was making her film, and the mid-1980s of the Chrétien photograph. Each work, moreover, evokes or refers directly to all three of my subjects in this study — the North, war, and the process of creating national icons — and by doing so, each underscores the complex interconnections among these subjects, which in turn locate a significant aspect of their cultural power. In addition, there is a mixture of romance and irony, an undercurrent of self-conscious comic nostalgia in both works that I often detect, to varying degrees, in many examples of Canadian art. Both works rely on documentation of geographical and historical facts and people to create an aura of documentary authenticity. The film creates a portrait of the artist in a familiar landscape that is *real* for Canadians who live in Ontario (or for visiting tourists) but is recognizable, indeed iconic, for the rest of the country due to its frequent representation by painters, from the Group of Seven to the present, and the commodification of such landscape images on everything from tea towels to coffee mugs. The photograph stages self-portraiture, another genre of apparent authenticity, reinforced by artifacts (or identity props), from polar bear rug and Inuit sculpture to a shutter release cable.[4] Both works enlist cultural memory and require participatory acts of recognition and remembering on the part of viewers to produce artistic meaning; both invite Canadians to relate to, or identify with, something about *where* they are and have been in order to better see *who* they are.

I will return to these common features and, I hope, be able to clarify and expand upon them in the chapters to come, but here, at my outset, I want to reflect on why I have selected my three subjects, instead of many others, and on what this selection inevitably excludes. Most obviously, of

course, the McLean three-lecture series dictates a certain structure, and the limits of time and space further constrain what can be considered. I have come to this challenge after a considerable amount of work on two of the topics — the North and the creation of national icons — and there are numerous overlaps between them. But why war, and how does this difficult subject *fit* with the others? Although the importance of both world wars to this country is well documented by historians such as Pierre Berton, Jack Granatstein, Desmond Morton, and Jonathan Vance (to name just a few), and Canadians have been taught that the country came of age in 1917 on Vimy Ridge, general public education about the country's wartime activities has been neglected, the wars reduced to little more than traces, subtexts, and brief Remembrance Day commemorative ceremonies on 11 November — until the early 1990s, that is. For a variety of reasons that I shall return to, the subject of Canadian participation in wars past and present, rather than peacekeeping in war zones, has acquired urgent importance. Today there is ample evidence of a heightened attention to war — in current international affairs, in future concerns over climate change, and in a spate of recent books (fiction and non-fiction), films, television documentaries, plays, and, of course, in painting.[5] The exhibition Canvas of War, which toured between 2000 and 2004, the May 2005 opening of the new Canadian War Museum in Ottawa, the deployment of Canadian troops in Afghanistan (with the inevitable casualties), and the military exercises currently under way in the Canadian Arctic are a few of the most public and impressive examples of the renewed attention to war and its meaning for Canadians. Canada is by no means the only country revisiting its activities in past wars in the context of current conflicts, and the self-reflexive nature of much of this representation is connected, in complex ways, with debates about history, memory, trauma, and testimony. For Canadians, these debates influence how we understand or construct the nation.

In the final analysis, however, I have chosen my three subjects — or domains of inquiry — because they provide crucial sites of memory and cultural representation, and as such they are central to the process of inventing Canadian identity. All three have an active history, by which I mean that their creative lives extend over significant periods of time and are very much alive today. The fascinating, informative interconnections that exist within and across these subjects mean that an exploration of representations in one area opens windows on another. But most important for my purpose in this study is the fact that Canadian artists, working in different genres or media, continue to explore and exploit these subjects. By doing so, they create a cumulative commemorative process, and my task is to map that process, to locate key markers of identity, and, a little like the researcher in Timothy Findley's *The Wars*, to make sense of what I find. These three subjects help me organize a wealth of artistic materials, to illustrate persistent yet changing concerns with Canadian identity, and to understand more about Canada's position in the larger world.

Although I have included voices and perspectives that were not part of Vincent Massey's Canada (First Nations, for example), a number of subjects and perspectives have inevitably been left out. I wish there were more women artists telling me how to be Canadian, but I have singled out a few for close attention such as Emily Carr, who plays a prominent iconographic role in our collective story, or Mina Benson Hubbard, who is well on her way toward gaining significance as part of our northern story. Although I wish I could include more *Quebecois* artists, my use of this term indicates my reluctance to force Quebec into the Canadian framework. That said, in *Canada and the Idea of North*, I traced some of the ways in which concepts of nordicity/*nordicité* and *le grand nord* contribute to both a Quebec and a Canadian definition of place and self. And there can be no question but that both world wars played a critical role in

the history of federal-provincial relations — as some Quebecois novelists and poets remind us.[6] But how can anyone discuss Canadian icons and Quebec icons in the same breath? Who lays claim to Talbot Papineau, Brother André, Maurice Richard, Céline Dion, or Leonard Cohen, who was born in Quebec but has spent long periods living elsewhere and is now an international cultural icon? Finally, what about other Canadians who are beginning to represent themselves and look for themselves in the art around them, those Canadians who have recently arrived, those who have only recently gained visibility, and those who have always been here? This Canada is officially multicultural, a fairly late evolution in the ongoing process of being and becoming Canadian, and for this Canada I would need a fourth or fifth chapter as well as more time for research and for the cumulative process of representation to gather force.[7] There is much to do, and other students of Canada will continue the journey.

Before I begin, let me suggest a few of the artists and artistic events that I think of when I think of Canada, mental images that conjure this country for me: Molly Parker's face on the big screen in *Perfect Pie* (her intelligent, mobile, non-Hollywood beauty is mesmerizing); Colm Feore performing Glenn Gould or Pierre Elliott Trudeau; watching the CBC television production of George Elliott Clarke's opera *Beatrice Chancy* (absolutely breathtaking and unforgettable) or the equally moving and informative broadcast of the April 2007 rededication of Walter Allward's Vimy Memorial; listening to John Estacio and John Murrell's 2003 opera *Filumena* on CBC radio after travelling to Calgary for the premiere; listening to my colleague Gu Xiong, a painter and photographer, describe his visits to Banff or listening to Joy Coghill describe her struggle with Emily Carr while holed up in a writer's cabin at the Banff Centre; and Coghill herself, just her presence on so many of our stages, or Frances Hyland (who died in 2003), Martha Henry, Brent Carver (as Robert Ross in the film adaptation of Findley's *The Wars*), and Gordon Pinsent, who starred in

the 2006 film *Away from Her* (based on a story by Alice Munro). Or Nicholas Campbell as Shorty McAdoo in the 2008 CBC film adaptation of Guy Vanderhaeghe's novel *The Englishman's Boy.* I will return to Campbell. Watching R. Murray Schafer spectacles — in train stations. Listening to Ben Heppner sing! Or hearing the iconic theme song (discontinued in 2008) that has introduced CBC's *Hockey Night in Canada* since I was a child. The inimitable Mavor Moore (1919-2006), a one-man archive of Canadian art (with his bald pate and bespectacled, shrewd face), who was a passionate, terrifyingly energetic, talented visionary. Or Pierre Berton, or Farley Mowat. Rick Mercer barging in on the Barenaked Ladies — *bare-naked*; Stan Rogers, k.d. lang, Joni Mitchell, Susan Aglukark, and so many more. I grew up with Wayne and Shuster (two faces now forgotten by many and completely unknown to younger generations) and will never forget that inimitable comedy team, the Royal Canadian Air Farce, which gave its final CBC television show on 31 December 2008. And I have not mentioned my favourite filmmakers or playwrights: Anne Wheeler, Denys Arcand, and Atom Egoyan; Tomson Highway, Marie Clements, Sharon Pollock, and Michel Tremblay. If I were marooned on King William Island and able to take a selection of Canadian artists' works with me, I could survive, imaginatively at least, and remember how to *be Canadian*, by reading Rudy Wiebe's *Playing Dead*, with Harry Somers' *North Country* or Christos Hatzis' *Footprints in New Snow* playing in the background.

Creating a Northern Nation

À partir du moment où le Nord fera vraiment partie des
preoccupations du pays, les affaires pan-canadiennes ne pourront plus
être décidées seulement par les seuls citoyens du Canada de base.
— *Louis-Édmond Hamelin*

Until we grasp imaginatively and realize imaginatively
in word, song, image and consciousness that North
is both the true nature of our world and also our graspable destiny
we will always go whoring after the mocking palm trees and beaches
of the Caribbean and Florida and Hawaii.
— *Rudy Wiebe*, PLAYING DEAD

I IMAGINING NORTH

To judge from his painting *The Mistook North* (1984), Charlie Pachter's
take on Canada and the true North strong and free is somewhat ironic
(see Figure 3), but I begin with this image because Pachter's irony and
humour also have a serious message, one that addresses some of the ques-
tions I have raised about the *art* of being Canadian. If I believe Pachter,
what Canadians perceive as North is shaped by a Group of Seven Ontario
landscape painting (or a canvas by Tom Thomson), and I am the Canuck

in his painting (mouth open in surprise — or is it recognition?) who mistakes the image for the real thing. But the comic irony of the piece, captured by its title, is integral to the joke. Pachter calls the work *The* Mistook *North*, thereby evoking a famous formulation of the subject by artists themselves, such as Lawren Harris, and by art historians and curators: the "mystic North."[1] But just how much of a mistake is represented by Pachter's painting? And how mistaken are we to turn to our artists for an understanding of the country? Perhaps the joke is more complex than we might at first glance think, and our artists have a greater influence on how we see ourselves than we realize. Pachter's placing of a familiar landscape picture against a larger backdrop of a *real*, equally familiar, landscape is a deliciously rich act of citation — a painterly *mise en abyme* — that throws our perceived distinctions between art and reality into doubt. At the same time, the painting reminds me that people tend to understand themselves, not only in relation to the actual world around them, but also (and perhaps more profoundly) through the artfully constructed world of an imagined national iconography.

Geographically, Canada stretches into the northernmost reaches of North America, and a great majority of the physical country lies north of 60°; geopolitically, we are one of the circumpolar nations of the world; meteorologically — with the exception of the tiny southwestern corner of the nation — we must live with ice, snow, very cold temperatures, and the flora and fauna of such a climate for at least six months of the year. Historically, economically, and culturally, as Harold Innis told us in 1930, we have been shaped by our nordicity, which is an inescapable fact of life for both indigenous and settler populations. Challenges to our sovereignty have not been restricted to our longest undefended border. They have often occurred well out of sight for the majority of Canadians — over the Northwest Passage, on Baffin Island, in the Yukon — and such challenges

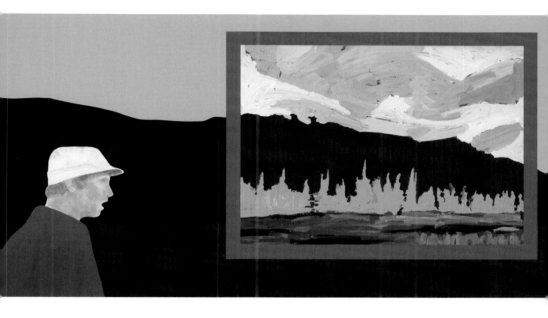

FIGURE 3 Charles Pachter, *The Mistook North* (1984), acrylic on canvas,
91 x 182 cm. Toronto painter Charlie Pachter is famous for his portraits of
Canadian artists and for his unique perspective on Canadian myths and icons,
from Queen Elizabeth to Group of Seven landscapes. This painting suggests
how profoundly the images of the Group have influenced what people see
as a Canadian landscape. Collection of Denise and James Rex Inglis;
reproduced with the permission of the artist.

FIGURE 4 Don Proch, *Magnetic North Mask* (2000), 50.8 x 38.1 x 40.6 cm, mixed media (silver point, graphite pencil, coloured pencil on fiberglass-backed white ceramic surface; the top arc is black and blue fiberglass inlaid with crosscut animal bone and studded with chrome-plated brass pins, and the area behind the canoe is nickel- and chrome-plated copper). The materials of this piece and its images of human face, landscape, and canoe represent familiar natural and cultural aspects of Canada's northern identity. Collection of John and Sherrill Grace; reproduced with the permission of the artist. © "A Sessippi" Don Proch.

are not going away. Indeed, sightings of submarines in the Arctic Ocean, recent Canadian military exercises on Baffin Island, and the looming threat of climate change suggest that a national presence is still required in the North if we wish to retain control over this vast territory. But my focus is not on any of these issues, or on global warming, which of course intensifies our need to pay attention to the North. My focus is on our arts and on how some of our artists have represented the many aspects of our "nordicity" (a term I borrow from Louis-Édmond Hamelin, one of our pre-eminent geographers). This is not to say that I think questions of sovereignty, global warming, and meteorology are unimportant. But I have long believed that it is the artists who have told Canadians the most about why the North matters and that it is the arts that have the power to persuade voters and consumers to appreciate North by recognizing how profoundly it shapes the country, even when some Canadians cannot wait to flee south to warmer climes or when others mistake a painting for the real thing.

Don Proch captures the complex and profound interdependency of North and human identity with exceptional clarity in his striking *Magnetic North Mask* (see Figure 4), and I want to explore the following four indices of North, all of which are represented in this mask, as they have been articulated, reinforced, and created by generations of artists:

- that North is as much an idea, and a present force right here in southern Canada, as it is a physical place *out there — somewhere* and far away;
- that what Canadians understand as the North has moved, over time, from its earlier location in the southeast of the country, where Vincent Massey located it, to areas farther west and much farther north, as Adrienne Clarkson reminds us;

- that these ideas have changed over time to include more perspectives than before and that they are still a changing, vibrant part of our culture;

- and lastly, that these changing ideas of North are fundamental to an understanding of the Canadian nation and to our sense *of being Canadian.*

Proch captures all these ideas in his powerful work, but most importantly of all, he reminds us that we create and are created by ideas of North because his work of art is a mask, and as a mask it shows us an image of our northern landscape by using those familiar signs of the North — magnetism, rock face, water, and canoe — *as a human face.*

Over the past century and a half of Canadian cultural history, many writers, artists, and historians have described their sense of national and personal identity through images of North, although their characterizations of the North have differed dramatically. I have already discussed a wide range of these comments, from Confederation to the turn of the twenty-first century, in *Canada and the Idea of North,* so I will simply recall a few especially interesting ones that illustrate the persistence of ideas about North in our culture, as well as the passionate, even mythic, attraction the North exerts on Canadians' imaginations and cultural life. In a 1936 essay called "I'll Stay in Canada," Stephen Leacock, an author and humourist whose sense of irony matches Charlie Pachter's, insisted that "to all of us here" (Leacock's *here* was his armchair in Montreal), "the vast unknown country of the North, reaching away to the polar seas, supplies a peculiar mental background" (284). Lawren Harris, who, along with A.Y. Jackson, painted various northern landscapes and visited the High Arctic more than other members of the Group of Seven, is famous for his highly nationalistic and spiritual descriptions of the North; for Harris, the North was "mystic," visionary, and the source of what he understood as

"the pervading and replenishing spirit" of artistic expression *and* Canadian identity (39). Speaking years later on the occasion of Canada's centenary, Glenn Gould was a bit more realistic, if no less romantically inspired than Harris, in his description of the North and its influence on his life and work. He had been commissioned to write a special piece in celebration of Canada's birthday for which he created the first of his remarkable sound documentaries *The Idea of North*. Gould has been a strong influence on my own imagination, and I shall need to return to him, but a brief quotation from his liner notes for this composition demonstrates why I single him out as representative of our continuing attitudes about the "northern third of our country":

> I've been intrigued for quite a long time ... by the incredible tapestry of tundra and taiga country ... I've read about it, written about it occasionally, and even pulled up my parka once and gone there. But like all but a very few Canadians, I guess, I've had no direct confrontation with the northern third of our country. I've remained of necessity an outsider, and the north has remained for me a convenient place to dream about, spin tall tales about sometimes, and, in the end, avoid.

Never to be outdone in the emphatic tone of his pronouncements, composer R. Murray Schafer is categorical and portentous in his statements about the North. "The idea of North is a Canadian myth," he insists in the liner notes to his 1980 composition *North/White*, before warning that "without a myth a nation dies." To which I might add that, in this century, Schafer's North may itself be dying and that as it melts, Canadian sovereignty may be dying with it.

My last quotation, from Wendy Lill's play *The Occupation of Heather Rose*, rings quite another note. It comes from a play that challenges many

of southern Canada's mistaken notions about both North and Native northerners, but Lill is not joking, not even seriously, as is Pachter in his painting. The play is a monologue in which Heather Rose directly addresses her audience:

> Who me? What brings me here? Oh, I've always been attracted to the North ... like a firefly to light. No ... never this far before. Mainly the Barrie area, but it's a lot like this. One-sided trees, fiery sunsets, loons ... You've heard of Camp Cocano? (300)

Heather Rose is a naive, well-meaning young nurse who has flown into a northern Indian reserve bringing with her all her southern illusions about northern adventure and a Florence Nightingale concept of the white woman's burden. She is addressing us as she waits in a southern office for a meeting with her boss, but by the end of the play (the boss, like Godot, never shows up), her traumatic memories of her experiences up north, and her reconstruction of the story of her initiation into the realities of her own ignorance, will have transformed her into a different person. She will be angry, aware of the arrogant mistakes made in the North by cynical southerners, and she will take responsibility for her failures. Heather Rose is a type of Ancient Mariner or Marlow figure, seizing us by the arm, forcing us to see her heart of darkness, so that we too will understand just how dangerous romantic fantasies and irresponsible actions in the North can be.

II *IMAGE-ING* NORTH

Maps are among the most powerful of the many visual images that have fascinated and influenced me. They bear eloquent testimony to ideas of North that have circulated for centuries; they teach us how these ideas

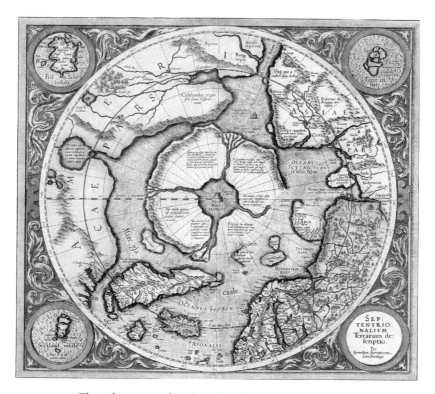

FIGURE 5 Flemish cartographer Gerardus Mercator (1512-94) is remembered today for developing the Mercator projection map. His beautiful map of the North Pole blends medieval information and myths about undiscovered areas and open waters at the pole with information from sixteenth-century explorations in Arctic regions. Derived from Mercator's 1569 map of the world, it has been reproduced in many books and atlases over the centuries.

have changed, and they show us how we shape and are shaped by such images. Gerardus Mercator's sixteenth-century *Map of the Arctic* (see Figure 5) is a colourful reminder of how the European mind once saw the North — as an intriguing mix of partial fact and pure fiction, with pygmies living near the pole and an imaginary island called Frisland — of just how old some ideas of the North are, and of how far we have come in

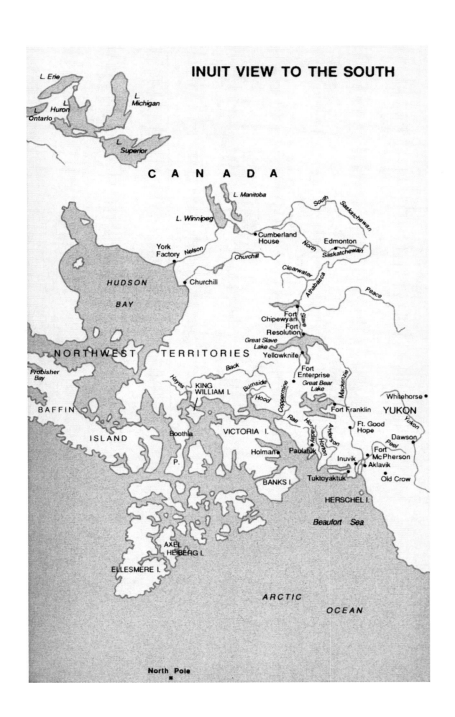

INUIT VIEW TO THE SOUTH

L. Erie
L. Michigan
L. Huron
L. Ontario
L. Superior

C A N A D A

L. Manitoba
L. Winnipeg
York Factory
Nelson
South
Saskatchewan
Cumberland House
Edmonton
North
Saskatchewan
Churchill
Clearwater
Athabasca
Peace
HUDSON BAY
Churchill
Fort Chipewyan
Fort Resolution
Great Slave Lake
Slave
NORTHWEST TERRITORIES
Yellowknife
Frobisher Bay
Back
Hayes
KING WILLIAM I.
Burnside
Hood
Fort Enterprise
Great Bear Lake
Mackenzie
Whitehorse
BAFFIN
Coppermine
Hornaday
Rae
Anderson
Fort Franklin
YUKON
Yukon
ISLAND
Boothia
VICTORIA I.
Holman
Paulatuk
Horton
Ft. Good Hope
Dawson
Peel
P.
Inuvik
Fort McPherson
Aklavik
BANKS I.
Tuktoyaktuk
Old Crow
HERSCHEL I.
Beaufort Sea
AXEL HEIBERG I.
ELLESMERE I.
ARCTIC
OCEAN
North Pole

22

FIGURE 6 (FACING PAGE) *Inuit View to the South,* from Rudy Wiebe's
Playing Dead: A Contemplation concerning the Arctic (1989). Wiebe is one of
the earliest and most important writers (along with Pierre Berton and Farley
Mowat) to urge southern Canadians to understand the North from a northern
perspective. In the twenty-first century, the impact of climate change on the
Arctic, with its attendant spectres of military conflict over resources and
environmental devastation from global warming, makes Wiebe's northern
message all the more prescient and urgent. Reproduced with the author's
permission.

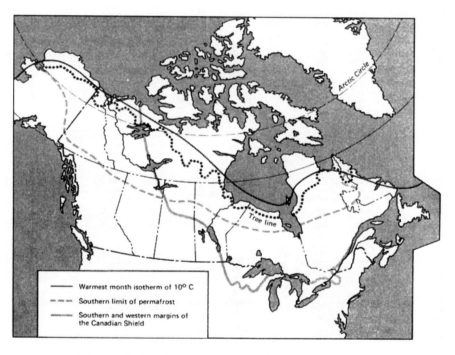

FIGURE 7 *Where Is the North?* illustrates some of the main indices of
Canadian nordicity. Reproduced, courtesy of Bruce Hodgins, from *The Canadian
North* (1977).

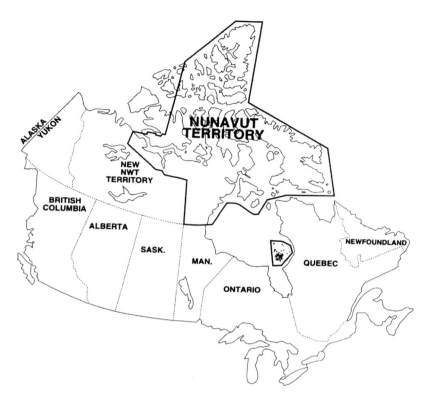

FIGURE 8 This map shows the new internal boundaries of the Canadian North as of 1999. When Nunavut became an official territory on 1 April 1999, the map of Canada changed significantly, and the North gained new prominence. The former NWT was divided to create Nunavut (Our Land) to the northeast, leaving the smaller NWT to the southwest. The population of Nunavut is primarily Inuit, and the capital is Iqaluit on Baffin Island. Reproduced from John Hamilton's *Arctic Revolution* with the permission of The Dundurn Group © 1994.

our cartographic authority.[2] Almost four hundred years later, Rudy Wiebe gives us his equally fanciful imagining of the North but from a post-modern perspective in which he turns the tables on the South by turning our country upside down (see Figure 6). But in case Wiebe's perspective is as disorienting as Mercator's, two contemporary Canadian cartographic

representations of our physical shape (although not as artistic) show us clearly where nordicity is located by scientists and how the internal boundaries of the country changed after 1 April 1999, when Nunavut was created from the former Northwest Territories (see Figures 7 and 8). But now I want to put such *facts* aside and invite you to venture forth with me on a short historical and artistic expedition.

If you were to visit the Art Gallery of Hamilton tomorrow, chances are you would be able to see a famous Canadian painting prominently displayed on its walls. The canvas is not especially large (151.1 by 191.4 centimetres), but its power is not a function of size. In the foreground, a hooded figure, with snowshoes strapped to his back, kneels in the snow. All around him, and receding into distant drifts, lies moonlit snow. The sky is dark, but if you look closely there are a few stars; however, it is not the stars, the night sky, the pale snow, or even the fallen trapper that holds your attention. Ahead of this man, just beyond his outstretched arm, and clearly discernible against the snow, is a figure walking away into the picture plane and out of the painting. Who or what is this? Another trapper? A ghost? Or, given the resemblance of the fallen trapper to the ghostly presence, is this figure the trapper's doppelgänger, his very soul, and thus the image of his death? The painting I have just described is Blair Bruce's *The Phantom Hunter* (recently renamed *The Phantom of the Snow*), a critical success at the 1888 Paris salon (see Figure 9).[3] Today it is Bruce's most famous painting, enjoying a privileged place in the iconography of Canada's image of itself as a northern nation.

Bruce's inspiration for the painting came from "The Walker of the Snow," an 1859 poem by Charles Shanly. This is a deceptively simple narrative poem based on legends or folktales about the Shadow Hunter, a figure who bears some resemblance to the Windigo of Ojibwa and Cree mythology. The speaker in the poem tells his listener about an encounter he has had — and survived? — with the Shadow Hunter, "who walks the

midnight snow" (Shanly, in Grace, *Canada and the Idea of North* 108) and kills men who pass through the valley alone on cold winter nights. The hunter wears a grey hood and appears suddenly beside you just as you are about to enter the valley; more importantly, he leaves "no foot-marks on the snow" (108). The climax of the tale comes just as the speaker and his companion are about to enter "the valley / Of the Walker of the Snow":

> Then the fear-chill gathered o'er me
>> Like a shroud around me cast,
> As I sank upon the snow-drift
>> Where the Shadow Hunter passed.
> And the otter-trappers found me,
>> Before the break of day,
> With my dark hair blanched and whitened
>> As the snow in which I lay.
> But they spoke not as they raised me;
>> For they knew that in the night
> I had seen the Shadow Hunter,
>> And had withered in his blight.
>> (109)

Even today in a postmodern Canada, where we can build towns like Inuvik on the permafrost, take oil from the Beaufort Sea, escape from wind chill temperatures of minus 30 into the West Edmonton Mall, and transport the Canadian Shield to downtown Toronto, it is difficult to shrug off this poem. It is difficult because the poem reminds contemporary readers, just as it did Blair Bruce at the end of the nineteenth century, that a northern world is a dangerous one. The poem, like the painting it inspired, reminds Canadians forcibly of things they might prefer to forget,

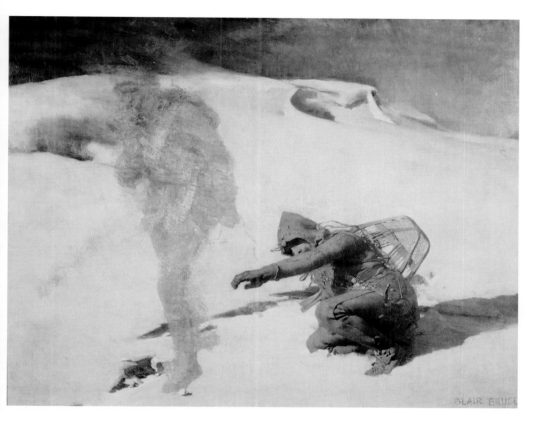

FIGURE 9 William Blair Bruce, *The Phantom Hunter* (c. 1888), oil on canvas, 151.1 x 191.4 cm. This powerful nineteenth-century painting is now an iconic image of Canada-as-North. I discuss its imagery and sources in further detail in *Canada and the Idea of North* (104-22). Collection of the Art Gallery of Hamilton, Bruce Memorial, 1914, and reproduced with permission of the gallery.

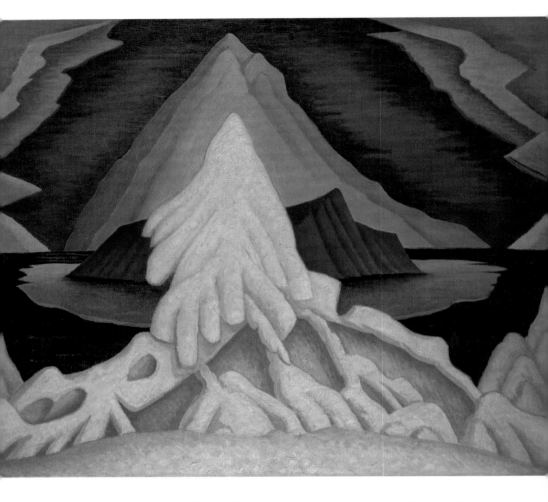

FIGURE 10 Lawren Harris, *Winter Comes from the Arctic to the Temperate Zone* (c. 1935), oil on canvas, 74.1 x 91.2 cm. Perhaps best known for his austere paintings of northern Ontario landscapes, Harris also painted the Rocky Mountains and the Arctic. This dramatic image captures the extent of nordicity in Canada and represents the country as symbolically informed and united by its northern climate. Collection of the McMichael Canadian Art Collection, purchase 1994 (1994.13) and reproduced with permission.

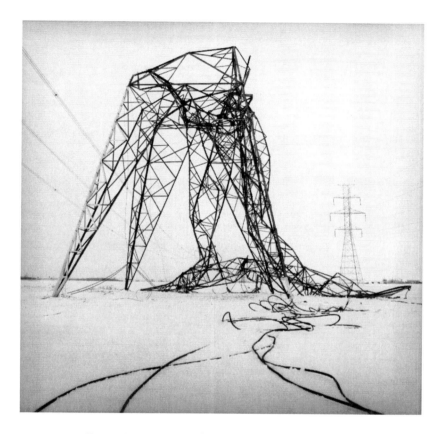

FIGURE 11 Benoit Aquin, "Le verglas #16, Boucherville" (1998). This stunning photograph of a collapsed power line, caused by the ice-storm that struck areas of south-central Canada during the winter of 1998, was part of the photo-essay "Lethal Beauty," by Montreal photographer Benoit Aquin. It provides a striking reminder of Canadian nordicity and of the vulnerability of our technologically sophisticated society. Reproduced with the artist's permission. © Benoit Aquin.

such as the terrible ice-storm that crippled Montreal in January of 1998 and was captured by Quebec photographer Benoit Aquin in his stunning series of photographs titled "Lethal Beauty" (see Figure 11).

By the turn of the twentieth century, cameras were going to the Far North with explorers and ethnographers because they were becoming

small enough to carry, and they used film that could survive cold temperatures. One early example of published Kodak images is Mina Benson Hubbard's 1908 classic A Woman's Way through Unknown Labrador, but Vilhjalmur Stefansson, Diamond Jenness, and many others also published their photographs as visual proof of their northern exploits.[4] However, the first southerner to take a film camera into the North with the intention of making a movie was Robert Flaherty. Nanook of the North was released in 1922, but it was filmed earlier largely around the Revillon-Frères fur-trading post at Port Harrison (now Inukjuak), Ungava. The film made Flaherty famous and popularized the image of the "Eskimos" as childlike, fur-clad, smiling people. Contemporary videos of it are easily available today and still used in university film studies and anthropology classes.[5] In the opening sequence of the film, Canada is equated with the North of Hudson Bay and Ungava, and the "Eskimo" subjects of the film are constructed as representative of all Inuit; the actors are not identified by name as actors. Instead, we come to know them as "Nanook," the "great hunter," and his family. Compared with the deadly, haunting North of Shanly and Bruce, Flaherty's North is liveable, and its cheerful inhabitants are quite at home. Of all the shifting ideas and images of North, the ones presented in films are the most striking for the transformations charted by their changing representations over time. True, technological advances are immense in this art form, but attitudes and perceptions have changed as well. Contemporary films about the North differ from past films because of the ideological distance artists (and audiences) have travelled, as a comparison of Robert Flaherty's Nanook with Zacharias Kunuk's Atanarjuat demonstrates.

Eight years after Nanook began entertaining the world (and after the hero of the film had died, unnoticed and uncelebrated, of starvation), the southern Ontario playwright Herman Voaden published Six Canadian Plays (1930), the volume in which he announced his new northern vision

for a Canadian theatre. Voaden, who was deeply influenced by the Group of Seven (especially by Lawren Harris), believed that a truly Canadian drama must use Canadian subjects and northern settings. The six plays he edited for the volume employed these subjects and settings, and Voaden illustrated the book with production photographs, drawings of northern scenes by Lowrie Warrener, and paintings by members of the Group. Voaden's introduction was, in fact, a manifesto linking Canadian nationalism, nordicity, and the arts. For his own plays, such as *Northern Storm*, *Northern Song*, and *Rocks* (1932), Voaden used silver-grey-blue lighting on the simplest abstract sets to evoke a northern atmosphere that would make the "North," as he put it, "a participant in the action, an unseen actor" (quoted in Grace, "Re-introducing Canadian 'Art of the Theatre'" 128). But, as with the film *Nanook of the North*, I mention Voaden's work here to provide a time frame and a marker of the distance travelled by contemporary playwrights such as Wendy Lill, Patti Flather and Leonard Linklater, Sally Clark, and Marie Clements, whose play *Burning Vision* I will consider shortly.[6]

But no consideration of images and ideas of the Canadian North is complete without acknowledging the influence of three popular champions of all matters northern: Vilhjalmur Stefansson (1879-1962), Pierre Berton (1920-2004), and Farley Mowat (1921-). Stefansson, arguably Canada's greatest Arctic explorer, the subject of a major biography (see Hunt) and a National Film Board documentary film called *Arctic Dreamer: The Lonely Quest of Vilhjalmur Stefansson* (2003), organized three expeditions to the Arctic and wrote several important, and very popular, non-fiction books about his explorations, the Inuit, and Arctic history and legend. He was a controversial explorer, an anthropologist, an ardent advocate of the North, and an extremely interesting writer who argued for the friendliness of the Arctic and attempted to dispel a series of what he believed were ill-founded prejudices, errors of fact, and negative assumptions

about the North. In *The Friendly Arctic* (1922), he set out to convince his readers (and the governments who might fund his research) that the North is a friendly place, rich in resources and high in potential for development and settlement. "It is the mental attitude of the southerner," Stefansson insists, "that makes the North hostile. It is chiefly our unwillingness to change our minds which prevents the North from changing into a country to be used and lived in just like the rest of the world" (687).

Canada's recent loss of national icon Pierre Berton, who died in 2004, is important for many reasons, but one of the most compelling of them is his articulate vision of the North. Whether he was writing about Arctic exploration or the romance of the Klondike in books for adults or children, Berton always saw Canada-as-North, Canadians as northerners, and the country's national responsibilities as northern and circumpolar. In his last book (his fiftieth), *Prisoners of the North* (2004), Berton returned eloquently to what he called his "Northern heritage," and he confessed that, like his father, "and like the five remarkable characters that follow, I, too, in my own way am a prisoner of the North" (3). The "remarkable characters" he refers to are the heroes and heroines of his book — Klondike Joe Boyle, Vilhjalmur Stefansson, Lady Jane Franklin, John Hornby, and Robert Service — but their life stories are inextricably woven with Berton's insofar as they share with him (as he with them) a northern destiny that includes understanding the complex history and realities of a Canada defined by the North. Among his many reasons for prefacing his final story about the nation's collective identity with a quotation from Robert Service's poem "Men of the High North," the key one may be responsibility. Berton's final message, along with that of Service, is to "Honour the High North" and "learn to obey" her laws.

Although Farley Mowat may not write with the same *gravitas* as Berton (and Mowat, thankfully, is still with us and still writing), he too has staked his claim to personal and national identity on the North in his many

books, for adults and children, about the Keewatin (*People of the Deer*, *Never Cry Wolf*, *The Snow Walker*, to name just a few) and the Arctic (*The Polar Passion* and *Ordeal by Ice*), and he too has returned to his private North in two of his recent books, *High Latitudes* (2002) and *No Man's River* (2004), and in his 2008 memoir *Otherwise*. Some scholars and scientists choose to scoff at the notion of a serious interest in Mowat, but I reject that attitude. I enjoy reading Mowat on the North and believe Canadians (indeed, all people) need to be reading him in this era of climate change, more than ever before. Margaret Atwood put the matter succinctly in her introduction to *High Latitudes* when she reminded us that, "as Farley Mowat has always known, and as more and more people have come to agree, it's a race against time, and time — not just for the north, but for the planet — is running out" (xi). By reading Mowat on the North, we are able to enter and share in his deeply personal, hands-on sense of place; he writes, passionately, in the first person, often mixing fact and fiction in his inimitable manner, and always bringing the people, the life (animal and vegetable), weather, and land- and waterscapes close enough, in vivid sensuous detail, for us to smell and touch. It is difficult to ignore a reality that comes so close to our lives. Mowat first went north when he returned from the battlefields of Italy after the Second World War. He wanted to escape memories of that horror, but instead of escaping, he found himself entrapped, imprisoned (like Berton) by a world that, he tells us in *No Man's River*, "was to become a determining influence in my life" (3). His escape became a mission, and through his books and two feature films, Farley Mowat's North has touched more people living in the south of Canada (and around the world) than anyone else's.

Without doubt, Stefansson did convince some of this country's politicians, from Prime Minister Robert Borden to Lester Pearson and John Diefenbaker, of the potential of the North.[7] But today, it is even more important that current politicians listen to Berton and Mowat, or to the

advice of former governor general Adrienne Clarkson, whose belief in the cultural and strategic importance of the North is unequivocal. In a 2004 interview titled "On Being a Northern Country," she explained that, "as Governor General, my going to the North draws attention to the fact that: it exists [and that] it is extremely important for Canadians to realize that they are a Northern country. Otherwise you pretend that the greater part of your country is not there and you live in denial about your real identity. *We are a northern people.* I want us to think of how we relate to the countries that share the same latitudes" (6). I suspect that Clarkson takes Berton and Mowat very seriously, and I suggest that current and future politicians should do the same.

But let me return to the painters. Lawren Harris always insisted that his "work was founded on a long and growing love and understanding of the North, of being permeated with its spirit" (7), and over his career his North expanded to include areas far north and west of Algoma and Lake Superior. More than any other member of the Group, Harris wrote about the North in comments that have been printed, quoted, and reprinted until it has become a critical commonplace to associate him with the "mystic north," the "replenishing" North, the "spiritual clarity" and "flow" of the North, and with a national ideal of northernness.[8]

Of all the Harris paintings I might have chosen to contemplate here, *Winter Comes from the Arctic to the Temperate Zone* (c. 1935) captures many of the ideas of North that are circulating in my examples thus far (see Figure 10). The first striking aspect of this canvas is the limited palette: the pure, shimmering blue mountain- or glacier-like shape rising in the background is balanced, but not displaced, by the creamy-white, snow-clad shapes of tree and shoreline in the foreground. These two massive vertical forms mirror each other across the smaller horizontal deeper blue form of an island. On the dominant vertical axis of the painting, the eye moves from the distinct cold blue tips of mountain or glacier down to

the tree top and down again to the frozen shapes in the foreground, until, at the very bottom of the picture, it rests on spots of yellow, the only warm touches in the entire composition. From there, the gaze travels back up the painting and off the top of the canvas toward an imagined Pole. What Harris has done in *Winter Comes from the Arctic to the Temperate Zone* is to connect the temperate zone of boreal forest with the barren, ice-surrounded sub-Arctic and the High Arctic of glaciers; he has linked the more southerly North of Shanly and Bruce with the Far North of Stefansson. By joining them visually, by imaging their symmetry and mirroring duplication, he creates an allegory of Canada-as-North.[9]

For Canadians such as Voaden and Harris, *the North* was indeed God's country. However, the idea of "God's Country" had other roots, which have spread deeply in the fertile commercial ground of popular art over the last hundred years. Putting aside the movies explicitly using this term, such as *Back to God's Country* (1919) starring Nell Shipman, I want to consider a popular image that is inextricably bound up with ideas of North that many Canadians born in the 1940s will remember from childhood: *Sergeant Preston of the Yukon.* In the first half of the twentieth century, images of the Mounties were proliferated through radio serials or movies about Canada. Pierre Berton claimed that, of the 575 Hollywood films made about Canada between 1907 and 1956, the overwhelming majority represented the country as vaguely northern or arctic, and 256 featured the Mounties (*Hollywood's Canada* 111). Of these movies, *Rose-Marie* was the most popular; the 1936 sound version, starring Jeanette MacDonald and Nelson Eddy, remains famous. Although Preston owes much to the earlier Canadian Mountie radio serial *Men in Scarlet* and to movies, this northern hero probably reached more Canadians than any of his predecessors because he was aired serially on CBC radio during the late forties and early fifties, and he starred in seventy-eight episodes on CBC television between 1955 and 1958. The incorruptible Preston, often

in dress uniform, always gets his man, despite fierce blizzards, numbing cold, and the dramatic sound-effects of blowing wind, barking dogs, and cries of "Mush!"

The forties and fifties were, in fact, rich in popular images of the Canadian North, and one of the youngsters watching *Sergeant Preston of the Yukon* on CBC television in the fifties was Paul Haggis, who created today's most famous TV Mountie, Constable Benton Fraser, the dashing, pure-minded hero of the award-winning series *Due South*. The program aired in 1994 and ended in 1996, but it lives on in many ways. Constable Fraser, played by a handsome, clean-cut, young Paul Gross, has kept the iconic image of the Canadian Mountie alive along with the satiric wit and comic exploitation of cultural stereotypes (of how Canadians see themselves and their southern neighbours) fundamental to the program's stories and characters.[10] He always gets his man, of course, along with the help of his trusty dog — a husky-wolf cross named Diefenbaker after the former prime minister — a canine side-kick that recalls the famous dog King (perhaps named for another PM), who worked alongside Sergeant Preston. Since 1996, when the series ended, it has enjoyed a successful afterlife on BBC2 in the United Kingdom, on video and DVD, through books such as Geoff Tibballs' *Due South: The Official Companion* (1998) or paperback treatments of episodes by Tom McGregor, and on-line, where one can buy "official" *Due South* trinkets, see photographs of Gross as Fraser, or read about "Dief." The generation of voters who brought Diefenbaker, the politician, his stunning majority in the 1958 election was brought up on *Men in Scarlet* and Sergeant Preston and, during the Second World War, on such explicitly northern comic-book heroes as Dixon of the Mounted, Fleur de Lys, and Nelvana of the Northern Lights, otherwise known as Alana North, secret agent. Nelvana, the brainchild of Adrian Dingle and Franz Johnston, was a white goddess

figure, daughter of the King of the Northern Lights, and very loosely based on Inuit mythology. Unlike Preston or Fraser, she was a wartime propaganda heroine; she could travel at the speed of light on the aurora borealis, make herself invisible, transform others, and, most importantly, control communications. Although less famous than her male counterparts, Nelvana has lived on through a commemorative stamp and comicbook folklore (see Plate 4 in Grace, *Canada and the Idea of North*).

When I turn to the world of Canadian music, it is by no means only in the realm of popular culture that I find representations of northern identity or iconic figures. Many Canadians know Stan Rogers' ballad "The Northwest Passage" or the Tragically Hip's song about Tom Thomson or the music of Susan Aglukark (just one of several northern singers or groups I might name), but they are less familiar with classical compositions inspired by their composers' experiences of northern landscapes and peoples. Harry Somers' *North Country* is one of the earliest of these and still, to my ear, one of the most moving. Somers composed this work in 1948, three years after the period he spent (1943-45) with the RCAF during the war and after some restorative camping trips in Algonquin Park. This short orchestral suite (just over fourteen minutes on my recording) in four movements evokes the four seasons in that part of Canada, and I also detect in it a haunted quality, as if Somers' memories of the war lie just beneath the surface of this music. Although insisting on representation in non-programmatic music is problematic, it seems to me that Somers' vision of his north country is perfectly captured in the language of contrapuntal organization, extended crescendo, dynamic contrast, and what Brian Cherney calls his "tension-producing appearances ... of tonal elements within a non-tonal context."

The title of this piece — *North Country* — provides my key representational coordinate, but I am on firmer ground with my next musical

example, by Glenn Gould. It is tempting to imagine Gould, who was born in 1932, listening to *Men in Scarlet* and *Sergeant Preston* on the radio or reading *Dixon of the Mounted* and *Nelvana of the Northern Lights*; he was, after all, an inveterate radio listener and quite comfortable with popular culture. It is tempting, but I have no evidence for it. Gould claimed that his inspiration for *The Idea of North* came from school maps of the Northwest Territories, reproductions of Group of Seven paintings on schoolroom walls, aerial photographs, and Geological Survey maps.[11] Gould's unusual composition was commissioned as a centennial project for CBC *Ideas* and first broadcast on 28 December 1967; three months later, it aired on CBC's Northern Service *Tuesday Night*. Gould's introductions for the two broadcasts differ in interesting ways and demonstrate his awareness of the gap between southern and northern Canadians' perceptions of the North.[12] In 1970 he adapted it, adding visuals and actors to the libretto and score, to create the CBC television version of the work, and he was photographed bundled up against the cold and standing beside the Muskeg Express, the train that would take Gould, who refused to fly, as far north as he would ever get. Since then, *The Idea of North* has been recorded on vinyl (in 1971) and on compact disk (1992), as one of three sound documentaries in his *Solitude Trilogy*. In his 1993 feature film *Thirty-Two Short Films about Glenn Gould*, François Girard combined ideas of solitude and nordicity (cold, snow, empty distances) to create his image of Gould the man: in the long opening and closing shots of the film, a black figure materializes from the expanse of white as he approaches the camera and then moves away from it to disappear into that same empty white landscape. All we hear is the crunching, at first faint and then louder, of the man's boots on the snow. In between these framing shots, we see Gould (played by Colm Feore) living, performing, and recording in a studio, but he has been established for us from the start as a spectral figure

(reminiscent of Blair Bruce's phantom), one with the winter landscape, and as quintessentially Canadian because of that identity. Girard has made the North a governing metaphor for Gould himself.

But just as Gould's *Idea of North* has had several incarnations, which, by the 1990s had recuperated Gould himself, making him over as (or into) North, so the composition itself does not inscribe a fixed, single *idea of North*. Gould's North is, in fact, contrapuntal and multiple: it presents the "interaction of [the voices of] five characters" who were carefully chosen by Gould to represent five different responses to the North; they include an "enthusiast," a "cynic," a "governmental budget-watcher," someone who "represents that limitless expectation and limitless capacity for disillusionment" (a position filled by an anthropologist and geographer), and lastly, the philosopher/narrator Wally Maclean (Gould, "'The Idea of North'" 392). Inevitably, each "character" turns to the question of the relationship between the North and the rest of Canada, to the idea of nation, and to the way the North shapes the southern individual who goes there. These reflections flow smoothly into observations about some of the harsh realities of the North — poverty, alcoholism, starvation, racism, and sexism. And so the polylogue continues, swaying back and forth, like the train, from one voice to another, from romance and myth to harsh facts, from dreams of Eldorado or Utopia to the challenges of the future. An extremely important theme, introduced late in the composition, concerns the future of the North: one man sees it as similar to that of the rest of Canada, another sees it as full of dramatic developments, such as drilling for oil in the Beaufort Sea, and another believes that the North will become the place of creation, recreation, re-creation, the place to go for universals and knowledge "on a global scale." Just audible, underneath these voices, is what Gould called the "basso continuo" of the train carrying us all further and further north.

III From Gould to *Atanarjuat* and Beyond

Since the 1967 premier of Gould's *The Idea of North*, artistic representations of the North have continued to circulate within our culture. Between 1967 and the present, the North has become more important to the entire country and a more significant — albeit problematic and challenging — subject. Although, unlike Hamelin's, my nordicity indices are not scientific, I have my own way of calculating what I see as the increasing profile of the North over the past thirty-five years. For example, the rising importance of the North is demonstrated by the sheer quantity of published work on or about it. This work ranges from scientific papers and scholarly monographs in history, geography, art history, and so forth to popular books, often lavishly illustrated, children's books, serious fiction, plays, films, biography, and autobiography, and to work by northerners such as *It's Like the Legend: Innu Women's Voices*, edited by Nympha Byrne and Camille Fouillard, or novels by Northwest Territories writer Robert Alexei. A number of important events have kept the North in the public eye, from the obsessive interest in Franklin that was renewed when Owen Beattie opened the graves on Beechey Island and published photographs of the remains, which he found to be astonishingly well preserved by the permafrost (see Figure 12), to ongoing negotiation for a pipeline in the western Arctic, new agreements in Quebec for hydro-electric development around James Bay, the creation in 1999 of Nunavut, the 2005 centenary of Mina Benson Hubbard's successful expedition across Labrador, and the intense media attention to Canadian research being conducted in the High Arctic — I am thinking of CBC's national news anchor Peter Mansbridge's trip on the *Louis St. Laurent* in the summer of 2006 but also of the constant coverage of climate change and issues of sovereignty in our newspapers and magazines.

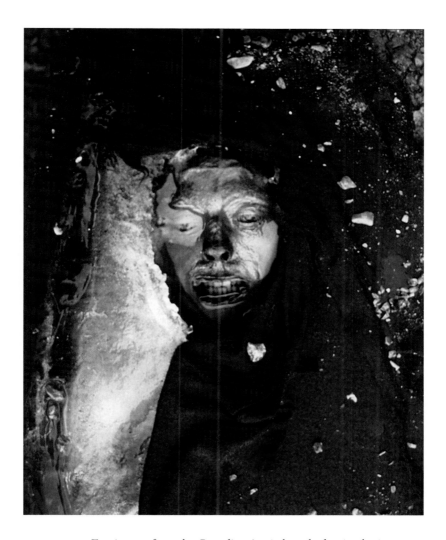

FIGURE 12 Few images from the Canadian Arctic have had quite the impact and wide circulation as this haunting photograph of John Torrington in his coffin on Beechey Island; it was taken when the blue wool shroud covering him was pulled back to reveal his well-preserved face 140 years after his death on the fatal Franklin expedition. The photograph was first published in *Frozen in Time: Unlocking the Secrets of the Doomed 1845 Arctic Expedition* (1987) by Owen Beattie and John Geiger. Dr. Beattie, a professor of anthropology at the University of Alberta and principal investigator of this research into the fate of Franklin and his crew, took this photograph, which is reproduced with his permission.

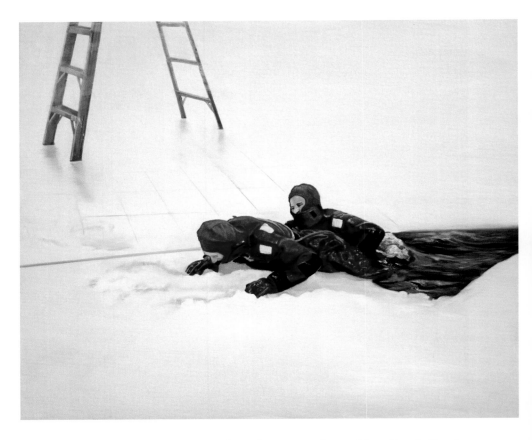

FIGURE 13 Dominique Gaucher, *Abstractionist Rescued from Certain Depth 2* (2006), oil on canvas, 91.4 x 76.2 cm. This powerful painting is part of a diptych in which the artist explores the boundaries between abstraction and figuration, illusion and (apparent) reality, and surfaces and depths. A viewer may find many other meanings in this complex, evocative work, but I see a prophetic irony in this scene of sophisticated red-suited Arctic explorers/scientists scrambling to safety as the ice melts beneath them *in a Montreal studio*. This painting was first shown in the 2006 exhibition On the Surface of Things, at the Douglas Udell Gallery; it was printed in Gaucher, *On the Surface of Things*. Reproduced with permission of the artist. © Dominique Gaucher.

This social, political, and cultural activity provides the necessary context for understanding the impact of the arts and their crucial role in informing Canadians about their nordicity. In 1995-96 the retrospective exhibition celebrating the Group of Seven called The Group of Seven: Art for a Nation/Le group des sept: L'émergence d'un art national (see Hill) toured from Ottawa's National Gallery of Canada to Toronto's Art Gallery of Ontario, the Vancouver Art Gallery, and the Musée des beaux arts in Montreal. A splendidly illustrated catalogue was published simultaneously, and the event was a massive and, I would argue, *strategic* success. I call this exhibition strategic because of its political timing, its cross-country itinerary and major venues, and its ideological underpinnings. Prominently displayed on the book's dust jacket above a full-colour reproduction of Arthur Lismer's *Pine Tree and Rocks* (1921) is this quotation from a controversial 1919 exhibition: "The great purpose of landscape art is to make us at home in our own country." One obvious purpose for this bilingual exhibition was to reinforce Canadian faith in "our own country" at a point in our history, post-Meech Lake (1987) and the second Quebec referendum (1995), when the country seemed to be coming apart. The idea of North, like the story of the Great War, has periodically served as a flag around which to rally in a shared, unified identity and common national purpose. This synergy is once more gathering momentum as the ice melts and the Northwest Passage opens. However, Art for a Nation is only one of a number of significant arts and cultural events of recent years to be specifically associated with the North. The latest are the newly created Magnetic North Theatre Festival and the 2002-03 Tom Thomson retrospective and catalogue. For many years, the Great Northern Arts Festival has been held in Inuvik; in 1998 Canada hosted the first Northern Encounters Festival, which brings the artists and arts of *all* the circumpolar countries together; from 1996 to 1998, the country celebrated the

hundredth anniversary of the Klondike Gold Rush, which precipitated the publication of many books and CD-ROMs, extensive television coverage, and an increase in tourism to the Yukon; and in January 2008, Quebec City began its four-hundred-year anniversary celebrations with, among other winter sports, the "Red Bull *Crashed* Ice" event on a massive ice slide constructed through the heart of the old city for extreme skaters, skiers, and snowboarders to descend with dizzying (bone-breaking) speed — this was a classic example of le grand nord coming due south to remind everyone of where they were.

My favourite Klondike centenary event was the publication of Robert Kroetsch's novel *The Man from the Creeks* (1998), its title and characters drawn, as many Canadians will recognize, from Robert Service's famous poem "The Shooting of Dan McGrew":

> Then I ducked my head, and the lights went out,
> and two guns blazed in the dark,
> And a woman screamed, and the lights went up,
> and two men lay stiff and stark.
> Pitched on his head, and pumped full of lead,
> was Dangerous Dan McGrew,
> While the man from the creeks lay clutched to the
> Breast of the lady that's known as Lou.

The Man from the Creeks is both a historical fiction about the Klondike and a highly self-conscious intertextual narrative about the processes of myth-making, historiography, and storytelling that provides, in the form of an entertaining novel, a *serious* rewriting back into Canadian history and contemporary consciousness of an event of major significance for Canada (see Grace, "Afterword"). The great Gold Rush of the late 1890s

brought thousands of prospectors and others into an inaccessible and undeveloped northwestern corner of Canada. In a few short years, it transformed tiny Dawson City into a bustling metropolis, and it challenged Canadian sovereignty and law because most of the miners were American.

Kroetsch, of course, is not the only one to have written about the Klondike. Apart from Robert Service, Pierre Berton has immortalized the time and the place in several books, including his last one, *Prisoners of the North* (2004), but Kroetsch has done several things in his rewriting that add to and expand upon the story. He makes his hero a woman: despite the novel's title, the central character of his Klondike is "the lady that's known as Lou." He revises the received version of the story about who discovered the gold in August 1896 that would spark the stampede north, and he makes his discoverer the First Nations woman Shaaw Tláa (see Grace, *Canada and the Idea of North* 232-33). What's more, he creates a symbolic journey under the ground and into the permafrost in a search for the mother lode, and he brings back to the surface the ghosts from the past, giving them voices in our shared present. In short, he has used his novel to celebrate the Gold Rush as a living testimonial to our current history and geography, thereby confirming its place in the creation of nation. He has, through the power of imagination and story, written Lou, Shaaw Tláa, and a host of other ghostly presences into an understanding of our contemporary shared nordicity.

Sally Clark's play *Wanted* (2004) is also set in the Klondike during the height of the Gold Rush. Like Kroetsch, Clark makes a woman her central character, which in itself is unusual because most northern adventures feature men, and the Gold Rush has always been portrayed as a male story. Clark researched and wrote the play during a period she spent as writer-in-residence at Dawson City's Pierre Berton House in 2002, and the

play premiered with the Nakai Theatre in Whitehorse before moving up to Dawson City's historic Palace Grand Theatre. In other words, although Clark herself is from British Columbia, *Wanted* was written in the North about a northern event and then had to pass muster with northern theatre audiences. It is in many ways her most Canadian play to date.[13] But Kroetsch and Clark, for all their love of the North, are southern writers and know it. What the specifically northern arts continue to give us is enormous and different. From their small beginnings under James Houston in the 1950s, Inuit sculpture, graphics, and wall hangings have blossomed into a successful national and international art that brings the North to the South and returns benefits to the North. And northerners are now actively representing themselves to the rest of the country in other media as well, from fiction and non-fiction to music, theatre, and film.

Although it is premature to say what the film *Atanarjuat* will do for our sense of being Canadian, it is now important in any discussion of North. *Atanarjuat (The Fast Runner)* won its director Zacharias Kunuk the Camera d'Or at the 2001 Cannes festival for the best first feature film, and it has gone on to win more awards and much attention. This film is often thought of as bringing an Inuit perspective and story to a non-Inuit world, but I am certain that it is doing much more. First, it is a spectacularly beautiful film that quotes and *revises* a host of earlier so-called Eskimo or God's Country movies, from *Nanook* to the present. I see *Atanarjuat* as a cinematic "writing-back" to that earlier non-Inuit tradition. Second, it marks a fascinating conjunction of ancient narrative (of myth) with the latest technology, and by making such a link, it celebrates human creativity. Third, it represents the Igloolik Inuit to themselves *as a people living in time*, something Kunuk values above all else: his toughest screening test was not at Cannes but in Igloolik, his home, where Igloolik Isuma Productions is based, and where his community judges his achievement.[14]

IV GOING *NORTH* RIGHT HERE

As I hope is clear by now, the North is *not only* a geological or meteoro-
logical matter of treelines, eskers, permafrost, ice, snow, and temperatures
that can drop as low as minus 81 Celsius. Although it has certainly been
naturalized as essential to Quebec in the *pays d'en haut* concept and to
Canada as "the true North strong and free," North is a human construct,
like the Quebec City ice slide, like Canada itself; it is full of meaning
because of its multiple artistic representations. It has become part of what
the French scholar Pierre Bourdieu calls our "habitus," and we have
learned to accept it as a given, even perhaps to *mistake* it — as Charles
Pachter suggests — for a Group of Seven landscape painting. Images and
ideas of North have done, and continue to do, a great deal of ideological
and practical work for this country because they demonstrate the degree
to which the North permeates all aspects of our culture, from painting to
comic strips, and from politics to classical music and epic fictions, such
as Rudy Wiebe's *A Discovery of Strangers*, Mordecai Richler's *Solomon
Gursky Was Here* (1990), Gabrielle Roy's classic novel *La Montagne
secrète* (1961), or long poems such as *Cantos North* (1982) by Henry Beis-
sel. North surrounds us in tourist trinkets and in advertisements for every-
thing from mutual funds and beer to bottled water and diamonds. But
there are also images of North circulating in our immediately contempor-
ary culture that urge us to look beyond the North as a playground or as a
commodity, and I want to conclude my thinking about North by consid-
ering a few of these works that remind me of more serious issues while
contributing to our expanding concept of a northern nation.

My first examples are from films, feature and documentary, one of the
most entertaining of which is *The Snow Walker* (2004), based on Farley
Mowat's stories from the 1975 collection with that title. This is not the

first Mowat text to be made into a film; in 1983 his first autobiographical narrative — or what he called his "subjective non-fiction" — *Never Cry Wolf* (1963) became a popular family film delivering a conservation message.[15] With *The Snow Walker*, however, Mowat and the film's director, Charles Martin Smith, have exchanged the romantic adventure story and humour of the earlier film for a sobering illustration of the North's power to teach, to kill, and to sustain life and for a celebration of the Inuit, who know how to live (and die) with their environment instead of fighting and exploiting it. The white man in *The Snow Walker*, a bush pilot who flew bombers during the Second World War, is an arrogant, dangerous fool, and the consequences of his greed and stupidity are fatal. He will survive his crash in the Arctic, as he survived the war, but the juxtaposition of his memories of war trauma with scenes of his Arctic ordeal suggest that he has learned much from the North and the Inuit that he did not learn from war: most importantly, how to be a better human being. Through its sumptuous cinematography of vast landscapes, thundering caribou herds, and exquisite sunsets, this film, like the earlier one, also brings the beauty and majesty of the North to southern Canadian audiences and suggests that we can survive in this harsh landscape only if we respect it and adapt to it.

The National Film Board has been making films about the North and its indigenous peoples almost since its beginnings, but its most recent northern documentaries focus on climate change and on educating Canadians — and others interested in Canada — about the impact of global warming on Canada and on the world. As the advertising for the series called *Arctic Mission* indicates, the Arctic is on the frontline (an apt military metaphor) of climate change, the permafrost is melting, whole islands and communities, as well as wildlife such as polar bears, are under threat. "The impact of global warming on Canada's North," the blurb reminds us, is of urgent concern and we are part of a global ecosystem; we

will all lose if we do not change our ways.[16] The 2004 NFB documentary *Through These Eyes* is another example of the film board's constantly evolving representation of northern peoples, in this case of the Netsilik of Pelly Bay. In this film, as in Part 5 of *Arctic Mission* (titled *People of the Ice*), the Inuit describe their history and culture and warn the rest of us about the degradation of their habitat in their own words and from their own perspective.

The White Planet (2006), a France-Canada co-production directed by Thierry Piantanida and Thierry Ragobert provides a fascinating counter-discourse to *March of the Penguins*, the popular nature film about Antarctica. The white planet of the title is the circumpolar North, although many scenes are shot in Canada, and whereas *March of the Penguins* anthropomorphizes the life cycle of the birds in terms of a dramatic pilgrimage of epic proportions, *The White Planet* quietly represents the Arctic as the birthplace, the true mother lode, if you will, of all life on earth. Through remarkable wildlife documentary footage, we are allowed to watch birds and animals migrate north in spring and summer to food-rich oceans and tundra, where they can bear and raise their young. The narrator of the film, who remains relatively unobtrusive and is never didactic, refuses to draw a moral from these scenes; he allows the viewer to reach her own conclusions about the so-called empty and barren wastes of the Far North. Only once, and almost en passant, does he acknowledge that climate change could destroy this fragile life-sustaining ecosystem.

But in these brief reflections on cinematic contributions to our increasing awareness of the Canadian North, I cannot forget Igloolik Isuma Productions' major film *The Journals of Knud Rasmussen* (2006). Although I found this film much less compelling than *Atanarjuat*, its subject and message are, if anything, more timely. Kunuk and co-director Norman Cohn have returned to a critical moment of cultural encounter in the 1920s, when Danish ethnographer Knud Rasmussen met the people of

Igloolik and recorded in his journals the catastrophic impact of Christianity on their traditional culture. In an interview at the premiere of the film, held in Igloolik before his own community, Kunuk explained that Christian missionaries had robbed the Inuit of their beliefs: "They killed our spirit," he said, so it is no surprise that today the Inuit "are killing themselves" (quoted in MacDonald R1). *The Journals of Knud Rasmussen* reminds Inuit and non-Inuit, northerners and southerners alike, about the lasting evils of colonialism while at the same time trying, in Kunuk's words, to "answer two questions that have haunted me all my life: Who were we? And what happened to us?" (quoted in MacDonald R5). By providing answers through exploring the historical context, he believes he can give some hope to younger generations of Inuit. Kunuk's art may well be more efficacious than the Canadian government's formal apology on 10 June 2008 for such past wrongs as residential school abuse.

My theatre example of an artist's creation of new aspects of the North and of being Canadian is *Burning Vision* (2003) by Marie Clements. Like the films, it insists that southern Canadians recognize the North as integral to the rest of the country (and the world) and that, in doing so, they also acknowledge responsibility for the way in which the North and its people have been used by southern governments and interests. In this play, the North in question is Dene land around Port Radium on Great Bear Lake, but the play's setting reaches far beyond this remote area. The story Clements tells unfolds on several levels and through juxtapositions of different historical moments and physical places. On one level, it enacts the discovery, in 1930, of high-grade pitchblende for producing uranium. This led the American government, with the full cooperation of Ottawa, to order sixty tonnes of ore needed for the Manhattan Project, which would develop the bombs the world now knows as Little Boy and Fat Man after they were dropped on Japan in August 1945. This ore was mined and handled by Dene men who needed jobs, but they were not

provided with protective clothing for a kind of work known to be extreme-
ly hazardous.

The play opens in "intense darkness" and with a countdown to the
massive explosion that, at the April 2002 premiere in Vancouver's Firehall
Theatre, was one of the most impressive theatre moments I have ever ex-
perienced. The lights that came up after this blast were flashlights and the
dying embers of a fire, and the audience only gradually realized that it
was underground with the Labine brothers, who are credited with the
1930 discovery of the ore. These two white men dismiss local Dene proph-
ecies warning against the power of the pitchblende — it is only money
they are after — but at a corner of the playing area, before the low fire, a
Slavey woman is mourning the death of her husband.[17] What we see as
the play develops is, in a sense, what she calls up from the embers of her
fire: scenes depicting the violence of war, the destruction of Japanese
civilians, and the ruthless exploitation of Canada's North and its people
in the interest of what Clements calls "Western civilization building a
country" (75). By the play's end, the audience has borne witness to a burn-
ing vision of radium, war, and cancer but also of reparation when the
survivors among the Dene and the Japanese meet. And we listen to the
voice of the "Dene See-er" reminding us, "I wondered if this would hap-
pen on our land, or if it would harm our people. The people they dropped
this burning on ... looked like us, like Dene" (119). The Canadian North
and what happens there affects the Dene, whose ancestral lands are there,
as well as the rest of the world because Canada's North is a shared home
and a shared responsibility that people can embrace only if they know all
sides of the story.[18]

Whether I think of our constant retelling of northern stories as myth or
as revisionist history, there is no denying the perennial appeal of past
northern adventures and tragedies for the contemporary Canadian im-
agination: Kroetsch and Clark turned to the Klondike and to the poetry of

Robert Service; in *A Discovery of Strangers*, Rudy Wiebe chose to retell the first Franklin expedition from multiple perspectives, including those of the Indians; Lawrence Jeffery reimagined the death of John Hornby in *Who Look in Stove* (1993), and Elizabeth Hay showed what a persistent ghost Hornby has proven to be in her 2007 Giller Prize—winning novel *Late Nights on Air*; Sharon Pollock tackled the seemingly intransigent subject of two Inuit found guilty of murdering Catholic missionaries in 1914; in January 2007 John Estacio and John Murrell used the re-creation of Martin Frobisher as the subject of *Frobisher*, the first full-scale Canadian opera written about the North; and in 2008 John Walker released his award-winning documentary film *Passage* in which he provided a thoughtful, innovative investigation of Dr. John Rae's search for the lost Franklin expedition. All these re-creations of North take the Arctic or the territorial norths as their settings, but the provincial norths of Ontario and British Columbia also continue to inspire our writers in surprisingly new ways. For example, northern Ontario, in Mary Lawson's novel *The Other Side of the Bridge* (2006), is a fragile refuge, not only from the noisy corruption of southern cities, but more significantly from the catastrophes of war, and Michael Poole's mysterious northern British Columbia coast provides draft dodgers a temporary sanctuary from the military police during the First World War in *Rain before Morning* (2006). This very contemporary representation of North as a refuge from both world wars strikes a new note in the imagining of this country, a note that is pushed to painful intensity in Joseph Boyden's *Three Day Road*. But Boyden's North in this novel is so inextricably bound up with the horror of the Great War that I want to delay my discussion of it until my next chapter and conclude this chapter with a brief consideration of artistic inventions and celebrations of three northern expeditions: Mina Benson Hubbard's 1905 crossing of Labrador, the 1914 murders of Fathers Rouvière and Le

Roux while they were on a mission to the Inuit, and the late sixteenth-century search for the Northwest Passage by Frobisher.

Hubbard is a fascinating example of the degree to which writers, film-makers, and others have used the woman herself, her book, her journey, and her relationship with her guides and her husband to reinvent a figure from the past and invest her with a range of romantic, idealistic, even mythic qualities. When the actual Mina Benson Hubbard (1870-1956) crossed Labrador, from tiny North West River on Grand Lake to Ungava Bay in the summer of 1905, she was accompanied by four male guides. She was attempting to complete the work of her first husband, an American named Leonidas Hubbard Jr., who had starved to death in October 1903 toward the end of his failed attempt to lead his expedition west and north from North West River to the great interior Lake Michikamau and, from there, north with the George River to Ungava. He made a number of serious errors in planning for and conducting his expedition, but he was also misled by the incomplete Geological Survey maps of the Labrador interior, which were all he had to rely on at the time. When his lovely young widow took it upon herself to mount the second Hubbard expedition, she caused a scandal: her husband's family was furious about what it saw as her public spectacle; the paparazzi had a field day impugning her motives and casting doubt on her female abilities in such a masculine endeavour as a northern expedition; and public opinion was against her because it was felt that no respectable, educated, middle-class, white woman would vanish into the wilderness in the company of four men, especially four Native or "half-breed" men. But vanish she did, for five weeks, the length of time it took her to cross so-called unknown Labrador, take the measurements necessary to redraw the maps, photograph the Innu people in their camps, and keep a detailed journal that would become the basis for her book *A Woman's Way through Unknown Labrador*

(1908), published by John Murray in England and by William Briggs in Canada.[19]

Mina was a success. After her return from the North, she gave public lectures with lantern slides, published articles on her expedition, and travelled to England where she was eventually recognized by the Royal Geographical Society. She often returned to Canada but never to stay; she married a British man (John Edward Ellis Jr.) with whom she had children and, after subsequently divorcing him, remained in England to raise them. When her book went out of print with the Second World War, Mina Benson Hubbard was largely forgotten until renewed interest in Labrador and in her husband's expedition led to her rediscovery during the 1980s. Since then, artistic attempts to imagine Mina and to retrace her "way" across Labrador have escalated until it is fair to say that she has come to represent that rare northern phenomenon — a female explorer, who may or may not have had an affair with her chief guide, George Elson, who may or may not have mourned her lost, beloved first husband as she completed his work, but who indisputably succeeded where a man had failed, lived to tell her story, changed the map of Labrador forever, and discovered a new, powerful sense of herself, of her independence, and of pride in her accomplishments. And it was this self-discovery, as much as what she did or wrote, that was celebrated in June 2005 on the beach in front of the old Hudson's Bay trading post in North West River, where the community staged a re-enactment ceremony to remember the woman it continues to see as *its* hero, as a part of *its* history and place. A film crew was there to capture the event; a play about Mina, by a local writer, was performed; books were launched, paintings and photographs displayed, special Mina T-shirts sold, and everyone from North West River and from *away* had his or her opinions to voice. At this centenary, the real person called Mina Benson (Hubbard/Ellis) passed from history into

legend, and her story — rewritten, reinterpreted, re-enacted, and elaborated upon almost beyond recognition — became the stuff of northern myth. I consider her an iconic figure and discuss her status as icon in Chapter 3.

The story about what happened to Fathers Rouvière and Le Roux is by no means so uplifting. The two Oblate priests were sent by the Roman Catholic Church into the vast barren lands of the central Far North (now Nunavut, but in 1914 part of the Northwest Territories) to convert the "Copper Eskimos," as the Inuit of the area were called. But the priests failed to return, and it was not until many months later that rumours about a possible disaster filtered south to the ears of the church and the police. A search into this remote area of taiga, tundra, rivers, and lakes was led by Inspector Lanauze of the RCMP, and by the summer of 1917, two Inuit, Sinnisiak and Uluksuk, had been charged with murder and brought south to Edmonton for trial. Perhaps the most sensational aspect of the case was their confession that they had eaten a piece of liver from each of the dead priests. The deaths of Rouvière and Le Roux, so far from the scrutiny of white, Christian eyes, attracted international press coverage during the trial, and the events have continued to be recounted, studied, and explored for their significance for almost one hundred years. For francophone Catholics in the 1930s, the priests were martyrs, and students were taught that their deaths were sacrifices in the struggle to save pagan souls. For popular culture aficionados, the more grisly aspects of the case qualify it for inclusion in the annals of murders committed in the Canadian North. Perhaps not surprisingly, scholars such as R.G. Moyles and a recent writer McKay Jenkins read this story of violent murder on the barrens as a cultural confrontation between two incompatible views of the world and as an example of southern colonization of northern spaces, peoples, and resources.

However, it is what Sharon Pollock has done with the story in *Kabloona Talk* (2008) that I find most interesting. Pollock has resisted the temptation to reinvent Inuit characters or Catholic missionaries and thus to put words into the mouths of men she could not possibly know. Instead, she has chosen to focus exclusively on the August 1917 Edmonton trial in which Sinnisiak was acquitted of murder by the jury, and she explores the response to this verdict by the lawyer for the prosecution, the defence, and the presiding judge. In other words, she exposes *southern* attitudes and southern manipulation of the justice system, which colluded behind the scenes (and over the protestations of the lawyer for the defence) to conduct a second trial, with a new jury, in Calgary (where a guilty verdict was reached), and the extreme self-interest of southern politicians and developers in maintaining unchallenged authority over the North and its future exploitation. What was interpreted in the 1930s as a violent, barbarous outrage committed by savages against innocent priests, who had every right to impose their faith on pagans, and later viewed as a saga of police detective work under extraordinarily harsh conditions, has been turned upside down. Instead of staging the murders or the trials and inventing characters called Sinnisiak and Uluksuk, Pollock puts southern prejudice and ignorance on trial to reveal a host of hidden agendas for and narratives about a northern reality that few southern Canadians appreciate or accept, even today. Pollock's North in *Kabloona Talk* is one about which white men talk endlessly from the comfort of their southern city offices.

Frobisher (2007) could hardly be more different, even allowing for the fact that grand opera cannot be easily compared with a stage play. In this opera, playwright John Murrell imagines a deadly, mysterious North of everlasting cold and ice, not only for his imagined sixteenth-century Martin Frobisher character, but also for his two young twenty-first-century filmmakers who are trying to create a film about *their* Frobisher. Murrell

has said that he sees "the Far North of Canada" as "unknowable, yesterday and today; a magnificent riddle ... an alluring phantom" ("Frobisher: Program Notes" 25). For him, Frobisher represents "the attraction and the dread of the North ... which frightens and compels us, and always will" (25), and that is why his filmmakers are also drawn to the North and to what Murrell depicts as Frobisher's dream of a polar paradise. In opera, of course, we must have tragic deaths, usually inflicted on the soprano/heroine, but in *Frobisher*, the people who die are Frobisher and his contemporary avatar Michael the filmmaker. It is left to Anna, Michael's wife and co-director/scriptwriter, to complete the film after Michael disappears into the deadly, alluring North. Without doubt, the staging, music, and performances in *Frobisher* were stunning. At the premiere, I knew I was witnessing a tour de force of operatic spectacle, and a rare spectacle at that, because the North was a major character in the drama, and it was imagined and brought to life before my eyes and ears as I have never before experienced it. However, in 2007 this highly romanticized southern idea of North struck me as somewhat anachronistic.[20] We know that the North is not a realm of everlasting ice; we know that it is not an empty *terra incognita* but a home to many Canadian citizens; and we know that we must take responsibility for our southern exploitation and destruction of northern ecosystems and cultures. Impressed as I was with the collaborative artistry of *Frobisher* in performance, I am more moved to critical self-reflection by a modest work such as *Kabloona Talk* and more intrigued with our mythologizing of northern heroes by our continuing inventions of Mina Benson Hubbard.

Rather than close this chapter on an uneasy note of operatic romance, I want to stress my sense that our interest in the North as place, story, history, northern home, and southern destiny demonstrates the abiding relevance of nordicity and the North for the imagined community of the

entire country. Other writers, in addition to Clements, link the North with war, a phenomenon I examine in my next chapter, and new voices are coming south from the North in novels such as *Porcupines and China Dolls* (2002) by Robert Alexei and *The Lesser Blessed* (1996) by Richard Van Camp. Southern urbanites are bringing their experiences of North south in music such as *Footprints in New Snow* (2002) by Toronto-based composer Christos Hatzis and in exhibitions such as On the Surface of Things by Montreal-based painter Dominique Gaucher. *Footprints in New Snow* recalls Gould's *The Idea of North* in its experimental electronic soundscapes, but unlike Gould, Hatzis went north and was inspired by Inuit throat-singing, which he combines with his contemporary classical vocabulary in acoustically dramatic and innovative ways. Gaucher's works have a similar contemporary appeal, but in this case the canvases, especially those in which red-suited explorers (or are they scientists conducting experiments, or soldiers on military exercises?) appear to scramble free of yawning crevasses of ice and water on his studio floor, speak to me of imminent danger (see Figure 13). These men are not searching for some distant, mysterious North Pole or some inaccessible, deadly Northwest Passage, and they look incapable of defending Canadian sovereignty in the Arctic. They are struggling to escape from an Arctic world that is melting right here under our feet, in our cities, now, today, beneath our safe, complacent, imagined surfaces.

Theatres of War:
Battle Fronts and Home Fronts

At the age of six ... I knew something about war.
Each November 11 we gathered around The Monument in a ritual that
was taking place in every community across the nation ... and this
common rite, I think, played a part in what we call 'national unity.'
— *Pierre Berton*

Lest we forget. Remember me. To you from failing hands we throw.
Cries of the thirsty ghosts.
Nothing is more difficult than to understand the dead, I've found;
but nothing is more dangerous than to ignore them.
— *Margaret Atwood*, THE BLIND ASSASSIN

I REPRESENTING WAR

Jane Urquhart opens her novel *The Stone Carvers* by stepping back in
time to an unfamiliar place and a "stone woman" that lie at the heart's
core of her story:

In June of 1934, two men stand talking in the shadow of the great
unfinished monument. Behind them rises a massive marble base
flanked by classically sculpted groups of figures and surmounted

by an enormous stone woman who is hooded and draped in the manner of a medieval mourner. At her back, a shedlike building occupies the space between two twin obelisk-shaped pylons, each with their own wooden rooms attached to them at a great height. (1)

One of these two men is Walter Allward, a name that means little to today's Canadians. The "great unfinished monument" behind the two men is the Canadian War Memorial at Vimy Ridge (see Figure 14), the memorial that Sandra Gwyn (to whose memory Urquhart dedicates her novel) visited and photographed for her *Tapestry of War* and that the spring 2008 issue of the *Journal of the Society for the Study of Architecture in Canada* celebrates.[1]

Canadians have been told incessantly, and as recently as April 2007 when Allward's monument was rededicated after its restoration, that the country came of age on Vimy Ridge, but Allward and his Vimy masterpiece have been largely forgotten by twenty-first-century Canadians. Today, tourists can take expensive guided tours of Vimy and the other battlefields and monuments in Belgium and France because these sites have become marketable. But that is not what Urquhart wants her readers to experience through her visit to Vimy Ridge and through her re-creation of Walter Allward, the Toronto artist/architect who designed and supervised the creation of this vast marble testimony to the war and to the thousands of Canadian men who died in the trenches and mud of that war and whose names are carved into the marble. What Urquhart demonstrates through her art is the important social role of art and of the artist in the creation of Canadian identity and in the celebration of Canadian history. I will return to Allward, Vimy, Urquhart, and Sandra Gwyn in the concluding section of this chapter, but I begin with this novel and this quotation, with Walter Allward and the Vimy Memorial, because they establish some of

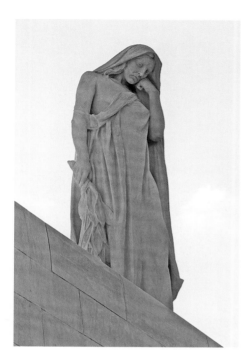

FIGURE 14 The Canadian First World War Memorial at Vimy Ridge was designed by Canadian architect Walter Allward and completed and dedicated in 1936. After extensive restoration, the memorial was rededicated in April 2007 to mark the centenary of the battle. These photographs by John Palmer show the scale of the monument rising from the Douai Plain and the marble figure of Canada (on the other side) mourning her dead sons. The photographs are reproduced with the artist's permission. © John Palmer.

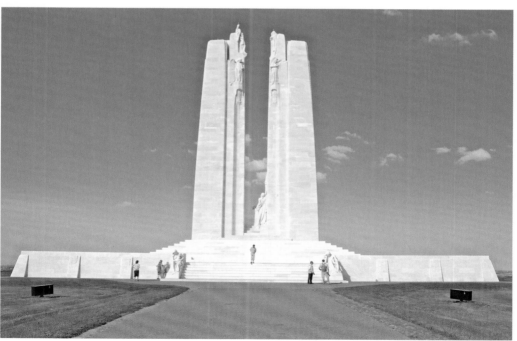

FIGURE 15 Frederick Horsman Varley, *For What?* (1918), oil on canvas, 147.2 x 182.8 cm. Varley, an official war artist during the Great War, was traumatized by his experience, and in this eloquent representation of burial in a muddy, shattered landscape, he bears witness to the horror, tragic waste, and futility of war. Beaverbrook Collection of War Art. © Canadian War Museum, 19710261-0770.

the boundaries for this chapter: *here* in Canada and *there* in France, *then* in the early twentieth century during the First World War and *now* in the early years of the twenty-first century (April 2007 to be precise), sixty years after Canadians decided to call themselves Canadian *citizens* instead of British subjects, here and now among the living and the dead whose ghosts haunt the pages, canvases, screens, and stages of our war art (see Figure 15).[2]

Between 1915, when John McCrae wrote "In Flanders Fields," or 1918, when Fred Varley painted *For What?* (Figure 15), and our most recent representations of war, Canadian playwrights, painters, composers, film-makers, photographers, and writers have explored many different approaches to this difficult subject, and the changes that I detect in this representation of war over the past eighty-plus years are profound and illuminating. In general, I would say that Canadians have gone from celebrating war, however cautiously, to realistic descriptions of battle, followed by a period (during the Cold War) of repressing war trauma and downplaying former military activities, to our recent painful rediscovery of the meaning of both world wars for the development of the country, and, lastly, to attempts to understand our latest experiences abroad as peacekeepers and combatants.[3] To judge from the chronology of artistic attention, Canadians began *rediscovering* the Great War in the 1970s: Roch Carrier's classic *La Guerre, Yes Sir!* (1968) appeared in English in 1970, followed quickly by plays such as Tom Hendry's *Fifteen Miles of Broken Glass* (1975) and Timothy Findley's *Can You See Me Yet?* (1977) — a work so haunted by war that, in retrospect, we should have expected his great novel *The Wars* (1977) to appear. Reprints of earlier novels were also published in the seventies; for example, First World War work such as Charles Yale Harrison's *Generals Die in Bed* (1930; 1975) and Second World War works such as Colin McDougall's *Execution* (1958; 1972) or Gwethalyn Graham's *Earth and High Heaven* (1944; 1969). A challenging novel from

the Quebec perspective, Louis Caron's *L'Emmitouflé* (1977; translated as *The Draft Dodger*, 1980) reached anglophone readers soon after its appearance in French. However, with the exception of William Fruet's feature film *Wedding in White* (1972) and a few early NFB documentaries, our filmmakers had yet to tackle the subject, but their turn would come, and they would create the greatest artistic stir we have so far experienced on this subject of Canada and war.[4]

I take the seventies as the turning point in Canadian representations of war, and if pressed I would pinpoint 1977 as a breakthrough year. Prior to 1977, when Findley published *Can You See Me Yet?* and *The Wars*, the written arts — poetry, fiction, non-fiction, even drama — either avoided the subject or, with a few exceptions, wrote about it rather awkwardly and literally. The two exceptions to my mind are Hugh MacLennan's *Barometer Rising* (first published in 1941), a complex portrayal of a soldier's revenge set against the background of the 1917 Halifax explosion, and Raymond Souster's war poems, which provide an excoriating indictment of the Second World War — as this brief example demonstrates:

> The R.A.F. called it
> The Dresden Special
>
> ...
>
> One hundred thirty thousand
> Charred bodies jammed together
> Between two bread slices. ("The Dresden Special" 108)

Two early collections of Canadian war poetry published since 1918 are rarely mentioned and have long been out of print.[5] Prior to the 1970s, and also forgotten, Canadian war paintings languished in vaults in Ottawa, rarely seen and largely unknown, and it was not until 1977, when Heather Robertson published *A Terrible Beauty: The Art of Canada at War*, that

Canadians could begin to see what artists had created from their battle-field experiences in both wars. Even the war monuments so visible in cities and towns across the country and visited every 11 November were ignored until 1987 when Robert Shipley published *To Mark Our Place: A History of Canadian War Memorials*. It is as if generations of Canadians took for granted, or simply refused to *see*, the memorials to war and peace right before their eyes.

In this chapter, I want to focus attention on artistic developments from the 1970s to the present, with only a brief backward glance at the rep-resentations published or produced earlier. The exception to this rule is the painting. Although the paintings I consider were created during or shortly after each war, they entered the public scene and a wider imagina-tive awareness only after 1977, but now that they have surfaced, they oc-cupy a significant place on the national stage, as the touring exhibition Canvas of War, with its accompanying catalogue, and the opening of the War Museum in Ottawa make clear. The questions I want to pursue are as follows: Why has Canada become so interested in its war history over the past thirty years or so? What shape has this interest taken, and what issues do our artists address? How does this considerable body of work differ from earlier work created *during* either war? And, finally, what do our contemporary artists want to tell or show us about being Canadian through their representation of war? If we accept what historians, polit-icians, and artists have told us, Canada came of age as a nation in the Great War, but how has the nation represented itself through war and "for what" purpose?[6]

II FROM "IN FLANDERS FIELDS" TO *THE WARS*

In the works I discuss, several place names occur that are familiar, even when their precise locations are uncertain for today's readers and audiences

(see Figures 16 and 17). The landscape of memory from the First World War includes Ypres, where two battles were fought in April and May of 1915; the Somme, an area that saw extensive fighting between July and November 1916 and where, at Beaumont-Hamel on 1 July 1916, the Royal Newfoundland Regiment was massacred, as David French reminds us in his 2002 play *Soldier's Heart*; Vimy Ridge, now infamous for the casualties incurred during April 1917, commemorated in Allward's monument and celebrated in Urquhart's *The Stone Carvers*; Passchendaele, a name synonymous, after October and November of 1917, with the trauma of Ypres and Flanders fields and the subject of the 2008 film *Passchendaele* starring Paul Gross; and Amiens, August 1918, where Jack Hodgins takes us in *Broken Ground*. For the Second World War, the sites of loss and trauma must include Dieppe, which, as a result of 19 August 1942, Berton has called Canada's "greatest disaster in the Second World War" (*Marching as to War* 384); Ortona, with its devastating battle of Christmas week 1943 portrayed so powerfully by several artists and writers but perhaps most notably by Charles Comfort in his memoir *Artist at War*; the Juno Beach of D-Day, itself the sole subject of films, poems, and books; and finally, Nijmegen, that musical name brought home to us in Earle Birney's poem and Alex Colville's painting, both of which I will turn to in a moment. Much less has been said or written from a Canadian perspective about the war in the Pacific or about its impact on Canadians, but that does not mean that its repercussions are not part of our story, as novels such as Joy

FIGURE 16 (FACING PAGE) This map of the western front separating the Allied and German armies in 1917 shows the sites of several battles that are remembered in Canadian films, plays, and novels. It is excerpted from Pierre Berton's *Vimy*. © 1986 Pierre Berton Enterprises Ltd. Reprinted by permission of Doubleday Canada.

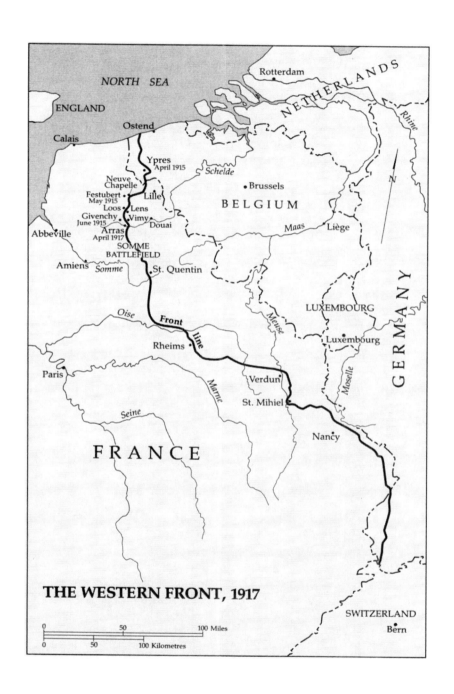

NORTH SEA

ENGLAND

Rotterdam

NETHERLANDS

Ostend

Calais

Ypres
April 1915

Schelde

Rhine

Neuve
Chapelle

Brussels

Festubert
May 1915

Lille

BELGIUM

Loos Lens

Liège

Givenchy
June 1915

Vimy

Maas

Douai

Abbeville

Arras
April 1917

SOMME
BATTLEFIELD

Amiens Somme

St. Quentin

LUXEMBOURG

Oise

GERMANY

Front

Luxembourg

Rheims

line

Paris

Meuse

Verdun

St. Mihiel

Moselle

Marne

Nancy

Seine

FRANCE

THE WESTERN FRONT, 1917

SWITZERLAND

Bern

0 50 100 Miles

0 50 100 Kilometres

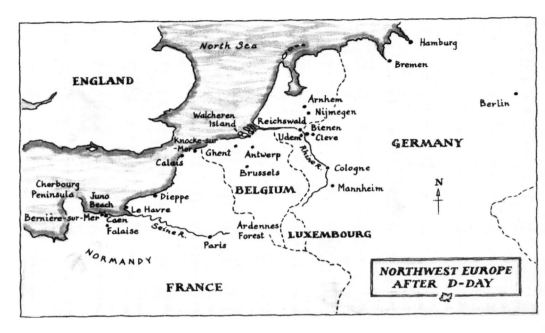

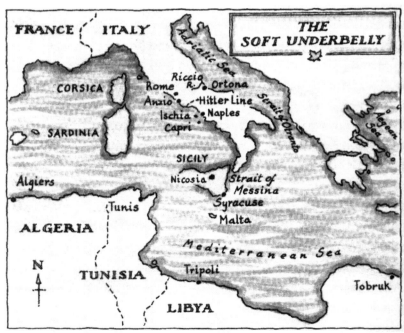

FIGURE 17 (FACING PAGE) Canadians fought during the Second World War, not only in France, Belgium and the Netherlands or, to a lesser extent, in the Pacific, but also in Italy. Indeed, some of the most important war paintings and memoirs come from experiences during the Italian campaign. These maps illustrate both "theatres" of war and are excerpted from Pierre Berton's *Marching as to War*. © 2001 Pierre Berton Enterprises Ltd. Reprinted by permission of Doubleday Canada.

Kogawa's *Obasan* (1981) and Michael Crummey's *The Wreckage* (2005), films such as Anne Wheeler's *A War Story* (1981) and *Bye Bye Blues* (1989), plays such as Marie Clements' *Burning Vision* (2003) and Robert Lepage's *Seven Streams of the River Ota* (1996), or a scholarly work such as Oliver Lindsay's *The Battle for Hong Kong* (2006) remind us.

John McCrae's "In Flanders Fields," one of the most famous poems from the First World War, has become iconic, enjoying an afterlife McCrae could not have imagined. The poem has an undeniable power, and it is, I feel, more complex than its popularity implies; even today it can move listeners, despite our slide into less romantic and more cynical times.[7] Shortly after its first publication, it was seized upon to promote the war effort, and since then it continues to be quoted in advertisements and on the ten-dollar bill, alluded to or cited in everything from newspaper articles to children's books and serious novels such as Margaret Atwood's *Blind Assassin*. The lines are familiar, even if we seldom pause to reflect on their meaning:

> In Flanders fields the poppies blow
> Between the crosses, row on row,
> That mark our place; and in the sky
> The larks still bravely singing, fly
> Scarce heard amid the guns below.
> We are the Dead. Short days ago

We lived, felt dawn, saw sunset glow,
Loved, and were loved, and now we lie
In Flanders fields.
Take up our quarrel with the foe:
To you from failing hands we throw
The torch; be yours to hold it high.
If ye break faith with us who die
We shall not sleep, though poppies grow
In Flanders fields.

The point here, at least for Canadians in the twenty-first century, is that it is the dead who address us, like the spirits in Dante's *Inferno*, who insist that we — readers, listeners, later generations — pay attention, keep the faith. First World War advertisements for war bonds admonished Canadians that, if they could not "take up our quarrel" by going to battle, they should "keep the faith" by buying war bonds, and as recently as 1998, the poem was set to music by Stephen Chatman and sung by Vancouver's Chor Leoni on 11 November that year.[8]

Most of the poems I have found from the First World War are similar in general tone and sentiment to McCrae's. Robert Service's "A Song of Winter Weather" (1916), deploring the mud, rain, and cold, is a cocky exception (even among his own verse):

It isn't the foe that we fear;
 It isn't the bullets that whine;
It isn't the business career
 Of a shell, or the bust of a mine.
It isn't the snipers who seek
 To nip our young hopes in the bud:

No, it isn't the guns,

And it isn't the Huns, —

It's the MUD,

MUD,

MUD.[9]

Not until John Gray and Eric Peterson wrote and performed *Billy Bishop Goes to War* would Canadian artists once again sing quite so heartily about the realities of war. Charles G.D. Roberts' "Going Over (the Somme, 1917)" and D.C. Scott's "To a Canadian Aviator Who Died for His Country in France" demonstrate a more common poetic response to the Great War — romantic, heroic, infused with Christian faith, celebratory, and euphemistic, as was much of the early poetry written by the British about the Great War — and neither of them quite strikes that eerie, haunted note of ghostly challenge that McCrae's dead soldiers voice.[10]

By the time of the Second World War, poetic rhetoric about keeping the faith and making sacrifices was impossible, and the poems to be written from or about that war by Raymond Souster, Dorothy Livesay, Earle Birney, Joyce Nelson, and later Alden Nowlan all signal an abrupt shift in tone and focus. For Nelson, in "Home Front, 1942," it is the women left at home to work in the factories who catch her attention, as they caught the attention of women war artists who, like Paraskeva Clark, could not paint the war itself and were restricted to scenes at home such as the one in *Parachute Riggers* (1947), where the women workers are bent over fabric. The experiences of women on the home front would later move John Murrell to write *Waiting for the Parade* (1980), a war play about the home front that, along with *Billy Bishop Goes to War*, still receives frequent productions. This artistic turn to the home front has become one of the most striking aspects of almost all our important representations of war

created since the 1970s, but for poets such as Souster, and Birney, who were writing about their battle experiences, the war left them numb, angry, critical, and above all questioning the reason for such butchery and without much hope of rediscovering their own or anyone else's humanity. Birney's "The Road to Nijmegen" provides a powerful verbal counterpart to the despair and desolation captured by Colville in his *Infantry, near Nijmegen, Holland* (1946) — (see Figure 18):

> Numbed on the long road to mangled Nijmegen
> I thought that only the living of others assures us
> the gentle and true we remember as trees walking
> Their arms reach down from the light of kindness
> into this Lazarus tomb. (10)[11]

When Alden Nowlan wrote "Ypres, 1915" in the 1970s, he did so from a much greater distance in time and place since that war, and the first-person voice in the poem is no longer that of the soldier in battle or the factory worker but the voice of an "old man on television," a First World War veteran asked to describe what it was like, sixty years ago, to be in those trenches. Even for this man, the reality of his being there has faded into the memory of "water up to our middles / and rats" (63), and we who watch him with Nowlan can no longer grasp the full meaning of his words. Memory and the act of remembering are what we are left with, and memory will increasingly become the essential guide and theme of the war art to come. Indeed, that is precisely how Frank Davey re-creates his childhood during the Second World War in his volume of poems called *Back to the War* (2005). He begins by recalling himself as "a small boy" (13) colouring battleships, and from there his memories crowd forward — of newspaper headlines, of blackout curtains, of the

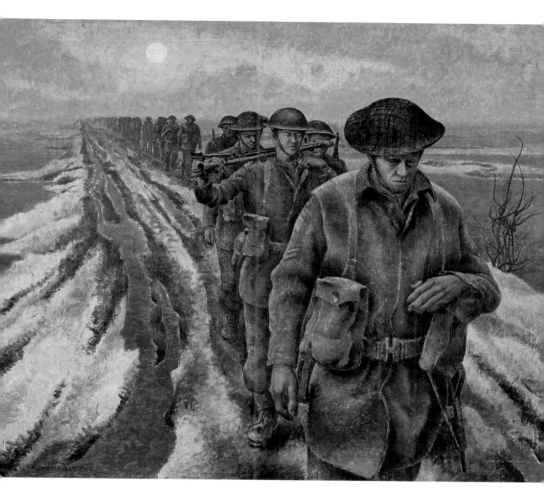

FIGURE 18 Alex Colville, *Infantry, near Nijmegen, Holland* (1946), oil on canvas, 101.6 x 121.9 cm. This famous painting by the young Colville, a Second World War war artist, captures, in Colville's words, "the terrible life that they had; lack of sleep, food, exposure, constant danger. It's amazing that people endured. They did, these ordinary young guys" (quoted in Laura Brandon, *Art or Memorial?* 72). Beaverbrook Collection of War Art, Canadian War Museum #19710261-2079.

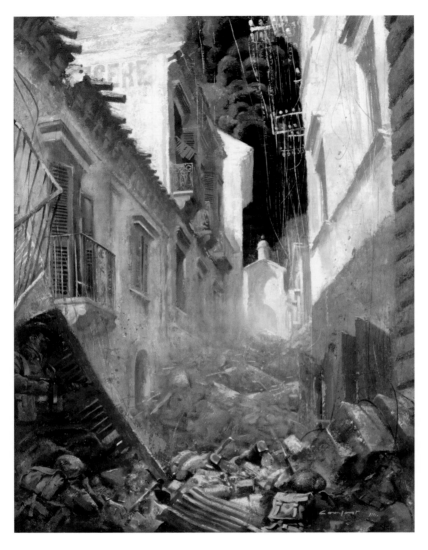

FIGURE 19 Charles Comfort, *Via Dolorosa, Ortona* (c. 1944), oil on canvas,
101.6 x 76.2 cm. When Comfort's autobiography, *Artist at War* (1956), was
reprinted in 1995, it featured colour plates of his works, including this picture
and *Route 6 at Cassino, Italy* (see Figure 20). Comfort's description of the
devastation before him is heartbreaking: "Torn and muddied oleanders were
strewn in the gutters [of Via Monte Maiella] and it was flanked by an abstraction
of utter ruin" (103). Beaverbrook Collection of War Art, Canadian War Museum
#19710261-2308.

Lee-Enfield rifle someone sends his father, and his childish fantasy of "bullets ... racing / between the legs of our dining room table / back to the war" (73).

These shifts in language, imagery, tone, and perspective, as well as the mounting reliance on memory, are also apparent in the fiction published *after* the Second World War but prior to my watershed decade of the seventies. For the most part, the focus of the novels and short stories written out of both wars is on war itself and on the soldiers who were in the trenches, on the long marches, or in the RAF bombing raids. As Dagmar Novak demonstrates in *Dubious Glory: The Two World Wars and the Canadian Novel*, these earlier novels and stories begin, as does the poetry, with patriotic, highly Christianized, romantic celebrations of sacrifice for one's country and for the good of mankind.[12] Some, such as Beckles Willson's novel *Redemption* (1924), portray the Great War as a force for the making of the Canadian nation; a very few, such as Frances Beynon's anti-war novel *Aleta Day* (1919) or Harrison's bitter *Generals Die in Bed* (1930), represent an emerging criticism of war and a realist treatment of the subject. A more critical approach to war appears in the works representing the Second World War, and the best fictional examples of important shifts in focus and response are, to my mind, Birney's *Turvey* (1949) and McDougall's *Execution* (1958). In each of these novels, the soldier is an ordinary suffering human being (a three-dimensional character or, in the case of Thomas Leadbeater Turvey, a bumbling survivor), not the stereotypical sacrificial hero or adventurous, aggressive combatant. And in each, the war itself becomes a stage for exploring psychological trauma, for questioning the ethics of what McDougall calls authorized "execution," and for portraying the challenge of return to some form of normal civilian domesticity. As early as 1941, with *Barometer Rising*, Mac-Lennan brought war home — the Great War at the time of the 1917

Halifax explosion — thereby signalling a step that almost all the later works in most of the media I am considering would take. This bringing home of the wars would have two major facets, both of which are central to MacLennan's vision — the returned soldier bringing his consuming rage and pride home with him and the artist's need to redirect that energy into the creation of a new Canadian identity. In MacLennan's hands, the explosion during the First World War, remembered and re-created during the Second World War, becomes a symbol of purgation, a violent eradication of an old colonial order in Canada that must make way for the rise of a new independent nation (albeit still loyal to Great Britain).

But what of the painters? In his voice-over commentary for Part 3 of *The Valour and the Horror* — the 1992 CBC documentary film about the Second World War that would cause such a furor among viewers and, especially, veterans — Terence McKenna tells us that only the Canadian war artists were free enough to depict the truth of the war because every other form of communication, including dispatches by the war correspondents, was censored. The problem here is that, however accurate McKenna's claim might be, this art has been largely invisible until very recently. Terence and Brian McKenna used several paintings to great effect in their film, but *The Valour and the Horror* was not shown until 1993, and it has rarely been screened since. As a consequence of the vociferous protests provoked by this film, both the CBC and the NFB have become more cautious about portraying the Second World War: the 1995 three-part series *Canada Remembers* is guarded, neutral, and noncommittal about blame or guilt, and *Canada's War in Colour*, aired in January 2005, is downright cheerful and upbeat. My question, then, is this: how should Canadians assess the impact of the visual art produced during the two wars, which was then buried until Heather Robertson's *A Terrible Beauty* appeared in 1977? It is, after all, art from the first half of the twentieth century, even though its rediscovery and impact are recent, and its display

in the War Museum resituates the paintings in a historical context. Laura Brandon names the dilemma precisely in the title to her important study: *Art or Memorial? The Forgotten History of Canada's War Art.*

A partial answer to my question can be found in autobiography, and the most useful text for my purposes is Charles Comfort's *Artist at War,* which was first published in 1956 and reprinted in 1995.[13] Comfort's narrative is full of critical intelligence, sensitivity, verbal eloquence and visual intensity, and understated lament — lament for the destruction of history and landscape, lament for the loss of life and for basic humanity in war, and lament for the artist's failure to express the inexpressible. Comfort was a war artist with the First Canadian Infantry Division during the Italian campaign of 1943-45, the same campaign in which Farley Mowat fought, that McDougall re-creates in *Execution,* and that Michael Ondaatje remembers in *The English Patient* (1992). Like them, Comfort constantly takes his bearings by comparing an Italian landscape, sky, river, or town with the familiar and safe ones at home. Because he was there at the battle of Ortona and at the breakthrough on the Adolf Hitler Line, and because he witnessed the decimation of Cassino, he makes convincing autobiographical claims to truth and authority. Unlike the traditional artist depicting war in a studio, within the conventions of a formerly epic genre, he and his compatriots Will Ogilvie and Lawren P. Harris were painting "inside the storm itself" (52). "We are getting the raw material," he explains, "the eye-witness experience, which should lend authority to anything we might eventually do" (113). Nevertheless, when he and Harris entered a captured Ortona, he confesses, "I could not possibly paint, or even sketch, on that first dreadful visit" (103). The images he would eventually create, images reproduced in his autobiography, show us why (see Figure 19).

Charles Comfort was no uninformed eyewitness: he was aware of what treasures of art and architecture were being destroyed and that memory

alone could never redress the loss. And he is precise about his own task, as compared with the war artists of the past. In an important aside, he reflects on the difference between his war art and those grand scenes in which "all their bloody havoc is transmuted and resolved into the elegant, decorative terminology of Cinquecento Art" (122). Faced with the spectacle of Cassino (see Figure 20), he writes,

> Rounding the monastery hill, Cassino itself came into view. For sheer horror and utter devastation, I had not set eyes on its equal. The terraced structure of its streets might be discerned, if one searched for structure in that formless heap of calcined stone, but it resembled rather some imagined landscape on the moon. It had ceased to be terrestrial, it was like some lidless, blind eye, glaring back at the sun with empty lifeless inertia ... In a most depressed state of mind, I set up my equipment ... and sketched what was left of the town. (135-36)

Perhaps Terence McKenna was right when he said that, until his documentary film was created, only our painters were telling us the truth.[14] Certainly, those autobiographical qualities of truth and authority that Comfort claimed for war artists are powerful tools. In all the major Canadian documentaries about the Second World War, from *The Valour and the Horror* and Anne Wheeler's *A War Story* (about the Japanese POW camp in which her father was interned) to *Canada's War in Colour* and Brian McKenna's *The Great War* (2007), interviews with veterans, quotations from and re-enactments based on letters and diaries, and so-called live footage and reporting from the scenes of battle and the home front provide crucial narrative substance that determines the remembering and retelling of the stories.

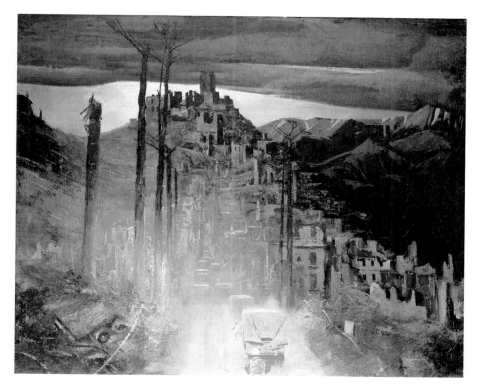

FIGURE 20 Charles Comfort, *Route 6 at Cassino, Italy* (1944), oil on canvas, 101.6 x 121.9 cm. The scene of destruction at Cassino was Comfort's worst experience as an artist. In his note on the sketch for the final painting, he wrote, "Cassino is a lifeless, soundless ghostly ruin, with the deadly pallor of an eyeless skull, permeated with the stench of death" (Comfort, *Artist at War* 187). Beaverbrook Collection of War Art, Canadian War Museum #19710261-2275.

III FROM *THE WARS* TO *CANVAS OF WAR*

There is a passage in *The Wars*, just before Robert Ross is about to embark for Europe, in which his biographer (the researcher/narrator of the story) imagines young Robert imagining his own death. This scene, provoked

by an elegant photograph of Robert ("5 x 9 and framed in silver"), reads, in part, like this:

> Oh — I can tell you, sort of, what it might be like to die. *The Death of General Wolfe.* Someone will hold my hand and I won't really suffer pain because I've suffered that already and survived. In paintings — and in photographs — there's never any blood. At most, the hero sighs his way to death while linen handkerchiefs are held against his wounds ... *I'll faint away in glory hearing music and my name.* (49)

The painting described here is Benjamin West's *The Death of General Wolfe* (1770), now considered an iconic Canadian work repatriated to Canada after the First World War (see Figure 21).[15] But as Charles Comfort, Alex Colville, Fred Varley, and the other Canadian war artists quickly discovered, the generic conventions of an allegorical painting such as West's, with its theatrical composition and Christian symbolism, scarcely represented what actually occurred in a war, let alone on the Plains of Abraham (which West was not there to see), and held little relevance for the horrors of either world war. Nothing in Findley's portrayal of the Great War resembles West's art, but for Robert Ross, who grew up in early twentieth-century Toronto (and for Findley), the painting represents a lie that young men like Robert were told about heroic duty and glorious, painless sacrifice. By invoking, in the context of the Great War, this famous painting of one of the few major battles actually fought on Canadian soil, Findley highlights the obscenity of artistic deceptions and insists that today's artists must try to do better.

The Wars is important to my understanding of the Canadian depiction of war because it provides a definitive example of the art of being Canadian through its construction of the Great War and Findley's insistence

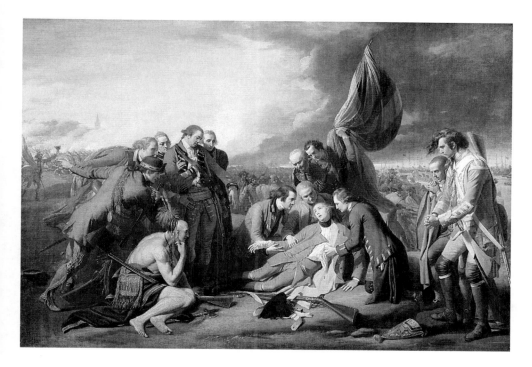

FIGURE 21 Benjamin West, *The Death of General Wolfe* (1770), oil on canvas, 152.6 x 214.5 cm. Few paintings of war on Canadian soil have acquired the cachet of this highly inventive image of the British victory on the Plains of Abraham near Quebec City. Collection of the National Gallery of Canada, Ottawa, #8007; transfer from the Canadian War Memorials, 1921 (gift of the second duke of Westminster, England, 1918). Photograph © National Gallery of Canada.

that we discover our identity in and through its representation. On the simplest level of plot, it is the story of how Robert Ross, who had survived Ypres, gas attacks, mud, rats, and the loss of friends, was finally driven to disobey commands, to desert, and to shoot a superior officer in June 1916 before being so seriously burned in a fire with the horses he was trying to save that he would eventually die of his injuries. Ross, we are told, was an *"homme unique"* (16) because he did what others would not dare to do: he

refused to cooperate with military protocol and the rhetoric of blind patriotic obedience. He rejected what Simon Schama so aptly calls "the grandiloquent lie" of West's painting (30). The woman who calls him unique is just one of the voices Findley creates in a collection of apparent interviews conducted by the biographer, who is piecing together the story long after Robert's lingering, agonizing death in 1922. Like the painters before him and the documentary filmmakers and playwrights who would follow, Findley constructs a kind of documentary/historical fiction that includes fictional autobiographies and biographies (of Marian Turner, Juliet D'Orsay, Rowena, and Mrs. Ross) in order to convince us of the truth and authority of his narrative and of our own urgent need to participate in its creation. He casts memory in the lead role, giving her the voice of that nameless first-person male researcher gathering the evidence, and he weaves the story from the collected memories of his characters, especially his female characters. Women, in fact, are the key witnesses to Robert Ross' story, which is also their story: his mother, waiting at home in Toronto, is possibly the most important figure of all because she alone sees what is happening until, no longer bearing to look, she goes blind. Through the women, including Robert's nurse Marian Turner and Juliet D'Orsay, the young English girl who loved him, Findley brings the war home and into the present, thereby stressing the consequences of those events and their continuing presence in our lives. But *The Wars* is as much about trauma, what today we call post-traumatic stress disorder (PTSD), as it is about memory, the need to remember, and the art of remembering. Through memory we are reminded of the costs of war and of the risk to our fundamental humanity, which is made especially clear through the character of Rodwell — the soldier, artist, and animal lover who kills himself in despair.

To say that this is an anti-war novel, however, would be to oversimplify Findley's vision. The moral of the story, if I can put it that way,

is pronounced by one of the women, a now elderly Juliet D'Orsay, who tells Robert's biographer that "the thing is not to make excuses for the way you behaved — not to take refuge in tragedy — but to clarify who you are through your response to when you lived. If you can't do that, then you haven't made your contribution to the future" (103). Findley was writing *The Wars* and *Can You See Me Yet?* during the Vietnam War (c. 1963 to 1975) in the context of a world that had learned little from the war to end all wars or the one that followed. He was also writing in a post-1967 Canada that was revisiting the promises, many unfulfilled, of its own national identity, an identity that he had been told was forged in the First World War. In this, possibly his most important novel, he asks us to remember, to reflect, and to clarify who we are through our responses to the times in which we live. One of those responses may be to abjure violence, to refuse wars of aggression, and to resist the rhetoric of patriotism and national unity during a period of intense international pressure to fall into line with another lie about heroism and duty or unthinkingly to accept appeals to military might as the way to ensure national identity or international clout.[16] I suspect that no other single work of Canadian art, including Findley's own Second World War novel *Famous Last Words* (1981), has had as great an impact on subsequent representations of war as *The Wars*. If the, to my mind, brilliant 1982 film version, starring Brent Carver as Robert Ross and with a score by Glenn Gould, had been more widely shown, this impact would have been even greater.[17]

Among the feature films that have been made since then and are accessible, I want to consider just two: Terence Ryan's 1987 *Going Home* and Anne Wheeler's 1989 *Bye Bye Blues*.[18] The first, based on actual events (which were sequestered as *classified* for decades) and set in a demobilization camp in Wales in 1919, portrays the violence that erupts when the returning Canadian troops are held in the camp indefinitely

while plans to send them home are repeatedly delayed. The second tells the semi-biographical story of a young wife and mother who is sent home during the winter of 1941-42 to wait out the war while her husband, a Canadian medical officer with the troops in the Pacific, is swept up in the Japanese invasion of Singapore and Hong Kong. Both films are about home; both are based on historical facts; and both explore the profound impact of war on the identities of Canadians trapped by its cruelties.

Going Home opens innocently enough with the men of the Canadian Expeditionary Force marching down a charming Welsh road singing "Hanging on the Old Barb Wire." They are happy because they are finally going home; they have been told that the wait in camp will be brief. However, as the weeks and months drag by with no homecoming in sight, and as more and more soldiers arrive to be crammed into crowded, dirty quarters, tensions build, tempers flare, and memories of the trenches, of young Germans and fellow Canadians killed there, surface in the nightmares and reactions of those men suffering from shell shock. They cannot get home and they cannot leave the battlefields behind them. Then the Spanish flu arrives. The main character of this story, one Corporal Brill, played by Nicholas Campbell, is a decorated hero, but he will slowly change into a rebel when a full-scale mutiny breaks out in the camp, and he, with some of the officers, is ordered to shoot his own men. In the climactic scene of the film, the camp becomes a war zone, with trenches, barbed wire, and casualties strewn over the ground. This is the trench warfare of the First World War all over again, except that Brill, like Robert Ross in *The Wars* and Neil Macrae in *Barometer Rising*, will disobey orders. The film ends with most of the unarmed men, who simply longed to get home, dead, some of them hanging on the barbed wire, and Brill in prison facing a twenty-year sentence and obsessed with the desire to get the officer who ordered the slaughter. Brill will never go home in the full sense of that word, because he is imprisoned by his trauma, his memories, and the

past. *Home* has become an impossibility. It is also impossible, watching this film now, not to think of *The Wars* and of Jack Hodgins' *Broken Ground*, or of plays such as *Soldier's Heart, Unity (1918), Dancock's Dance, The Lost Boys,* and *Mary's Wedding,* all works in which the First World War refuses to stay over there or release its victims but insists on permeating home ground and haunting the future.

Bye Bye Blues is in most ways a very different matter. It contains no violent memories of warfare, and we must try to imagine the war in the Pacific, or the Second World War at all, from snatches of radio broadcasts, glimpses of men training at nearby bases, and the return of a brother minus a leg but full of bitterness for those safe on the Alberta farms that are the chief setting for the film. This film is as full of women as *Going Home* is of men. This is the home front of John Murrell's play *Waiting for the Parade* and of Joy Kogawa's *Obasan.* Nonetheless, there is a war on, and the women have taken over the factories and other jobs previously occupied by men. And they are poor. For the wives of men in the Pacific, serving under the British, paycheques simply do not arrive. The central character of the film is based on Wheeler's mother, who was sent home while her husband was caught in the POW camps of the Japanese. Having told his story in her earlier docudrama film *A War Story,* Wheeler turned to that of her mother and of the women left at home to cope with the daily struggle of the years between 1939 and 1945. Daisy Cooper, the wife in the film, needs to make money to support her children, and to do this she turns to the only marketable skills she has — playing the piano and singing. She makes herself invaluable to the local band that plays at the nearby airbase and step by step builds a life for herself. She becomes a breadwinner, an artist, and an independent woman. She earns the money that keeps her little family going. Wheeler follows her heroine as she gains confidence in her abilities, fights for her rights, and, perhaps inevitably, falls in love again — this time with an American musician who

has come up to Canada (avoiding the war that the United States had finally entered) to scrounge a living by his wits and his trombone and who ends up leading the band.

Those men who survived the Japanese POW camps were few and very badly scarred by their experiences, but some did make it home, and Dr. Major Edward Cooper will come home to Canada. His return, however, is presented with ambivalence. Like the other women in the film, Daisy will be expected to have kept the home fires burning and to be perfectly content to return to the life of domestic subservience and dependence that was the norm for women in Canada before the Second World War. But contentment is not exactly what Wheeler implies through the closing shots of the film. Instead, Daisy, who was about to embark on a whole new phase of her career as a musician, stands in the road watching her fellow band members leave without her while her husband, who has just returned, shattered and needy, watches her from the house. She does the only thing she can do: she stays home (see Cavell 12). But the home she is left with will not be the one she knew before the war. Beyond the end of *Bye Bye Blues* lies the reality of post-Second World War, Cold War Canada, and the closing shots of the film allude to the struggles that were coming, not only for the women of Daisy's generation, but for their daughters and granddaughters who would, like Wheeler herself, eventually gain some control of the memory-making and artistic representations of what it was — and could be — to *be* Canadian.[19] Just as *Going Home* makes me think of the recent re-creations of the First World War in fiction and drama, so this film captures much of the regret, hope, fear, and challenge of the struggle to survive on the home front that is portrayed in *Obasan, Waiting for the Parade*, and *Can You See Me Yet?* Unlike *Going Home*, however, it is not an anti-war film so much as one that refuses to judge those caught up in the exigencies of war, focusing instead on the repercussions of the Second World War for those at home. As Juliet

D'Orsay asked us to do in Findley's *The Wars*, Wheeler clarifies who these people are through their response to when they lived.

As Canadians moved into the 1990s, a number of major works dealing with the general subject of war appeared, one of the most important of which was Sharon Pollock's allegorical *Fair Liberty's Call* (first published in 1993), a play set in the eighteenth century that explores our national beginnings. I will return to this play in the conclusion to this chapter and in my epilogue, but for the moment, I want to reflect on the increasing attention paid to the two world wars. During the nineties, our playwrights remained concerned with the Great War and its consequences on the home front, with problems confronting personal and national identity conditioned by war, and with the sense that the present was still profoundly haunted by the ghosts from those years. The Second World War also began to receive a much more intense examination on stage than it had over the previous fifteen years. The focus of this scrutiny is almost entirely on *here*, not on what Canadians were doing abroad, though to be sure that is not forgotten, but on what the war meant for Canadians at home — for Japanese, Italian, or German Canadians, and for Native Canadians like the Dene men mining uranium in Marie Clements' *Burning Vision*. In 2004, Playwrights Canada Press brought out *A Terrible Truth*, its second volume of Holocaust plays, the most moving of which is Jason Sherman's *None Is Too Many* (1997), a play (based on the Abella and Troper study) that dares to confront Canada's refusal to help Jewish children during the war. This refusal is, was, infamous, a national disgrace, one that drove A.M. Klein to distraction and led Mordecai Richler to imagine his own kind of retribution in his epic novel of nation building *Solomon Gursky Was Here*. In the early years of this century, more and more Canadian survivor narratives — memoirs, autobiographies, diaries — are being published, which suggests that we have finally reached a point, sixty years after the war, when we can face these realities on the home front, as well

as abroad.[20] (I note here that the United Nations itself only recently recognized the Holocaust by marking 24 January 2005 its *first* Holocaust Remembrance Day.) By 2007 there were enough Canadian plays about war to lead Playwrights Canada Press to plan a two-volume edition called *Canada and the Theatre of War;* Volume 1 appeared in June 2008 (see Coates and Grace).

The novels dealing with the First and Second World Wars from the 1990s and the first years of this century are in many ways doing similar work. Like the plays, they are memory pieces in which remembering a past experience abroad is anchored in and framed by a present experience at home. The narrative model was established by Findley in *The Wars,* coupled with passionate attention to trauma on the home front by Joy Kogawa in *Obasan* (1981), but writers such as Michael Ondaatje in *The English Patient* (1992), Jack Hodgins in *Broken Ground* (1998), Anne Michaels in *Fugitive Pieces* (1996), Jane Urquhart in *The Stone Carvers,* Michael Crummey in *The Wreckage* (2005), and most recently Mary Lawson in *The Other Side of the Bridge* and Michael Poole in *Rain before Morning* (both published in 2006) have pushed their fictions onto a still wider and more complex stage than the one imagined by either Findley or Kogawa. These novelists expose some of the ways in which returned soldiers and women at home set about building a new country on the continuously surfacing memories and stories from North Africa and Greece, India, Japan, and China, as well as Europe. The image that comes irresistibly to mind when I think of surfacing memories from the First World War is one that both playwrights and novelists use and that military historians confirm. Here, for example, is how writer/actor R.H. Thomson puts it in his play *The Lost Boys:*

The larger story is that the earth is not at peace. The earth is reworking its memory of war ... The larger story is also the dance of

the dead soldiers. A hundred thousand skeletons lie unclaimed beneath the surface of the battlefields. They too are moving. Their bones dance ... ever so slowly in the shifting of earth and mud ... stepping with the frosts for more than eighty years. And as the dead men dance the decades away ... a few break company each spring and come to the surface. (46-47)

But let me return briefly to 1980 and the two plays that premiered then but have since become classics on our stages: *Billy Bishop Goes to War* and *Waiting for the Parade*. These plays warrant a closer look because of their longevity, which means that, in the ephemeral world of live theatre, they have had an impact, been seen by many audiences, and been studied in schools and universities, and because they represent both wars and the blurring of distinctions between being here at home and being over there. Gray and Peterson's play is based on the life of First World War flying ace William Bishop and on his autobiography *Winged Warfare* (1919), but what they do with Billy hardly transforms him into a glamorous hero. Their Billy is like Earle Birney's Turvey — a bit thick, rather naive, very much a colonial boy, but a survivor nonetheless with a sense of humour who can sing and perform into the bargain. With Peterson as Billy, and Gray accompanying him at the piano, Billy monologues his way through his memories of the war. From his position in an undetermined present before his audience, he performs all the parts himself by mimicking seventeen other characters, from the British king and the generals to the snooty Lady St. Helier. He writes letters home to his sweetheart, Margaret; he demonstrates what flying his planes and bombing the Hun was like; and he reflects, at the end of the play, on what it all meant when he sent his own son off to the Second World War.

To grasp something of the play's comic satire, one might compare one of its scenes with the romantic painting *War in the Air* (see Figures 22

and 23). Figure 22, which depicts an aerial battle involving flying ace Bishop, is by C.R.W. Nevinson (a British painter working for Lord Beaverbrook's Canadian War Art Office). In the play scene, Billy holds up his toy RE-7 and recalls,

> We didn't know how grim it could get until we saw the RE-7 ... the Reconnaissance Experimental Number Seven. Our new plane. What you saw was this mound of cables and wires, with a thousand pounds of equipment hanging off it ... Roger Neville and I are ordered into the thing to take it up. Of course it doesn't get off the ground. [Until] by taking everything off but one machine gun, the thing sort of flopped itself into the air. (42-43)

In Gray and Peterson's hands, Billy Bishop, with his seventy-two "kills" (6), becomes a symbol of the folly and pointlessness of the Great War as well as of its reckless adventure. When he ends by addressing the audience *"with a certain amount of bewilderment"* (100) and saying that "we didn't think there was going to be another one back in 1918. Makes you wonder what it was all for?" (101), the questions and doubts become ours too.

Waiting for the Parade is a women's play; its five characters are all waiting at home during the Second World War, working for the war effort, worrying about their men, and growing increasingly influenced by war propaganda. One of the five women, Marta, is German Canadian, and John Murrell examines the war's impact within Canada by including her isolation and ostracism as part of the larger story. This play is by no means as comic or energetic as *Billy Bishop*, but it too is full of music — "Wish Me Luck as You Wave Me Good-bye," "The White Cliffs of Dover," "Lili Marlene," as well as the German songs played by Marta — and the growing tension among the women is at times expressed through their use of the

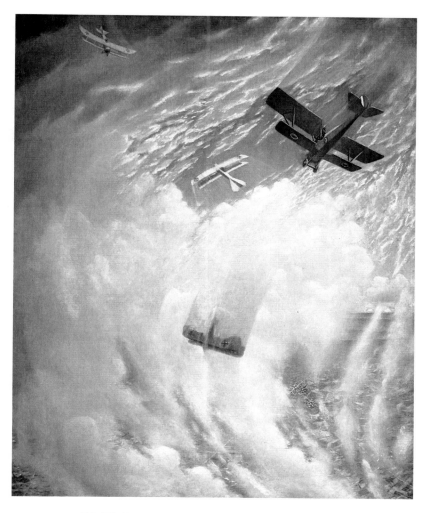

FIGURE 22 C.R.W. Nevinson, *War in the Air* (1918), oil on canvas, 304.8 x 243.8 cm. Despite its seeming prettiness, as Dean Oliver and Laura Brandon tell us, "the stress of painting a reconstruction of an aerial battle involving celebrated Canadian flying ace Billy Bishop finally brought about a nervous breakdown" for Nevinson (*Canvas of War* 42). Beaverbrook Collection of War Art, Canadian War Museum #19710261-0517.

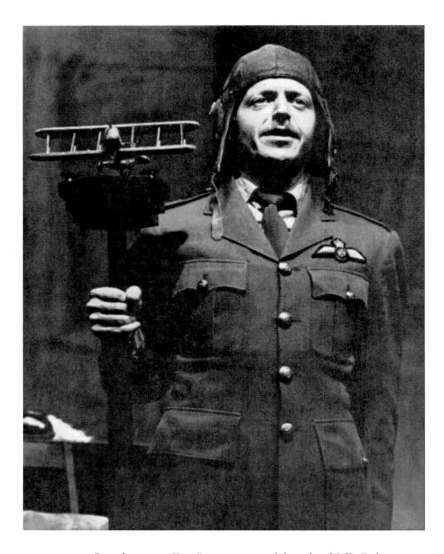

FIGURE 23 Canadian actor Eric Peterson *created* the role of Billy Bishop in the November 1978 premiere of the classic play *Billy Bishop Goes to War*. This production photograph of the now famous Peterson, along with other photographs, appears in the published text; it shows Bishop holding a toy model of the kind of plane flown by First World War ace William Bishop. This picture is reproduced with the kind permission of Eric Peterson and courtesy of Talonbooks. Photograph by Glen Erikson.

music of the day. This tension is also illustrated by their differing reactions to anti-Japanese propaganda: Janet, the female sergeant-major of the group, is constantly ranting about the war in the Pacific and praising the American presence in Canada's North — they know something important, she believes, and so we should support them. Another of the women, a high school teacher, is horrified: "My grade 10's made little buttons to wear that say: 'Zap the Jap.' I told them: 'Take those off!' But they complained to the principal and he gave them permission to wear them" (61). War propaganda was as prevalent during the Second World War as it was during the Great War; posters (see Figure 24) fuelled domestic prejudice by linking patriotism at home with Canadians killed or imprisoned by the Japanese, and a propaganda film such as *The 49th Parallel* called for vigilance at home because the Nazis might infiltrate Canada from the North if good Canucks were not standing on guard.[21] When *Waiting for the Parade* ends, the women are still waiting. The future they now face, of returned men and, for themselves, lost jobs and a return to the kitchen, is left hanging. Little has been resolved because little can be. Marta is perhaps a bit less isolated because what they all have in common is this waiting. But what we have witnessed, which is Murrell's intention, is the ugly spectacle of paranoia, suspicion, fear, and guilt performed on the home front where, like the Japanese Canadians, Germans, Italians, and foreign-looking people with foreign-sounding (non-Anglo-Saxon) names were stripped of their rights, rounded up, and sent to internment camps (see Dulani and Kordan). This reminder of how things were at that time is also a warning not to forget lest such prejudices surface today.

I especially admire Murrell's portrayal of the Second World War on the home front for its inclusivity. His attempt to show the ripple effects of war on those not at the battle front, including those at home who are not considered good citizens (because not white, Christian, or English- or French-speaking), anticipates that broader vision I see in the films, plays,

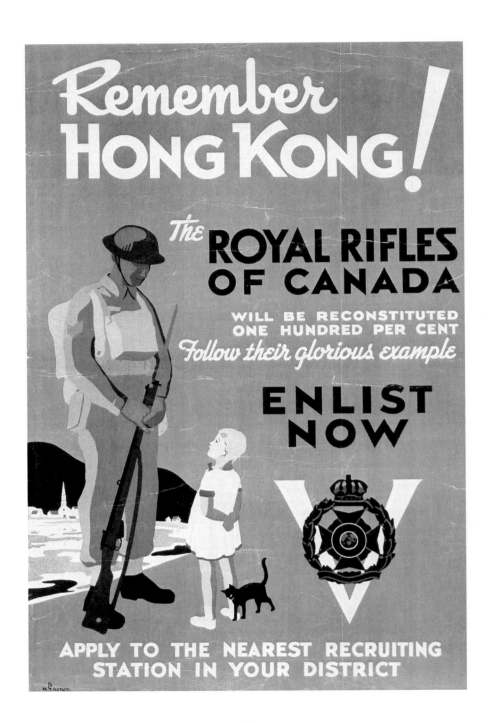

and novels of the 1990s. The most important film to date to portray the home front, with an urgent plea for inclusion and understanding, is Anne Wheeler's *The War between Us* (1994). It tells the story of a Japanese Canadian family (whose father fought for Canada in the First World War) torn from their Vancouver home and exiled to New Denver, an interior British Columbia town, and of the white folks in the town who struggle with their ignorance and racism when they are obliged to live beside these strange people.[22] Thus far, I have located only one painting from the Second World War — Molly Lamb Bobak's *Private Roy, Canadian Women's Army Corps* (1946) — that depicts a woman of colour in the Canadian army, but the 1995 documentary *Canada Remembers* makes a serious effort to include, not just women, but also Jewish, First Nations, and Chinese soldiers, all *good* Canadians who were neglected by the McKennas in *The Valour and the Horror*. These growing inclusions reflect many changes in Canada, from our demographics to our constitution and laws (the Charter of Rights and Freedoms and the Multiculturalism Act), and I can only imagine them expanding as time passes. Indeed, three recent novels come instantly to mind when I consider this question of inclusion: Crummey's *The Wreckage*, Poole's *Rain before Morning*, and Joseph Boyden's *Three Day Road* (2005). Crummey's novel offers a moving evocation of life in outport Newfoundland before the outbreak of the Second World War (with the slaughter at Beaumont-Hamel in the Great

FIGURE 24 (FACING PAGE) Recruiting posters were common during both world wars, as were blatant propaganda posters. This is one of the few examples I have seen concerning Canadians fighting in the Pacific during the Second World War, and the exhortation to "remember" Japanese atrocities in Hong Kong, combined with the symbol (a small Canadian girl) of the values and rewards (domestic security and admiration), creates a powerful inducement for men to enlist. Beaverbrook Collection of War Art, Canadian War Museum #19700036-024.

War always fresh in Newfoundlanders' memories). It is also the only one I know of to situate part of its story in a Japanese POW camp. Moreover, the Japanese soldier in charge of the camp, Norburo Nishino, is actually a Canadian from Vancouver (and the son of a First World War veteran), who experienced such painful racism as a teenager that he joins the Imperial Japanese Army and ends up ruling the camp with a special vindictiveness toward Canadians. *Rain before Morning* is unique, at least thus far in our artistic representations of the Great War, for its focus on draft dodgers hiding in remote areas on the BC coast. Anglophone Canadians have always been told that francophone Quebecers, of the kind described in Caron's novel *L'Emmitouflé*, refused to enlist and opposed conscription, but Poole opens up a little-known chapter in anglophone Canadian history to portray the tragedy that befalls conscientious English-speaking objectors hunted down by military police on home ground. Their stories, like the novel's parallel story of the nurse who goes to France only to be punished for criticizing the army hierarchy, make important contributions to the larger narrative of a Canada that emerged from the war.

Perhaps the most significant absence from our representations of Canadians in either world war has been that of First Nations soldiers. Although it is impossible, finally, to weigh the contributions made by specific groups to a war effort or to assemble a priority list of who most deserves remembering, Boyden has done for First Nations soldiers in the First World War what the country at large and our governments have neglected to do: he honours such men, not financially and socially, but by telling the story of two Cree snipers fighting the Germans on the killing fields of France. *Three Day Road* is an epic *fiction* and a haunting re-creation of violence, friendship, and death, but it is based, in part, on the biography of a real man, the First World War Ojibwa hero Francis Pegahmagabow, a name virtually unknown to Canadians (see Hayes). This novel does for Canada

and its Native soldiers what the 2006 French film *Days of Glory (Indigènes)* does for the Muslim Algerian soldiers who fought, and died, for France during the Second World War: it informs us about their service, sacrifice, and suffering; it reminds others of their unacknowledged debt to such men.

However, if I were to single out one work of art for its courageous confrontation of exclusion in the context of war, it would be *Burning Vision*. The power of this play arises from its shocking juxtaposition of the uranium mining in the North at Great Bear Lake by Dene miners during the 1930s and 1940s with the bombing of Japanese cities in 1945. By bringing together the *here* of the Canadian North, home to the Dene miners, with the *there* of Japanese civilians in Nagasaki and Hiroshima, Marie Clements has mapped the connections across time and space that bring the Second World War home to Canada in ways we have not yet fully acknowledged. Canada, Clements insists, exploited its own First Nations people here at home to feed the war effort in the Pacific even when the federal government knew the risks of mining and handling uranium. The burning vision of the title connects the Dene, who would die from this work, with the Japanese, who would be burnt by the bombs, and both groups with the governments and military forces that killed them. The play draws on some of the same historical information gathered by Peter Blow for *Village of Widows*, his documentary film about uranium mining, but unlike the film, which uses interviews with Dene who lived through the mining period and are now experiencing high cancer rates, the play relies on verbal and visual metaphor in live performance to underscore the need for an honesty of vision that can burn through the rhetoric and obfuscation of greed, exploitation, and aggression that cause war.[23] At its Vancouver premiere, this vision was staged with an innovative set design, symbolic lighting, and powerful sound effects, and through the ritual movements and stylized speeches of the characters. The published text begins with a map that

superimposes Canadian and Second World War history on the geography of Dene lands to create a visible textual reminder that we must listen to the voices of the dead (and not just those dead who speak to us from "Flanders fields") because they show us how to see beyond the laundered versions of official history to those events that connect us as human beings.

This process of establishing connections through memory is what makes Thomson's *The Lost Boys* such a moving play, and it is also what makes Hodgins' *Broken Ground*, like *The Stone Carvers*, a novel of nation-making scope. In his foreword to *The Lost Boys*, Thomson tells us that, "while the play surrounds itself with the minutiae of war, I never intended it to be about the war" (n.p.), and it isn't. Like so much of the recent Canadian art of war, this play is fundamentally about who we are now, here, as individuals with family histories living in a nation with a past that is too little known. By writing and performing this play, Thomson gives voices to some of McCrae's dead, and in the process, he discovers himself in his Great Uncle George, who died near Passchendaele and who looks so much like him:

> Height?
> "6.'1" (My height.)
> Complexion?
> "Fair." (My skin.)
> Eyes?
> "Grey Blue." (My eyes.)
> Hair?
> "Fair." (My hair.)
> "Are you willing to be attested?" (26)

This attestation information comes from Uncle George's formal agreement with the army, but it is also R.H. Thomson's attestation to his connection

with the man who was blown to bits near Passchendaele in 1917 and whose bones are among those that surface every spring as the earth reworks its memory of war. The Canadian actor speaking, performing, standing live before us, or captured in an author's photograph (if we are holding the published text) is the memory made flesh here, now, on home ground. At the end of the play, Thomson performs his return to France to look for the graves of his uncles; he keeps watch; he dances. But in his final words, he admits, "All that's left for me now is to be here" (70). Here — on the stage, on the page, at home — *here.*

Broken Ground is no more about the First World War than is *The Lost Boys.* And yet, I consider it an important statement about how Canada has evolved in its artistic representation of that war. It is the story of Portuguese Creek (the fictional name for the real Comox Valley community of Merville) on Vancouver Island and of the "Returned Soldiers" who were granted uncleared land there as "our country's thank-you" on condition they would clear and develop it (Hodgins 34). They came to the West from central and eastern Canada, after they had returned home, only to find that the meaning of home had vanished. Matthew Pearson, whose story lies at the centre of the many concentric circles of stories comprising this narrative of nation, tells us that, after a few years away, "home ... was only an idea without any real embodiment in this world" (111). And yet, *Broken Ground* is precisely about homemaking and nation building, a making and building that will be done through remembering the Great War, with its reverberating impact on individuals and communities. In this sense, the novel is a close counterpart to *The Stone Carvers:* the movement between Canada and France in the two novels may be different, but the end result in both is the incorporation of the past into the present, of the war there into the communities here, and of recorded memory into commemorative art.

As Hodgins' collective storytelling develops, we come to understand just how profoundly the war haunts and invades every home in Portuguese

Creek until the very soil of the place — its broken ground — holds the battlefields, blood, and bones of memory. Pearson will be drawn back to France over and over again in such a painful journey of remembering and reclaiming that nothing in his present of 1922 or in 1996, when the main narrator, Charlie MacIntosh, remembers him, can possibly make amends for his losses. Indeed, the central section of the novel, ostensibly reported by Charlie, who has access to Pearson's letters and journals, returns us literally to the past. In 1919 (or so we are told), Pearson was driven to wonder whether he would have been better off dying in the war or — shades of the film *Going Home* — murdered in that mutiny in Wales (201). But he survived the war, bringing back with him to Canada the child Elizabeth, whom he fathered there and who symbolizes his guilt, love, and desire for atonement. Then he survived the great fire of 1922 in Portuguese Creek that claimed Elizabeth's young life. After the fire, Pearson will be obliged to carry the scars of both cataclysms, to bury the child in the broken ground of Canada, and to struggle on with his shattered life. Through the voice of the eighty-four-year-old Charlie, who remembers and re-creates the fragmented polyphonic story we are reading, Jack Hodgins reminds us that representing Canada has become impossible without representing the First World War and the survivors who made their homes here, and whose stories of war and remembering keep surfacing into ours on the broken ground of nation, home, and story.

This process of remembering is what Sandra Gwyn has captured so magically in *Tapestry of War: A Private View of Canadians in the Great War* (1992), and I want to turn to a brief consideration of this non-fictional, yet deeply personal, documentary treatment of history. Gwyn uses two metaphors to describe her unusual historiographic method, that of the theatre and of a tapestry, both of which serve her nationalist project and artistic intent. Through letters, diaries, and autobiographies, Gwyn brings ten Canadians onstage and allows them to tell their own stories. But she

does not do this in ten separate chapters. Instead, she weaves or braids their stories together: for example, strands of Ethel Chadwick's story intertwine with Agar Adamson's, whose story intersects with Brooke Claxton's, and so on, until the voices and experiences of these actual historical figures bring the drama of Canada, and of being Canadian at that time, alive. These real people are her characters, each becoming in his or her own way, as did Harold Innis, Canadians — even *nationalists* — because of the war (368).[24] Without doubt, Gwyn favours one of these Canadians above all the others on her stage, and he becomes "the hero of this book" (390). This man is Talbot Papineau, the bearer of a famous name in Quebec history, who died at Passchendaele on 30 October 1917 and whose body was found under very disturbing circumstances. "Three weeks after Papineau fell at Passchendaele," Gwyn explains,

> a reconnaissance party led by his close friend Charlie Stewart went out across the sodden, blasted territory. 'A pair of feet with reversed puttees was seen sticking out of a shellhole full of water' Agar [Adamson] wrote to [his wife] Mabel on November 20, 1917. 'Stewart said Major Papineau always wore his puttees that way. They pulled the body out, and by examining the contents of the pockets, found it to be Papineau. He had been hit by a shell in the stomach, blowing everything else away.' (496)

Had he lived, Gwyn believes, Papineau would have served Canada and Canadian national identity as no other could because he championed this identity in public opposition to his cousin Henri Bourassa, who was a Quebec patriot.[25] "To a degree that was extraordinary," she tells us, "Talbot Papineau became for Canadians the symbol not only of Passchendaele, but of all the golden promise cut down by the Great War ... Even now Papineau remains a vivid and tantalizing presence. The easiest

description of the loss Canada experienced by his death is that he was the Pierre Elliott Trudeau who never was" (400-1). And "never was" is the operative term here because, as recent biographies by John English and Max and Monique Nemni make clear, Trudeau avoided the army, opposed conscription (as many Quebecois did, of course), sympathized with a contemporary extreme right-wing view of society, and showed little interest in the forces unleashed in Europe during the Second World War. Perhaps some symbolic reparation for Trudeau's refusal to fight can be seen in the fact that Justin Trudeau plays Talbot Papineau in Brian McKenna's new film *The Great War* (2007).

By the time Canada's war art had been rescued from the oblivion of storage vaults, prepared and curated for its national touring exhibition between 2000 and 2004, and then hung (some of it at least) on permanent display in the Canadian War Museum when it opened in 2005, the novelists, playwrights, filmmakers, biographers, and scholars had caught up with the painters. The exhibition catalogue *Canvas of War* bears eloquent testimony to the painters' perceptions of war, to the variety of their approaches to such difficult subject matter, and to the horror they experienced through their eyewitness accounts. The tired cliché that a picture is worth a thousand words comes to mind as one leafs through the catalogue. At least, it did for me until I read Fred Varley's words to his wife: "I'm mighty thankful I've left France — I never want to see it again. This last trip has put the tin hat on it. To see the land half-cultivated and people coming back to where their homes were is too much for my make up. You'll never know dear anything of what it means. I'm going to paint a picture of it, but heavens, it can't say a thousandth part of a story. We'd be healthier to forget, and that we never can" (letter to Maud, mid-May 1919, quoted in Oliver and Brandon 5). To read in the marginal commentary accompanying Nevinson's *War in the Air* (Figure 22) that the artist had suffered a nervous breakdown further emphasizes the human cost

behind this most innocuous-seeming painting. By the time I had reached Charles Goldhammer's excoriating images of burned airmen casualties or Alex Colville's *Bodies in a Grave, Belsen* (1946), I needed to know how an artist could create such pictures. For this insight, I turned to the documentary film *Canvas of War: The Art of World War II* (2000), narrated by R.H. Thomson. Several Second World War artists, who were then in their eighties and early nineties, are interviewed in the film, including Bruno Bobak, Molly Lamb Bobak, Robert Hyndman, and Alex Colville, but Aba Bayefsky stands out because to watch and listen to this elderly artist recall his war work and describe what he saw when he entered Belsen is to be close to the real presence of that experience. As a young soldier, a war artist, and a Jew, the man himself attests, beyond words or paintings, to the horror of war, and his comments, made so many years later, yet so immediate and unadorned, *answer* Varley's question from the previous war: "For What?" Bayefsky painted what he saw because he wanted to "make sure that this was put on record," and from that moment his life was changed forever: he would be and remain an artist.[26]

CONCLUSION: THE LESSONS OF WAR ART

During the 1990s, something significant happened to what Canadians understood by the representation of war. As those who actually fought in the First and Second World Wars have died, it has been left to those who have not known war first-hand to tell the stories, so it should not be surprising to find Canadian artists turning to look more closely at the consequences of those wars rather than at the wars themselves — although some recent work such as David French's *Soldier's Heart* and John Major's *No Man's Land* present the First World War without irony or self-reflexive frames of memory. The consequences of the First and Second World Wars have been profound, and if we pay attention to our artists, we

can see what those consequences have meant for this country. I find it interesting that we have not, at least not yet, made any of the men or women from either war into iconic figures, let alone heroes. Billy Bishop, it is true, has been fictionalized but hardly as a conquering hero, let alone as a figure of such scope that he could be called iconic in any way. Talbot Papineau, Sandra Gwyn's hero, has been long-lost, not only to Canadian history, but also to national memory, until, that is, Gwyn published *Tapestry of War* and Justin Trudeau re-embodied him. Perhaps General Roméo Dallaire, through his Rwanda experience, his books, the films, and his public role as a senator and an acclaimed lecturer, will become the first military iconic figure — only time will tell. In the next chapter, I examine a few of the Canadians who have, to date, been granted iconic status through their prolonged re-creations by artists, but a subject as grave as war, and as intensely present to the early twenty-first century, when Canadian soldiers are fighting — and dying — in Afghanistan, cannot be left behind without pausing to weigh some provisional conclusions about the *artistic* lessons of the two world wars.

Between Findley's *The* Wars or Urquhart's *The Stone Carvers* and Clements' *Burning Vision* or Boyden's *Three Day Road*, I see a very significant shift in this art, away from an earlier realism, satire, or battle action account to an art characterized by the stress laid on the *process* of remembering, on the attention to trauma aftershocks, on the need to expose a range of betrayals and lies that cost Canadian lives, on the healing power of commemoration through art (whether the carving in marble of the Vimy Memorial or the writing of a novel), and on the profound impact war has had on the home front. People not previously privileged, or indeed simply not present, in Canadian war art have begun to receive attention — the women waiting at home, the soldiers who were of First Nations or other non-anglophone or non-francophone backgrounds. The

Dominion Institute's "Memory Project" is a case in point: in recent advertisements, it describes itself as "a multimedia collection of Canada's military heritage from the First World War to Modern Peacekeeping" that foregrounds "Aboriginal, Female, and Francophone" personnel and veterans.[27] Artistic attention has increasingly turned to what was actually happening in Canada during the wars — to propaganda, resistance to conscription, and the treatment of Japanese Canadians, German Canadians, or Italian Canadians — and to what, during the Second World War, was ignored, such as Jewish children and others in imminent danger who were denied the sanctuary of Canadian soil. Most recently, and in a body of work I am not able to examine here, Canadians are writing plays, publishing memoirs, and creating films that explore other wars — in Armenia, Yugoslavia, Rwanda, Afghanistan, and the Middle East — wars in which Canadian soldiers and official Canadian policy were focused on peacekeeping. A new body of recollection and representation is appearing that includes Dallaire's autobiography *Shake Hands with the Devil* (released in a film version in 2007), Atom Egoyan's *Ararat*, plays such as Colleen Wagner's *The Monument*, Wajdi Mouawad's *Scorched*, or Marcus Youssef and Guillermo Verdecchia's *A Line in the Sand*, and war art such as Gertrude Kearns' monumental canvases of Canadian soldiers in Afghanistan or Althea Thauberger's stunning photograph of Canadians on training exercises.[28]

I also detect an increased interest in aspects of Canadian participation in both world wars. The sheer volume of artistic attention since 1992 invites Canadians to pay attention: something is happening out there, and it is important to ask what, and why. If Findley's *The Wars* can be understood, in part, as a response to Vietnam, a war that Canada did not officially, or in popular opinion, support, how can we contextualize the war art of the 1990s and today? Why is it important to remember Walter

Allward and his monument, which Urquhart celebrates so lovingly and Gwyn describes with pride? Canada has continued to withhold *official* support of foreign-led aggression or military invasion, and the art I have examined seems to be, on the whole, critical of war in general and suspicious of the propaganda that serves militaristic goals or anti-terrorist paranoia.[29] At the same time, it is only recently that we have dusted off, as it were, the paintings of Canadians at war in both world wars and only in May 2005 that we opened the Canadian War Museum in Ottawa, where these works are finally on permanent display. In April 2007, Canadians returned to Vimy Ridge to recommemorate and re-enact our military history there, and in the fall of 2008 Vern Thiessen premiered his new play *Vimy*.

This play is a moving elegy and commemorative drama in which Thiessen explores the meaning of being Canadian through the stories of four wounded soldiers from different parts of the country with very different home-front loyalties and ethnic backgrounds. One is a Blood Indian from Alberta; the other three are an anglophone construction worker from Winnipeg, an anglophone canoe maker from Renfrew, Ontario, and a francophone from Montreal who has joined the famous "Vandoos." The nurse who does her best to soothe and treat these young men is from Nova Scotia, and the setting of the play is a nursing station somewhere in France, not far from Vimy Ridge. However, despite the historical basis of the story, the play unfolds through the tormented memories of all four men and their courageous nurse as they recall scenes from pre-war civilian life, their varying reasons for enlisting (or joining the nursing corps), and the linguistic, political quarrels they have with each other. They tend to look down on the Indian and to spar with the "Frenchie," until they collectively reach the common memory that pulls them together: the preparation for and taking of Vimy Ridge. The climax of the play occurs as these wounded men re-enact in memory and imagination the hours

of that battle when Canadian troops fought together for the first time and won a decisive victory. Instead of arguing and insulting each other, instead of each man using his language in preference to all other languages, instead of insisting on the pronouns "I" and "Je," they shift into speaking as a chorus, together, saying "we" and "nous": "We need to work fast. We need to work smart. We need to work together ... Et nous avons besoin de tout le monde" (44-45).

Should we see this interest as an encouragement of war or as a reminder of past traumas and costs? Is an exhibition such as Canvas of War an invitation to celebrate the valour of battle, or is it a timely commemoration of the horror? When the publishers and authors of the catalogue *Canvas of War* were designing the book, they chose Lawren P. Harris' *Reinforcements Moving Up in the Ortona Salient* (1946) for its cover, but what did they want readers to see? What I see is a landscape of such desolation and violence that it numbs the mind's eye. Insofar as this catalogue, announced by this cover, can be said to address what it means *today* to be Canadian, the message is surely this: remember to bear witness so that what happened then will not happen again. This exhibition, which I saw in the Vancouver Art Gallery, struck me as orchestrating a collection of ghostly voices surfacing from the past to whisper about memory, trauma, and story. The paintings, resurrected from their vaults and brought into the light of day, asked me, in Varley's words, "For What?" *Vimy* also offers me an answer, even though Thiessen is at pains to make clear that his play "does not ask whether war is right or wrong" and that he does not "criticize or defend war" (v). Watching this play in performance brought me face to face with a small group of individual characters who spoke collectively about how shared memories, collective actions, and individual, private loss and grief, can, as Thiessen puts it, "define us ... as a nation" (v). Among the many strengths of this play — its beauty of structure, its dynamic languages, its powerful images and symbols — one quality in

particular stays with me: its inclusivity. Within an imagined, remembered landscape of Vimy Ridge in April 1917, the playwright gathers a representative group of young Canadians (French, English, First Nations, male and female, middle and working class) and tells his audience that this is who we are and what we can — together — do. Maybe Thiessen has suggested an answer to Varley's question, but if he has, it is not a military answer but one that compels us to remember and work, fast, smart, together, *tout le monde*.

Indeed, insofar as there are answers to such a daunting question, I look for them in works of art because they enlist the powers of artistic representation to make us think and feel; they urge us (as Findley's Juliet D'Orsay put it in *The Wars*) to clarify who we are in response to the times in which we live. I understand Findley to be warning me against a too hasty judgment of the past or of those who acted as they did in response to the circumstances confronting them. I believe Findley and Thiessen, speaking in the voices of their fictional characters and eyewitnesses to the impact of war, are asking readers and audiences to strive for compassion and understanding, which, together, may help us appreciate how that past contributed to this future, which is our present. Simply put, all these representations of the two world wars show us aspects of our history and thus our identity. Whether or not we believe that the victory at Vimy Ridge in 1917 was decisive in shaping the Canadian nation — that, as the maturation trope would have it, we *came of age* during that battle — they remind us that, though Canada has never been a militaristic aggressor, its citizens could be as ruthlessly efficient in war as the people of other countries, that we are susceptible to the rhetoric of patriotism, to the propaganda of fear, and to the bigoted repression of dissent, but that we are also deeply suspicious of individualistic heroics, macho bravado, and unselfcritical pride. They show us that, though our nation is perceived to be a peacekeeper, our methods, at home and abroad, have often been dubious,

and they warn us against complacency and forgetting. "Nothing is more dangerous," says Atwood's narrator in *The Blind Assassin*, than to ignore the voices of the dead, because they are "thirsty ghosts." "We are the dead," McCrae's soldier-corpses announce; "we shall not sleep," they warn us, although exactly what they will do if we forget them remains unstated (and all the more troubling for that fact).

Above all, we must not forget that we too might be called upon to stand on guard, to choose, to fight, to help create a better world, and to remember. In *Fair Liberty's Call*, Sharon Pollock urges contemporary Canadians to re-examine their eighteenth-century origins (specifically the arrival of United Empire Loyalists in what would become New Brunswick after the American Revolution) so they would better understand their values, priorities, and obligations at the end of the twentieth century. However, her play is not only about those Loyalists. It is also about loyalty, forgiveness, fair play, liberty, and peace; it is about rejecting vengeance, eschewing embittered recollection, and choosing not to reinstate racist intolerance and economic privilege. It is, above all, about starting anew, after a bloody war, by celebrating hope for a better inclusive future rather than by re-enacting memories of battles lost and won — which brings me back to the immediate problem of balancing remembrance with the cries of the "thirsty ghosts" at Vimy Ridge in April 2007 or on the stage with Thiessen's *Vimy*. *Fair Liberty's Call* insists that we must move beyond the repetition of past traumas, not by forgetting, but by remembering the shared costs of war, by trying to build a world (or a country) founded on fair liberty for all, and by accepting the reality of our differences.

Joel Ralph, a great-nephew of a First World War soldier who fought at Vimy Ridge, was among those selected to participate in Brian McKenna's re-enactment of that Easter Sunday battle in 1917 for the film *The Great War*. In an eloquent article about his experience, he describes his "mixed feelings" when McKenna asked the re-enactors to stand on the ridge and

shout "Vive le Canada" as if they were celebrating that victory ninety years ago. Although Ralph believes that Canada's participation in the battle was "a pivotal moment in our history," the re-enactment itself reminded him that he was not really risking death any more than he was actually killing German soldiers and that the film's focus on "death and remembrance often directs our attention to the violence received rather than the violence that was dispensed" (41). And Ralph concludes his reflection on the re-enactment, on McKenna's request for victory cheers, and on his own ambivalence with a powerful reminder:

> By the end of the war the Canadians were one of the most respected and professional fighting units on the Western Front because of their ability to kill and thoroughly destroy their enemy. The effects of the violence administered by Canadians are still as profound as the effects of the violence they endured, both of which were felt as we revisited Vimy Ridge. (41)

I had read Ralph's article before I watched the Easter 2007 rededication services and the CBC screening of *The Great War*; therefore, I was in a sense forewarned that McKenna's use of re-enactment by descendants of the soldiers who fought in the war might be problematic. And it was. In fact, for me, and for many of my students studying representations of the war, the film was a considerable disappointment. Although it was clearly intended both to pay respect to Canada's soldiers and to inform a younger, contemporary generation about its own history, the film said little about the German soldiers or the causes of the war. Instead, we were repeatedly told that the Canadians who died at Vimy (and in other battles) were fighting for their country and making sacrifices for *us*, that we came of age at Vimy, not only by winning the battle and taking the ridge from

the Germans but also — and possibly more significantly — because at Vimy Canadians were fighting together *as Canadians* for the first time.

Particularly bizarre, however (at least to my eyes and in the opinion of my students), were the fictionalized *performed* sequences in the film in which Talbot Papineau came back to life in the person of Justin Trudeau. Just as Papineau was Sandra Gwyn's hero in *Tapestry of War*, so he was in McKenna's treatment of the war except that, where Gwyn closed her story with the gruesome discovery of his blasted corpse, McKenna resurrected him: in the closing shots of the film, he reappears as a handsome, fresh, clean, well-groomed officer to embrace the young woman *back home* with whom he was in love.[30] Any acknowledgment of the violent reality of war is swept aside by this sentimental moment; any echo of the brotherhood, or "mateship" (a term used earlier in the film to explain why men fought), is erased by the heterosexual erotics of the final scene; and, most paradoxical of all, the story of the battle front is supplanted by this romantic return *home* to Canada. Only time will tell how well this film representation of the Great War will wear and whether it will be recognized as a worthy artistic attempt to remember our history and understand the forces that shaped the nation. For me, the single most memorable moment in the film occurs when a young woman from Newfoundland (a descendant of a soldier, like the other participants) tells her companions what happened at Beaumont-Hamel and sings the "Ode to Newfoundland." She weeps as she sings because, if any one part of the country felt the impact of the First World War more than another, if one area suffered more or was more profoundly altered, it was Newfoundland — not because of a victory, but because of a bloody, senseless defeat.

However, the film was only one part of the 2007 Easter celebrations. In real time and real life, the prime ministers of Canada and France (Stephen Harper and Dominique de Villepin) met at Vimy Ridge, on the site

given in perpetuity to Canada by France, to bear witness to the rededication of the monument by Queen Elizabeth II. The day was glorious, with warm sun and a blue, cloudless sky; it was a day utterly unlike the day of the battle in 1917, with its snow, sleet, and cold, and profoundly different from the battle scenes described by Boyden's snipers or evoked by Thiessen's shattered soldiers. And the scene was sharply different from that overcast day in 1936 when Canadians first gathered around the monument for its unveiling: then, the surrounding landscape was still scarred, grey, and bleak; now, it consists of green fields, with grazing sheep, stretching to the distant copses and fences that restrict entry to areas where mines and bombs still surface and explode. During pauses in the ceremony, the CBC microphones picked up the optimistic singing of birds. There were many fewer veterans there than in 1936, and those who attended were veterans of the Second World War, living reminders that the war to end all wars failed to bring peace. But many contemporary Canadian students and soldiers were there as well, and those present (or watching television coverage from home) were all told that the ghosts of Canadians walked on this ridge, that their sacrifices made this *Canadian* landscape on French soil a sacred place, the site, in fact, of our "creation story" (as Harper put it). "In Flanders Fields" was recited; Susan Aglukark sang "I'm Dreaming of Home"; a young First Nations violinist played "The Warriors' Lament"; wreaths were laid; two teenagers made vows, in French and English, never to forget; the last post was played; the queen spoke (of past losses and of the six Canadians killed in Afghanistan just days before); and four French jets performed a fly-by right on cue.[31] But constantly visible in the background, providing the stage and the set for the ceremony, was the pure white marble monument itself, and when cameras moved close to speakers or performers, it was the massive sculpture of Mother Canada (Figure 14) that filled the screen with her brooding

posture and mourning countenance directed down on the flag-draped tomb of the unknown soldier and on those gathered around the base of the monument.

If Walter Allward were alive today and had attended the 9 April 2007 rededication of his Vimy Memorial, would he have been pleased with what he saw? Would he have approved of the restoration of his sparkling white monument, with its "twin obelisk-shaped pylons" soaring above the Douai Plain, its symbolic sculpted figures in postures of grief and hope, its "enormous stone woman" mourning her lost boys? Would he feel that his greatest artistic achievement, so little known in Canada, still served its purpose and, thanks to television, was finally being appreciated by millions who could not travel to France? If ghosts were walking on Vimy Ridge that day, or if men could return from the dead like Sandra Gwyn's Papineau, surely it was Walter Allward and, with him, Sandra Gwyn whose presences were palpably present because it was, after all, Allward, Urquhart's demanding, obsessed artist, who transformed the violence of death into the peace of monumental art and who changed the horror of Vimy Ridge into the beauty of sculpture. And it was Sandra Gwyn, remembered by Urquhart (and McKenna), who found and re-created Talbot Papineau. Without the art, there is small hope of remembrance, but with it, the past continues to live in a *lieu de mémoire*.[32]

Inventing Iconic Figures

Within national discourse the stakes of biography are high;
the meaning of certain life-stories helps to shape the ways
in which the nation and its history are defined.
— *Marita Sturken*

Perhaps we have a difficult time defining what our country means
because we know so little about the people who made it mean something.
— *Paula Todd*

.

I INVENTING ICONS

Every country has its heroes and Canada is no exception, although I pre-
fer to call ours *iconic figures* for reasons that will, I hope, become clear.
Charlemagne, Joan of Arc, Richard the Lion-Hearted, Napoleon, Sir
Winston Churchill, Mahatma Gandhi, Lawrence of Arabia, Scott of the
Antarctic, the Red Baron, Abraham Lincoln, Helen Keller — I could
keep adding to the list almost indefinitely. In all these cases, the heroic
figures were real individuals whose status as hero was confirmed by their
contributions to some cause or event larger and of much greater social
and historical significance than themselves. Often they died young and
violently; often they lived flamboyantly. But most importantly, they were

written about in histories, biographies, fiction, poetry, and plays, sung about, painted, or in more recent times had films made about them. The fact of existing and accomplishing something was only a first step: in Canada this step may have entitled some of them to get their names on the 2004 list of "greatest Canadians," but that alone does not make them icons. It is the artists and storytellers who transform them into larger-than-life figures and give their lives meaning — for a national story, for an epic event, or for their times.

In this chapter, I examine a few examples of Canadians who have been transformed into iconic figures by our artists and writers, whether or not we agree that they deserve to be called heroes or can agree on what the term *hero* means. Many unusual, heroic, or talented Canadians have not yet reached iconic status, and some probably never will. But there are a few who have been so written about, sung about, reproduced on canvas and film, and photographed that they have developed an afterlife in excess of anything they did while alive; their stories circulate through layers of popular, national, and regional consciousness. Biography is a crucial player in this process of invention, in part because life stories are more widely read and influence greater numbers of readers than scholarly studies do, and in part because they necessarily reproduce factual, historical evidence (such as photographs), and by doing so, they resituate and inflect the meanings, or so-called *truth* of such documents, to support the art of biographical narrative.[1] But images of Canadian icons also appear in unlikely places such as billboards and websites, and they prove marketable on coffee mugs and T-shirts. In my book on Tom Thomson, I called this process *invention* and argued that "Tom Thomson," as we know him, is the product of obsessive invention by artists, biographers, and curators, as well as by popular culture more generally. I will revisit the inventions of Tom Thomson, but I first want to consider some of the other Canadians who have been invented and to ask why these individuals appeal to

their inventors, what makes them *Canadian* icons, and what their *inventions* might tell us about being Canadian.

The four figures I focus on are Louis Riel (1844-85), Emily Carr (1871-1945), Tom Thomson (1877-1917), and Mina Benson Hubbard (1870-1956). I have chosen these four because they have been so extensively invented and because they represent a wide span of the country's geography, but a number of other candidates also come to mind and deserve at least a brief mention. For example, Sir John Franklin has enjoyed a lively posthumous existence in Canada — in Wiebe's *A Discovery of Strangers* and Richler's *Solomon Gursky Was Here*, or in Stan Rogers' ballad "The Northwest Passage."[2] So has Billy Bishop, who is not only the title character of *Billy Bishop Goes to War*, but has had biographies, a film, and a children's play devoted to him; moreover, he appears on prominent billboards in Owen Sound.[3] And yet, war heroes, as such, are less popular choices for artistic invention in Canada than in other countries: Major James Walsh is portrayed as a defeated man more than a success; John McCrae is largely remembered for his poem "In Flanders Fields"; our generals, such as Sir Arthur Currie, have not had the easiest time of it abroad or at home. The story of Roméo Dallaire confirms this situation, although as time passes, Dallaire is acquiring a larger-than-life symbolic profile that may result in iconization.[4] Norman Bethune has cropped up in at least two major novels (Hugh MacLennan's *The Watch That Ends the Night* and Dennis Bock's *The Communist's Daughter*), two plays, and a film, so he may develop the status in Canada that I am describing.[5] Among women, Emily Murphy has appeared in plays and film, and Nellie McClung has had a degree of artistic afterlife, but Laura Secord notwithstanding, Susanna Moodie enjoys top iconic status as *the* prototypical pioneer, in very large part because of Margaret Atwood's *The Journals of Susanna Moodie*, for which Atwood did a set of illustrations.[6] Pauline Johnson's profile continues to blossom in new inventions (in

addition to biographies and extensive websites, a chamber opera commissioned by City Opera Vancouver, with libretto by Margaret Atwood and music by Christos Hatzis, is expected in 2010), and Anna Mae Pictou Aquash has been reinvented in contemporary plays and films.[7] Another interesting female candidate for iconic status is the northern explorer I mentioned in Chapter 1, Mina Benson Hubbard, whose process of invention I will examine shortly.[8]

Glenn Gould is another rich subject of invention: he was brilliant, eccentric, reclusive, and very private, and he died in his prime. He has already had one excellent feature film made about him, François Girard's *Thirty-Two Short Films about Glenn Gould* (1993) starring Colm Feore — which, as I mentioned in my first chapter, transformed Gould into North — several documentary films, two major biographies, a play, and a children's book.[9] Pierre Elliott Trudeau is another candidate for iconization through obsessive invention. As I write, John English is preparing Volume 2 of his monumental biography for publication, and Justin Trudeau is stepping into the political limelight to keep the Trudeau myth alive (as he did with the Talbot Papineau myth in *The Great War*). There are other biographical studies of Trudeau as well as Linda Griffiths' highly imaginative biographical play *Maggie and Pierre* and the 2002 CBC television docudrama *Trudeau* (also starring Feore). However, Trudeau has not been dead quite long enough for his voice to haunt us as Karen Connelly says our dead will do. And then, there is Maurice Richard. Here is a man whose symbolic stature and cultural capital for Quebec has only begun to be tapped by the 2005 film *The Rocket*, although his story as a hockey star is well known, and a statue of him skating can be seen in Jacques Cartier Park in Gatineau, Quebec.[10]

The art of biography is central to the process of inventing iconic figures, and biographers choose their subjects for many of the same reasons that appeal to visual and literary artists working at the more obviously

fictional end of the creative spectrum. Usually, the ideal subjects for invention are dead, and we *prefer* them, if possible, to die fairly young. Politicians and soldiers have not greatly appealed to the collective imagination, at least not so far, and I recall George Woodcock wondering why Canadians are attracted to Riel instead of Gabriel Dumont, the warrior and man of action, and musing about other common features of our icons (see Woodcock 9-11)." In life, Woodcock suggests, they were complex three-dimensional human beings and often outsiders, with a range of very human failings. They struggled against the norms of their day; they were considered mad, weird, or eccentric. And there was some element of mystery or debate about them — certainly, this last quality is a key to all four figures I examine: Louis Riel, Emily Carr, Tom Thomson, and Mina Benson Hubbard.

II From Batoche to the Manitoba Legislature: Louis Riel

I have chosen Riel as my first case study in iconization for two reasons: he has probably been more written about, contested, and artistically represented than any other figure from our history, and he was himself a poet, a very theatrical personality, and a man who appreciated the power of art. In fact, it was Riel who once prophesied that his "people would sleep for 100 years, and when they [awoke] it [would] be the artists who [would] give them back their spirit" (quoted in Mattes 21). The people he referred to were the Métis; however, with the irony or poetic justice of hindsight, he might almost be described today as speaking for all of Canada. Louis Riel is to this day the only political leader in Canada to have any real claim to the title *artist*. How could I not begin with him! But so many others precede me in this endeavour that I cannot possibly mention, let alone examine, all of them. The inventions began in 1885, the year of his

execution, with early plays in English and French, and by now more than thirty plays have been written about him (Johnson 291). Thus far, he is the only one of my icons to have had an opera composed on his life — I want to return to this work — and he has been invented and reinvented by poets, novelists, visual artists (including sculptors), filmmakers, popular singers, and inevitably by biographers. Historians have debated his legacy and his sanity, and Albert Braz has examined his broad cultural inventions in a full-length study called *The False Traitor* (2003). Over the 120 years since his death, Riel has been invented to serve many purposes, and his significance has shifted with the times. At the beginning, he was either a hero and a martyr or a villainous half-breed murderer and traitor, depending on whether you came from Quebec or Orange Ontario, were Catholic or Protestant, spoke French or English, championed freedoms and rights for Indians and Métis or had invested your money in the CPR. Although many layers of meaning have been added to the story, some of the early negative classification still sticks; some people in Saskatchewan were outraged when a public highway was named for Louis Riel because they saw him as a traitor (see Racette 46). By the 1960s and into the 1970s, Riel was being separated from his specifically Métis roots and context to be transformed into a mythic representative of the Canadian nation, most centrally a figure of western alienation who died resisting Ottawa and eastern Canadian hegemony. After the publication of his own diaries (in 1976), poetry (1985, 1993), and other writings (1985), it became possible to explore the inner man, not solely his sanity, but his whole psyche, personality, and his personal relationships, and much of the invention from the mid-seventies onward tries to present Riel as a human being in his time and place. Most recently, contemporary Métis artists have begun to reclaim him as their own and to insist that he be seen within a Métis context as just one figure from their history, albeit the most complex and charismatic.

The name Louis Riel, then, sends out a host of mixed messages, and it seems to me that the way one sees him is inevitably weighed down by politics to a degree not so apparent with Carr, Thomson, or Hubbard. One might think that his biographers would be the most neutral and even-handed, and yet biography is itself an art, and the biographer, who belongs to his or her own time and place, cannot help but read Riel in those terms and with the materials available at the time of creating the biography. Although the biographical inventions have presented the facts of his life, they have also contributed either to a less than sympathetic portrait of a half-breed, a madman, or a traitor (see Flanagan, Osler, and Stanley), or to a very sympathetic portrait of the man as a complex human being, with a noble vision for his country, who was betrayed by politicians, developers, and religious bigots. This last version of Riel is most definitely the one that Maggie Siggins gives us in her 1994 volume *Riel: A Life of Revolution*. Siggins draws extensively on Riel's poetry, letters, and diary entries and thereby allows him, to some degree, to have his own voice (see Figure 25). The result, of course, is that he comes alive in three dimensions as a real human being struggling with the dilemmas, challenges, and demons that constitute his humanity and make his death genuinely regrettable on the human level; this Riel is not an abstraction or a symbol. Nonetheless, he stands for something larger than his own individual self and family or even the Métis nation. For Siggins, Riel epitomizes what could still be good about Canada — our tolerance and ethnic/cultural diversity — because we are only now (in the 1990s when she was writing, and today) starting to recognize and value Native cultures. According to Siggins, "What makes Louis Riel so intriguing is that he managed to straddle two cultures, Native and white, and came as close as anyone to envisioning a sympathetic and equitable relationship between the two. That Canadians may someday achieve this vision," she concludes, "remains Riel's legacy" (448).

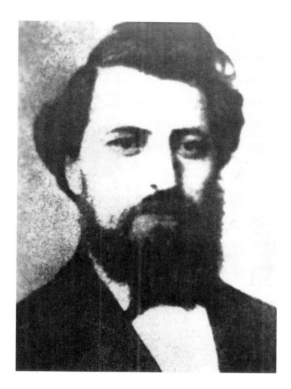

FIGURE 25 This photograph of Louis Riel, taken at the time of his August 1885 trial, is among the most familiar surviving images of the man. It has been reproduced in biographies and alluded to in artists' portrayals of Riel, thereby contributing over time to the general public recognition and iconic power of his face. This is the formally attired Louis Riel, whose sculpture (minus the full beard) now stands outside the Manitoba legislature, but the face and intense gaze reverberate in works by Marcien Lemay, John Boyle, and Jane Ash Poitras; see Figures 27, 28, and 29. Reproduced with permission, Saskatchewan Archives R-8750.

I am less certain about how to view or summarize the latest biographical invention of Riel except to say that, to my eyes at least, it is the most highly innovative treatment yet and that a younger generation appears to be hooked on the book.[12] In 2003 Chester Brown published his labour of

five years *Louis Riel: A Comic-Strip Biography* as a graphic novel. He has relied most on Siggins for his facts, and the Riel in his representation emerges less as a comic-strip hero or villain than as a human being with great gifts and fatal flaws. Without question, the villains in this version of Riel's life are Macdonald, George Stephen of the CPR, and the Thomas Scott/John Schultz contingent; Gabriel Dumont emerges as the more typical warrior hero — but that may be because, in the genre of comic strips or comic books, the pow-wham-bang exclamations suit action more than they do reflection (see Figure 26). In a recent interview, Brown noted that he was drawn to the story for its violence but that he did not want to depict Riel as either a hero (as Siggins does) or a victim.[13] He ends the story with a page illustrating Riel's hanging, but only five of the six available panels have images, and the last one is empty; my interpretation of this blank space is that Brown refuses to comment on the ultimate meaning of Riel's life or death. Unlike Siggins or the earlier biographers, he withholds his own final judgment, although he does add an epilogue and a set of notes to round off his narrative.

For me, one of the most compelling works about Riel is not biography but a novel: Rudy Wiebe's sweeping historical novel *The Scorched-Wood People*. The year 1977 seems to have been a magical point in Canadian literary culture (a bit like 1930) because it produced both this novel and so many major works that brought the Great War back to centre stage.[14] By calling his novel the "scorched-wood people" — the English translation of *bois-brûlés* — Wiebe signals his intention to tell the history of the

FIGURE 26 (FACING PAGE) Chester Brown's *Louis Riel: A Comic-Strip Biography* (2003) is possibly the most innovative treatment to date of Riel's life, trial, vision, and execution. For his representations of Riel, Brown has drawn upon surviving photographs. This page (188) is reproduced with the permission and courtesy of Chester Brown and the publisher Drawn & Quarterly. © Chester Brown, *Louis Riel* (2003).

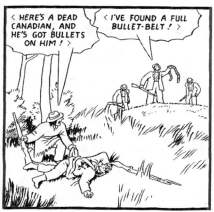

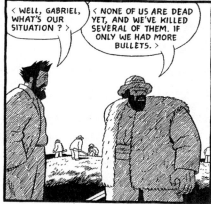

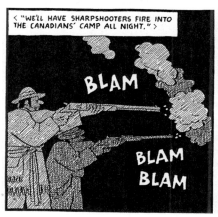

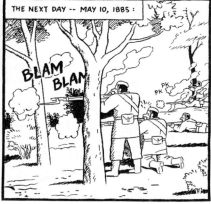

Métis, not just the story of Riel, from the perspective of the Métis themselves. His chosen narrator is the long-dead chronicler and singer of Métis history Pierre Falcon, and his use of this voice and perspective is a bold imaginative step in an era that was soon to chastise any white artist for daring to appropriate the voice or story of a non-white person. But I think Wiebe succeeds. His goal is to celebrate the Métis rebellion against an imperialist eastern or central Canadian government, and he divides his story between Riel and Dumont, even though (to my mind at least) it is Riel who occupies the novel's emotional and moral centre stage. In this novel, as in A *Discovery of Strangers*, Wiebe uses the form of the novel deliberately to create a national story that resists the Lawrentian thesis of Donald Creighton, who argued that central Canada was the heartland of the new country. Wiebe's view is closer to W.L. Morton's because he champions the West as the potential cradle of Canadian identity.[15] *Potential* — and I stress this word. In Wiebe's portrayal of Riel's story, the potential for a genuinely Canadian homeland, built upon the foundations of tolerance and ethnic diversity and recognizing Louis Riel as the founding father of Manitoba, is destroyed by the violence of Batoche and the paternalistic manipulation of Ottawa.

Wiebe is not shy about describing Batoche and what happened there, although we must remember that he is telling that story from the Métis perspective. He provides details on military organization within nineteenth-century armies and distinguishes clearly between the strategies of marching infantry in red coats and the trench warfare *(avant la lettre)* of the guerrilla troops that Dumont and Riel had mustered. He knows that the Gatling gun, precursor to twentieth-century weaponry, was first used at Batoche, and he notes the desperate need of the Métis men to protect their women and children against marauding Canadian soldiers. But perhaps most importantly, Wiebe weighs the man of thought against the man of action — Riel against Dumont — and finds both insufficient. His

final answer to this dilemma — how do you build a nation? with vision or violence? — is to give Dumont the last word. As we know, Gabriel Dumont survived Batoche, after Riel's surrender, by fleeing south and eventually joining Buffalo Bill Cody's Wild West Show in the United States. But Wiebe brings him back to life to pronounce his verdict, not on Riel or on Macdonald, but on Canada: "You think Riel is finished? He said a hundred years is just a spoke in the wheel of eternity. We'll remember. A hundred years and whites still won't know what to do with him ... There's no white country can hold a man with a vision like Riel" (351). More than 125 years have passed since Riel died, and Canadian artists are still trying to invent him and the country.

Of all the plays written about Riel, John Coulter's three attempts to dramatize the story are probably the most famous. *The Death of Louis Riel*, in two parts, premiered in Toronto in 1950 with the incomparable Mavor Moore as Riel. The third play, *The Trial of Louis Riel*, was commissioned by the Regina Chamber of Commerce in 1966 and became a regularly produced summer tourist attraction. Coulter, an Irishman who had emigrated to Canada in 1936, saw Riel as a Canadian myth and represented him as a universal figure of the hero fighting oppression — a rather Irish take on this Canadian subject (see Garay). Nevertheless, Coulter's work was theatrically sound, and his Riel has had a lasting impact on our inventions of the man and his cause. The single most important result of his Riel plays was in fact the opera based on his work, called *Louis Riel* and composed by Harry Somers as a 1967 commission by the Canadian Opera Company, with libretto by Mavor Moore and Jacques Languirand. Because this was a centennial project, the choice of Riel as its subject was a major endorsement of him as a national *Canadian* icon, and yet Moore's comments on Riel underscore the complexity of Riel's significance: he incarnates many ideas, according to Moore, from "idealist" driven mad by the hard realities of politics to a Hamlet-like thinker who is indecisive,

to the quintessential "half-breed" outsider who does not really belong in either world, to the heroic leader of his Métis people.[16] Somers' "multi-level composition" also captures the métissage of the title character by mixing folk tunes with abstract, atonal orchestration for "dramatic intensity," diatonic passages for irony or humour, and even electronically produced sounds to allow voices to surround the audience.[17] Riel's frenzied vision in the insane asylum, when he believes he is a type of the biblical David who has God's orders to lead his people, is an especially powerful musical expression of visionary madness. This episode in Riel's life is represented by most writers who take up the story, but opera is the ideal vehicle for conveying the passion and fully embodied symbolism of the moment. Here, at least in artistic invention, we can hear the voice of Louis David Riel.

Louis Riel, the opera, was very well received at its 1967 premiere and was broadcast later that year by the CBC. It was revived in 1968, televised by the CBC in 1969, and then ignored at home until January 2005 when the School of Music at McGill performed it at Salle Wilfrid Pelletier as part of its centenary celebrations (an interesting return to Quebec of this francophone icon). I have never seen it performed and must, therefore, limit my remarks, but in listening to the recording and studying the libretto, I am impressed by its highly contemporary resonance and vitality. Although I had anticipated a degree of political incorrectness in its representation of Riel, the Métis, and questions of race relations, I think the libretto is more progressive than not; three languages are required (French, English, and Cree), and Riel himself is a sympathetic figure, even though he is portrayed as every bit as stubborn as Macdonald. Moore deftly counterpoints both men's uncompromising characters by having each one say "I cannot let one foolish man stand in the way of a whole nation." Riel is speaking of Thomas Scott, the crude, violent Ontario

Orangeman who is executed by the Métis provisional government, while Macdonald is speaking of Riel. The point seems to be that both men were trapped by their times and their vision, and that the man with the greater economic and military power won the battle, if not the larger war of defining the nation. Although the libretto does not provide a final judgment on either Riel or Macdonald, the composite effect of the score, the libretto, the use of English, and the staging in the final scenes suggests there are two winners: on one side of the stage, we have Riel at his trial and execution; on the other, we have Ottawa, presided over by its canny prime minister. This sets up a number of crucial juxtapositions that, in performance, invite the audience to do the judging. Riel will appear as both sane and honourable, a prophet with a vision and a cause — human rights. Macdonald will appear to be duplicitous, vengeful, and possibly stupid (or at least short-sighted). The French language used extensively in the opera is drowned out at the end and scorned *in* English. And perhaps most disturbing, the English used by Riel when he speaks at his trial contrasts dramatically with the hysterical screaming of the English-speaking mob and with the vulgarity of John Schultz's words *snarled* (not sung) at the end: "The God damn son-of-a-bitch is dead." But of course Riel is not dead. He and his vision are still alive. This portrait of Riel may not be fully in step with the past twenty-five years of Rielisms, but grand opera is grand opera, and the political and ethical message of the work is no more dated than Wagner's *Ring* or Verdi's *Nabucco*.

Before I leave Riel and the theatre, however, there is one more play that I want to consider — Rex Deverell's *Beyond Batoche*. Unlike Coulter, Somers, Moore, and Languirand, Deverell is a Saskatchewan playwright whose play was written in 1985 to be premiered in Regina's Globe Theatre — on Batoche and Métis home ground — and the time and place matter. What Coulter could do in 1950 and the opera could do in

the late sixties as a Canadian centenary event, Deverell simply could not attempt. Too much had changed. So, in this play, the playwright character, Matt, dramatizes the struggle of the writer to invent a credible Louis Riel as a visionary and a hero — but the writer fails. In desperation he consults with a Métis woman about the current realities of Métis life, but in the final analysis, he capitulates to the producer, who demands a whitewash of Macdonald. As Matt delivers the climactic speech he has written for Macdonald, he discovers himself sympathizing with the victor, not the victim, whom he calls in this speech an "ignorant, savage, half-breed from the North West" (425). The play ends with the playwright transformed into the tour guide at the Batoche National Historic Site, where presumably he may learn more about the history he was trying to turn into theatre. The audience, however, already has Deverell's point: if we do not acknowledge the racism informing our history, we will not understand the contemporary consequences of that violent legacy, and we certainly have no right to capitalize on that history, to turn men like Riel into box-office commodities. Before Matt is defeated by his own ignorance and biases, Deverell allows him to provide one crucial insight into the whole process of inventing icons. When Yvonne, the Métis woman who is trying to teach him, asks why he wants to invent Riel, he replies, "I don't think anybody's ever gotten to the bottom of Riel's religion. He was a mystic and a prophet and a visionary — and what does it say about Canadians that our one outstanding frontier hero is this really eccentric volatile religious revolutionary? What does that say about us?" (406).

Deverell's writer/character is not able to answer this question. And perhaps this is the wrong question. Perhaps Riel's meaning lies elsewhere, and by reinventing him, we keep creating him in our own image, but this is precisely why figures such as Riel (and Carr, Thomson, and Hubbard) are so important: they do say something about being Canadian, but that

something never stays put and cannot be finalized or resolved into stable, coherent definitions.[18]

A more recent artistic attempt to make sense of Riel's inventions was the 2001 exhibition held at the Winnipeg Art Gallery, where sculptures, paintings, drawings, and multi-media works from the past thirty years were gathered for display. The show and the catalogue were called Rielisms, and much of the art exhibited was by Métis artists, but the curators did go back to John Boyle's 1974-75 Batoche Series and to the public sculptures of Riel dating from the late sixties to capture the range of meanings attributed to him. In her introduction to the catalogue, Catherine Mattes notes that Riel continues to be a controversial figure, and she reminds us (quoting Claude Rocan) that Canadians' interpretations of Riel are a "window into the Canadian psyche" (13). For Boyle, who also invented Tom Thomson in several of his works, Riel is a national symbol of Canadian history and inclusiveness, and his status as Métis serves a larger Canadian story of valour and resistance. In his Batoche—Louis David (see Figure 28), Riel unifies land and city, Indian and non-Indian, his very image combining the hybridity that Boyle celebrates. Marcien Lemay's sculpture (see Figure 27), created in 1968 for the grounds of the Manitoba legislature, became such a focus of outrage and debate that it was removed by the 1990s, and a much more heroic sculpture was erected in its place. Lemay's expressionist interpretation of Riel as a tormented individual stripped down to his essentials offended the Métis, and there is small doubt that it does not present Riel as heroic or as a leader. The statue that now stands in its place, by Miguel Joyal, shows a dignified, classic representation of Riel as a statesman holding the Manitoba Bill of Rights. This rendition may not be as interesting as sculpture, but it is certainly a more noble depiction of Riel. Considered together, the two works seem to defy the expectation that they represent the same man, and yet they do: Lemay's Riel is the private, inner man; it

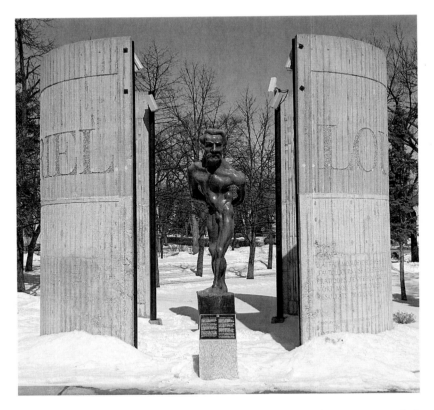

FIGURE 27 Marcien Lemay, *Louis Riel* (1968). Lemay's sculpture was unveiled in 1971, but after considerable debate and controversy over its depiction of an important figure such as Riel, it was moved from the legislative grounds to those of the Collège Universitaire de St. Boniface in 1995. Reproduced courtesy of the college.

is his soul we see. Joyal's is the public man, a politician, a universally recognizable figure of authority.[19]

My last image of Riel is from a work by Cree/Chipewyan artist Jane Ash Poitras for whom Riel "is a shamanic hero who died at the hands of an unjust, colonizing government" (20). This large collage and mixed-media work (see Figure 29), called *Riel Reality* (2000), is typical of Poitras' style. The style and mixed media seem entirely appropriate for her

FIGURE 28 John Boyle, *Batoche–Louis David* (1975), acrylic on masonite and wood, 91.4 x 121.9 cm. The face of Riel in this painting is based on a photograph taken when he was a teenager, but the intense gaze evokes the more familiar photograph and hence the end of Riel's story (see Figure 25). Photograph by Morton Perlman. Reproduced with the permission of the artist and the Canadian Artists' Representation Copyright Collective. © John Boyle.

FIGURE 29 Jane Ash Poitras, *Riel Reality* (2000), mixed media on canvas, 122 x 173 cm. Poitras has created many powerful collage narratives of First Nations life and history in which she juxtaposes images of Native culture, spirituality, and pride with images of white repression and persecution and the trauma caused by such treatment. This piece appeared in the Winnipeg Art Gallery exhibition and catalogue called Rielisms. It is reproduced with the permission of the artist. © Jane Ash Poitras.

invention of Riel as one man among many, all figured within a landscape that is both real (recognizably a prairie landscape) and symbolic, belonging to the past and yet haunting the present. Her use of archival photographs emphasizes, for me, the sense of haunting and inhabiting that her works always create, so that the closer you look, the more you see, the more there is to see in her landscape/portraits. But what Poitras does so eloquently with canvas and photography, Sherry Farrell Racette does with words in the essay that closes *Rielisms*. Her title really says it all: "Metis Man or Canadian Icon: Who Owns Louis Riel?" Racette, who is Métis, summarizes the various roles that Riel has been asked to play at different points in Canadian history and then isolates what, for me, is the key to Riel, something that is usually avoided or elided: he was biracial and his biracial identity was the source of his stigma in the past, of his taboo quality and aura of mystery from roughly 1967 to the mid-nineties, and the sign of his current power for the Métis, who are proud of their mixed-race identity. In Racette's words, "This image of Riel as the conflicted embodiment of the savage and the civilized has echoed throughout the telling of Canada's history" (47). If I were to write that fourth chapter I mentioned in my introduction — the one about contemporary Canada's multiracial, multicultural identity — I would do well to begin with Louis Riel as an example of what Michelle La Flamme might call the "soma text" of being Canadian.[20]

III ON BEING A *FEMALE* CANADIAN: EMILY CARR

Fewer plays have been written about Emily Carr than about Riel, and thus far there is no opera, but then, she has not been dead as long as he has, and artists need time to create their inventions.[21] Nonetheless, a lot of invention has been going on, and Carr was the first to invent herself in her autobiographies — *The Book of Small, The House of All Sorts, Klee*

Wyck — and her journals. As a consequence of this self-invention and Carr's jealous protection of her life story, no subsequent Carr inventor can ignore what she had to say about herself. To date, there have been several biographies (some highly autobiographical), art history books, catalogues, and major critical studies, at least two volumes of poetry, six plays, documentary films, a comic-strip response to her work, several children's books, some unusual music, at least two portraits by other painters (John Boyle and Gordon Rayner), two sculptures by Joe Fafard (see Figure 30), and a host of tourist trinkets and pop culture artifacts — cards, placemats — and, of course, the Carr House in Victoria.[22] By the standard of my key criterion — a critical mass of artistic invention — Emily Carr is a Canadian icon, as the title of the 2006 exhibition catalogue confirms: *Emily Carr: New Perspectives on a Canadian Icon*. What especially complicates her iconicity, however, is her gender. In her own way, and within the context of a rigidly masculinist society, Emily Carr was as much of a revolutionary as Riel, perhaps more so, and all her inventions bear the marks of gender inflection and accommodation — ours to her and hers to her sexist era.

I cannot examine all the work of inventing Emily Carr because that would require a separate book, like my study of Thomson or Braz's of Riel, but three examples of this inventing process — a volume of poetry, a play, and a musical suite — will give a fairly clear idea of what has been happening with the figure of Carr in recent years. All three works are by female artists, as is most of the iconization of Carr, and I believe that Carr's image has been invented to represent a specifically female vision of Canada, of life more generally, and of human creativity. Rather than viewing this gendered construction of Carr as a limitation, I see it as a strength, but in terms of being Canadian, Carr's qualities are more abstract and more universalized, perhaps, than either Riel's or Thomson's. The poetry

I will examine is Kate Braid's marvellous volume *To This Cedar Fountain*. The play is Joy Coghill's *Song of This Place*, and the musical suite is Veda Hille's *Here Is a Picture (Songs for E. Carr)*. In these works, as in all the others, Carr appears as a charming, if eccentric, lady who loved animals and trees, as a challenging artist in touch with forces that could empower and destroy, and as a lonely, isolated person, ostracized by society as a spinster and marginalized by the art establishment as *female*. The real challenge seems to be how does one invent Emily Carr as an artist, quite apart from her private life, and as worthy of respect *as an artist*?

In *To This Cedar Fountain*, poet Kate Braid has created her personal response, as a woman and an artist, to Carr's life and work, both her painting and her writing. This volume of poetry is constructed as a form of dialogue but a dialogue that takes place on many levels and is replicated visually by the layout of the book. The visual dialogue is most interactive (and seductive) when a Carr painting is reproduced on the left page facing a poem, as it is with the poem "Deep Woods," which sits on the right-hand page opposite the painting *Deep Woods* (1938-39). In this medium-sized picture (61.0 by 91.3 centimetres, oil on card), Carr presents us with a close-up image of dense green swirling forest and a foreground sweep of browns flowing into the picture plane, drawing the eye into the depths of the painting and the woods, where browns give way to light green ground cover, until the eye rests on a tiny spot of pinky-beige that lies almost at mid-centre of the canvas. *Deep Woods* pulls the viewer into the image and the forest, beckoning us to enter and look for the source of that small patch of glowing colour at the heart of the imagined scene. Because of the book's layout, the reader is invited to read back and forth across the pages, to think about the painting, to read Carr's own comments, quoted above the piece, and then to consider Braid's reflections on the painting, beginning with the palette:

Uncharacteristic of her to use
pink at the heart
of a picture

as if she cannot control herself
as if her flesh, her blood
race to the centre

as if her cheeks are painted
with the wild-and-unruly of it.
Trees rush

to a paradise of pink
glory. Little ones at the edge
swept to the centre

seek the half dark path
that leads to such life
at her throbbing pink heart. (43)

"Glory" is the word that echoes across the page, linking the two voices, pointing us toward what each artist sees and feels. However, Braid's *reading* of the painting opens up new worlds of meaning in the image, which are specifically female meanings for a painter whose work has often been described as phallic. To a degree, Braid has made speakable some of the things that Carr calls "unspeakable"; she has found words to express the "longings" (Carr's word) that Carr paints and possibly ones Carr has not consciously dared to paint. But then, that is the nature of a dialogue: it has voices in communion, moving through a process, giving and taking, sharing views, disagreeing, negotiating new perspectives, revealing sudden truths.

FIGURE 30 Joe Fafard, *Emily Carr and Friends* (2005), edition of seven,
bronze and patina, 167 x 126 x 87 cm. The sculpture of Carr by one of Canada's
pre-eminent senior artists stands on Granville Street in Vancouver, outside Heffel
Gallery, with other sculptures in the series installed on streets in Toronto and
Montreal. Fafard's smaller 2003 bronze *Emily Carr* shows Carr on horseback,
but I find this large piece especially important because it is a public work and
because it includes, in addition to a horse (one of Fafard's signature animals),
one of Carr's dogs and her pet monkey Woo. Here one great artist celebrates
another in and through their shared love for animals. The image is reproduced
with permission and courtesy of the artist. © Joe Fafard.

FIGURE 31 Emily Carr, *Self-Portrait* (1938-39), oil on wove paper, mounted on plywood, 85.5 x 57.7 cm. This rare self-portrait is a remarkable image of a fiercely independent artist, who seems to challenge her viewers with her direct stare. Returning this stare helps me understand how poet Kate Braid could imagine the artist addressing her in "AFTERWORD: SELF-PORTRAIT." Collection of the National Gallery of Canada, Ottawa, #30755; gift of Peter Bronfman, 1990. Photograph © National Gallery of Canada.

Throughout this volume, moving in tandem with the dialogue, is an autobiographical/biographical narrative. Carr's life is there in miniature, from an early lament at not fitting in anywhere to her growing acceptance of her own eccentricity to her ultimate celebration of nature and art, both of which Braid sees as profoundly female and sexualized or corporeal. This move from lament to acceptance to celebration is matched by the poet's responses, as Braid herself confesses — "Emily, you! Old and fat and dare to flaunt / such spirit. Is this why Lawren Harris / encouraged you from a distance?" (18) — only to admit later that Emily is her director and guide: "She plays games with me now. Emily as playwright ... / she said to keep my eyes shut tight, listen for the messenger / to lift the curtain on the bigger picture" (69). These elements of dialogue and autobiography/biography fuse in several of the major poems in the volume, such as "Rushing Undergrowth," a formal "glosa" that takes Carr's words and responds to and re-sites them within Braid's vision of Carr working alone in the forest. The poem thus becomes a portrait of Carr that, like the finest portraiture, tells us much about the poet/biographer/creator as well as about her subject.

One more example of the way in which layers of dialogue produce the biographical *and* the autobiographical text of Carr/Braid is "AFTERWORD: SELF-PORTRAIT," the last poem in the volume. This needs to be read with Carr's *Self-Portrait* (which is not reproduced anywhere in the volume) in mind (see Figure 31). Braid's subtitle, "After a Demonstration for Women in Trades on Parliament Hill, Ottawa," sets the stage: she is in the country's capitol and able to make a visit to the National Art Gallery, which offers a quiet sanctuary from the noisy demonstration in the streets. Braid finds herself alone before Carr's *Self-Portrait*, staring at her eyes, when suddenly the woman in the painting seems to speak:

It wasn't easy, a woman's voice whispers.

I check the door. There is no one there.

You thought it was easy?

The voice insistent now,

a flatness to everything she says.

It was hard to believe in myself

and the critics didn't help me, either. (91)

Just as the viewer is drawn into *Deep Woods*, so Braid finds herself drawn into a conversation with Emily Carr, her inspiration, her solace, and now her confidant. Braid begins to tell Carr what is happening today, out there, to women who long to take their rightful place in the workplace (the trades, the arts, the government), but Carr interrupts her: "*I know*, she says," because for Carr "*every walk / down Government Street was a protest*" (92). And then Carr asks Braid an astonishing question: "*I did OK?*" to which Braid replies, "*You did great ... You still are*" (92). But while the surprise of such a question hovers in the air between poet and painter, between poem and reader, and certainly resonates in my reader's mind (how could one of the twentieth-century's great artists doubt herself and still need affirmation, but of course, Carr must have doubted and needed — often), the poem continues. The moment of connection is slipping away; Emily Carr is retreating into her painted silence; another gallery patron is approaching, and it is today's woman artist, Kate Braid, who needs support: "*Come back*, I say. / *I never left*, she replies" (92).

Hanging in the National Gallery of Canada, Emily Carr — or at least her self-portrait — is assured of her canonical place in our art history. Through this poem and her conversation with the painting, Braid pays homage to a female mentor who travelled some of the same hard roads that Braid herself must travel, but through this very powerful and personal

link, something more is happening. Braid is, I think, elevating Carr to iconic status as inspiring role model for female success as an artist, as a human being, and as a Canadian. That this role model is emphatically Canadian surfaces everywhere in the paintings and poems — in west coast landscapes, flora and fauna, colours, the vision of nature, a merging of self in other and in geography — but it is apparent here, in this final poem, in the mixture of pride and self-deprecation captured by that small question "*I did OK?*" and in both artists' visceral connection with nature, "the smell in the air of pines" (92).

Joy Coghill's *Song of This Place* presents another female artist struggling to invoke and retell Carr's story, and again, in the process of doing so, the artist, this time an actor and playwright, tells her own story. Joy Coghill has explained a great deal about why she wanted to write this play and what kind of a struggle it was: by the early 1980s, she had reached a stage in her career when she wanted a big role for an older woman and an older woman *artist*. To make matters worse, she was "haunted ... by the ghost of Emily Carr" (ix), and no other Canadian writer wanted to tackle the subject: Millie Carr had acquired a reputation — difficult! But Coghill persevered and *Song of This Place*, in my view the best play on Carr to date, premiered at the Vancouver East Cultural Centre in September 1987 with Coghill in the role of Frieda (see Figure 32), the actor/playwright who is creating the role of Emily Carr. The play received an excellent new production in February 2004 at the Frederick Wood Theatre, but Coghill did not perform in it as planned (this time she had hoped to take the role of the interfering ghostly "Millie," who tries to thwart Frieda).

I have discussed the play at length elsewhere (Grace, "From Emily Carr to Joy Coghill"), so I will stress only a few general points about this invention of Emily Carr. First and foremost, this is an artist's play: Coghill does not flinch from presenting various facts of Carr's life, but that is not

FIGURE 32 Joy Coghill, one of Canada's greatest actors, wrote her play
Song of This Place herself when no professional writer would tackle the subject.
"I suffered agonies wrestling with the spirit of Emily Carr," Coghill recalls (IX).
Coghill starred as Frieda, the actor who wants to *perform* Carr, in the 1987
premiere of the play, and, as this production photograph shows, her ability to
capture Carr was both remarkable and haunting. The photograph of Coghill-
as-Carr is reproduced with the "permission and blessing" of Joy Coghill.
Photograph by David Cooper.

the main point of the play. *Song of This Place* is about making art and mak-
ing theatre. More specifically, it explores the challenges to making *Can-
adian* art, to making Canadian theatre, to making art in Canada, and to
being a Canadian woman artist in an era when both fields were dominated

by men. Coghill's own early experiences are alluded to in the play through the life of Frieda, but Carr's story, which Frieda must absorb so completely that she can perform Carr, is really the central focus of the play. Finally, and only after great effort, Frieda (Coghill) brings Carr to life, uncannily, as only theatre can, *in the flesh, embodied, really there before and for us,* in the present, now, today. She makes the dead speak — those wise dead whom poet Karen Connelly invokes — and by so doing, she makes Carr, in a sense, immortal and *iconizes* her. She does with Carr what Braid did — gives her a present voice — but she also does what Margaret Atwood did with Susanna Moodie: she brings her back to life to warn and advise and inspire us. At the close of *The Journals of Susanna Moodie,* Atwood has her Moodie tell us that, in the end, "we will all be trees" (59), and Carr's trees are, as Coghill has Frieda/Millie insist, her portraits.[23] Is it just too quirky or fanciful to suggest that Canadians see themselves in, or *as,* trees? That the art of being Canadian turns us into trees? Perhaps. But I relish that weird notion and will return to it with Tom Thomson.

My last Emily Carr invention is Veda Hille's extraordinary song cycle *Here Is a Picture.* In February 2004, at the Theatre and AutoBiography Workshop held at UBC, Hille performed some of these pieces for participants in what was *the* galvanizing moment of the entire event. For a few minutes, a live human voice embodied Emily Carr, and what Coghill calls "the space between" (between the performer and her audience) was full of intense life and meaning (x). The seventeen songs in the suite present an *auto*biography of Carr from her birth, through her career, to her death. Key moments in Carr's life story become musical scenes in the sequence, as the titles indicate — "Small," "Brutal Telling," "Boat Ride to Skidegate," and so forth — and favourite characters appear: Woo, the monkey, for example, and friend and editor Ira Dilworth. Most of the compositions have lyrics, and Hille draws on Carr's own words for the songs, but she

uses the first person when she sings them, and this, in itself, doubles the signature on the music. When we listen, we listen to Veda Hille *and* Emily Carr, to Hille *as* Carr. In one especially powerful piece, called "Meeting the Group of 7," we hear about Carr's famous encounter with members of the Group, when the encouragement she received from Lawren Harris led to possibly the greatest turning point in her life. After years of being ignored by the Canadian art world, marginalized by gender and physical location in Victoria, and living in extreme poverty, Carr had almost abandoned painting to make enough money to live. Then came the breakthrough, the sudden revelation, and recognition:

> What have I seen?
> Where have I been?
> Something is calling, something is trying —
> "You're one of us," was his reply.
> ...
> Jackson, Johnston, Lismer, MacDonald, Varley, Carmichael,
> Harris
> Harris, Harris, Harris.

Here Hille captures the private and public Carr and her vision of Carr-as-artist. However, the precious words of endorsement and inclusion — "You're one of us," which Harris wrote in a letter to Carr — resonate beyond that historical documentary source when they are sung before a live audience by a young woman artist. *Hille's* "You're one of us" includes Canadian art history and, by extension, all Canadian artists, but if one does not know the specific biographical source of the words, they carry still more possibilities for inclusion because "us" slides free of its historical reference to the 1930s art world to embrace all of us. Moreover, when these words are sung, they seem personally, intimately addressed to each

listener. The closing incantation of the names — like totems, like ances-
tors — performs a subtle metonymic and mesmerizing ritual that be-
comes *through its repetition* a legacy, a tradition. And, of course, I stress
this song because it points me onward to a name implied but not spoken
(Tom Thomson) while recalling one of my own starting points from
Chapter 1: Harris, Harris, Harris.

IV Northern Parsifal; Legendary Woodsman; *Natural* Artist: Tom Thomson

The facts of Tom Thomson's life are familiar and undistinguished. It is
his death and his art, in that order, that account for all the fuss. As Robert
Stacey has said, "Had he not existed, he would have had to be invented"
(63). And he has been invented, obsessively, almost from the moment of
his death and right up to the present. But why has he been so invented
and to what end? We actually know relatively little about him; unlike Riel
or Carr, or even Hubbard, he did not leave volumes of written evidence
behind him, and there is only one really significant self-portrait, a water-
colour painted in 1902 (see Figure 33). He was born in 1877 and died in
1917 — in his prime. He was born into a large, comfortable middle-class
family in Ontario, the sixth of ten children, and grew up on Rose Hill
Farm at Leith, near Owen Sound. He loved fishing and the outdoors, with
which he would always be closely associated; he did not have much post-
secondary education, and his formal art training was slight. He worked in
photo-engraving and commercial design in Seattle for a few years before
moving to Toronto in 1904, and in 1908 he joined Grip Limited, where he
met the men who would mentor and encourage him, who would form
the Group of Seven after the Great War, and who would be the champions
and guardians of his posthumous reputation — J.E.H. MacDonald, Arthur
Lismer, A.Y. Jackson, and Lawren Harris. Art historians and biographers

agree that he only began to paint seriously in about 1912, when he first visited Algonquin Park, either alone or in the company of his painter friends. When he died in July 1917, just before his fortieth birthday, he had been *a painter* for five years. And it was during those five years that he created the works for which he is now so famous, *paintings of trees* that have themselves become Canadian icons (see Figure 34): *The Jack Pine, The West Wind,* and *Northern River.* But it is Thomson's death that has made all the difference.

On that overcast July day in 1917, when Thomson set out in his canoe on Algonquin Park's Canoe Lake, he was only going fishing. But he did not return. His overturned canoe was found the next day and his body a week later, floating in shallow water, bloated and decomposing; he had a four-inch bruise on the side of his head and fishing line wound around one ankle. The official verdict was that he had drowned — this man who was touted as an expert canoeist and fisherman — but many people then and since have rejected the idea. Some were certain he was murdered; others suspected suicide. An accident in shallow water by such a man seemed improbable. Rumours began to circulate almost immediately. Because a coroner could not arrive quickly to do an autopsy, the exigencies of heat and decay necessitated his immediate burial in the tiny Canoe Lake cemetery. As a consequence, no thorough forensic report on the cause of death was ever filed, and he is described on the death certificate as having drowned. But that is only the beginning of the story.

Two aspects of Thomson's death were going to generate constant speculation: one of these was the cause of his death; the other was the whereabouts of his corpse. Two days after the burial in the cemetery at Canoe Lake, the Thomson family had his body disinterred and sent by train to Owen Sound for reburial in the small church cemetery near Leith where other family members would eventually lie. However, not

FIGURE 34 Tom Thomson, *The Jack Pine* (c. 1916-17), oil on canvas, 127.9 x 139.8 cm. Thomson's *Jack Pine* has become one of the most familiar and loved of Canadian paintings. Reproduced on tea towels, T-shirts, jewellery, and coffee mugs, the image is often read as a metaphor for Canada itself and as a symbol of the artist. Collection of the National Art Gallery of Canada, Ottawa, #1519. Photograph © National Gallery of Canada.

everyone believed that the body was in that casket. Many would remain convinced that Tom Thomson was still at Canoe Lake — in body as well as spirit! Indeed, in 1956 William Little excavated the grave at Canoe Lake and sent the skull he found there to Toronto for forensic analysis; he was positive he had found Thomson, and he wrote a book about his exhumation and theories so he could refute the experts who contradicted his conclusions.[24] As the rumours circulated about Thomson's death, the theories about what really happened started to gel: some thought it was surely suicide because Thomson felt he was being forced to marry a local woman, Winnifred Trainor, who may have been pregnant, and whom he did not want to marry. But no, he was not the type for suicide, even if he was depressed about the war — and there is reason to believe he was — or about his impending marriage. Others were certain that he had been murdered — by a German American tourist called Martin Bletcher Jr., with whom he had quarrelled, either about the war or about a woman, or by Shannon Fraser, a local Canoe Lake man who owned the lodge where Thomson stayed and with whom he had had a drunken fight the evening before he set off in his canoe. Or maybe a poacher did him in, or maybe Winnifred's father, or maybe —.

His fellow painters hurried to bring a decorous close to their grief and to the rumours clouding Thomson's reputation. Jackson had enlisted and was in Europe when he received the news. And he was devastated — the north country, he said, would never be the same without Tom — so it was MacDonald who organized the cairn, with its description of Thomson as "Artist, Woodsman, and Guide," to be erected at Hayhurst Point at Canoe Lake in his memory. With these words, still used repeatedly to celebrate Thomson, the legend, or the invention, as I call it, was under way. What the cairn asserts is that the body is *not* at Canoe Lake, but it is vague about how he died — it assures us that nature "took him to itself at last." Since

that moment, competing versions of the Tom Thomson story have been created in films, plays, novels, poems, short stories, biographies, exhibitions, paintings and sculptures by other artists, dioramas in Algonquin Park, songs, websites, billboards, trinkets, and T-shirts. One of the latest inventions is a party game called *The Tom Thomson Murder Mystery*. This charade-style game comes in a box with a reproduction of *The Jack Pine* on its cover, but it has nothing much to do with his art. Instead, we are invited to find out "Who killed him?" "Why?" and "How?" so we can "Solve one of Canada's most enduring mysteries." Inside the box are cards identifying all the suspects, a summary of events to guide the players, and a 2003 book *Tom Thomson: The Life and Mysterious Death of the Famous Canadian Painter*, by Jim Poling. Poling reviews the story, the facts, and the possible motivations for someone who wanted to kill Thomson; thus, his narrative makes a good companion piece to the game. My attention was snagged by Poling's emphasis on the context of the First World War and on Thomson's sensitivities and possible arguments with people concerning the Great War and Canada's role in it as potential clues to who might have done him in, why, and how.[25]

In *Inventing Tom Thomson*, I examined as many of these accounts and representations of him as possible, and in the introduction to the present discussion, I commented briefly on Joyce Wieland's 1976 film *The Far Shore* (8). Although I will not consider the film again, in my view it is one of the most interesting re-creations of Tom Thomson. Wieland's allegory of Canada, embodied in the figure of the artist as an anglophone northern landscape painter in love with a francophone musician, both of whom are destroyed by exploitative greed, verges on the elegiac and certainly reinforces the iconicity of Thomson as representative of the North (even if only as far north as Algonquin Park), of artistic vision in tune with nature, and of the best possible *unified* future for the country. Here I

focus on two examples of the voluminous Thomson-inventing — a novel and an installation piece — because these two works represent contrasting approaches to the story (approaches that are combined in Wieland's film) and convey a lot about what Thomson has come to mean for Canadians. The novel is *Canoe Lake* (first published in 1980 as *Shorelines*) by Roy MacGregor, and the installation piece, called *First Snow*, is by Panya Clark Espinal. It sat for several years in the Tom Thomson shack on the grounds of the McMichael in Kleinburg, north of Toronto.

Roy MacGregor was born in Huntsville, which lies just south of Algonquin Park, and his brother married Winnifred Trainor's sister; therefore, he knows the landscape, the people, the stories, and the rumours from the inside. *Canoe Lake* picks up the story of Tom Thomson many years after his death, but then goes back in time to determine whether the mystery of how and why he died can be unravelled. At the centre of this version of the account are two women: the Winnie character, called Jenny Turner, who now lives a reclusive life in her Huntsville home (as indeed did Winnie Trainor); and a young woman named Eleanor Philpott, who was adopted as a baby and is now looking for her birth parents. Her search leads her to the fictional town of Vernon (closely based on Huntsville), where she becomes convinced that Miss Turner is her mother and that Tom Thomson was her father. Through his character Eleanor, who uncovers one clue after another, MacGregor retells all the known facts about Thomson's life in the area and re-creates a picture of Winnie/Jenny — how she loved Tom, how they were to be married, and how she has mourned him since his death. But MacGregor goes further: he makes it clear that Jenny was pregnant at the time of Tom's death, that she went to the United States to have the baby and gave it up for adoption, and that there was another man, a Huntsville local, who was so deeply in love with Jenny and so jealous of Tom Thomson that — well, but then MacGregor

pauses. This man, Russell Pemberton, is now very old, but he has devoted his life to protecting Jenny from gossip and pain. When the nosey Eleanor arrives to disturb the peace, the old man decides to put an end to the snooping. He promises to take her in a boat to the exact spot on the lake where Thomson's body was found, but he actually intends to drown her right there. His plan backfires, however, and it is he who drowns; Eleanor survives, but as she struggles in the water, she imagines how her father was struck on the head and fell into the water and died. Although Mac-Gregor allows his fictional Tom Thomson daughter to reclaim, in imagination, her father, he is much more equivocal about Eleanor's mother. Eleanor will have one face-to-face encounter with the old lady, but Jenny Turner will deny her, leaving Eleanor rejected and yet certain in her heart that this woman is her mother. MacGregor ends his fiction — and he is at pains to insist that none of his characters ever existed — with Miss Turner dying and taking her secrets to her grave but with Eleanor calling herself Eleanor *Thomson*.

Canoe Lake is a murder mystery of sorts and a very good read. Part of its contribution to the invention of Tom Thomson is to flesh out a private, personal, and sexual life (as does *The Far Shore*) for a man whose life seemed devoid of such things. Unlike Wieland, however, MacGregor is not greatly interested in the paintings or in Thomson's artistic legacy. He is fascinated by the death itself and by the trauma surrounding it. In that crucial scene of discovery and recovery, as Eleanor struggles to save herself from drowning and imagines her father's last moments, MacGregor has tapped into the mythic subsoil of the Thomson story — mystery, vision, death in or by water — that keeps the story alive and shows no signs of sinking back into the sediment of Canoe Lake or Canadian memory. By giving Thomson a child, MacGregor grants him a new kind of posthumous life, *and* he renders Canoe Lake an almost supernatural lieu de mémoire.[26] MacGregor's Tom Thomson belongs to Canoe Lake,

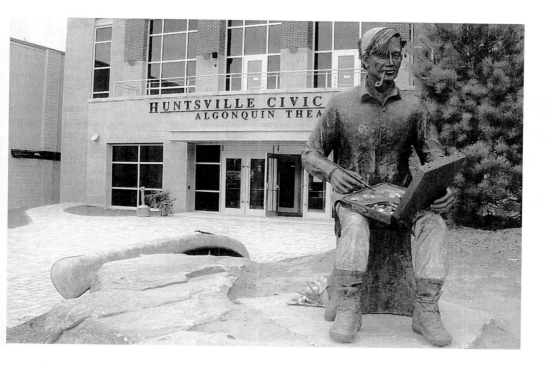

FIGURE 35 This charming life-size bronze-on-stone public sculpture/
installation outside the Huntsville Civic Centre on the town's main street was
created by Brenda Wainman-Goulet in 2005. The piece is called simply *Tom
Thomson*, and the board on which Thomson works is a sketch for *The West Wind*
(1916), now in the Art Gallery of Ontario. The photograph is reproduced with
permission and courtesy of the artist. © Brenda Wainman-Goulet.

to Algonquin Park, to the history of Huntsville and environs, real places
rendered more than real by his conjured, ghostly presence. This Tom
Thomson is one of the most endurable inventions we have, and Hunts-
ville has consolidated its own position in the Thomson story by com-
missioning a large sculptural installation by Brenda Wainman-Goulet,
showing Thomson seated with his painting box and canoe on the main
street of town where every tourist and passerby must see it (see Figure 35).

The other powerful invention is Thomson's iconic significance as an artist, and that is where I find Panya Clark Espinal's *First Snow* so important. This installation piece was created in 1998 at the same time as her larger installation *The Silence and the Storm*, which sat in one of the gallery's exhibition rooms, the former living room of the McMichaels, where it filled the space with pots of narcissus and replications of Thomson works from Harold Town and David Silcox's 1977 book *Tom Thomson: The Silence and the Storm*.[27] Clark Espinal's *The Silence and the Storm* was taken down after its exhibition, so it can now be recalled only through photographs and descriptions. However, *First Snow* remained in place for about five more years, and its site is one of the most symbolic (along with Canoe Lake) of Thomson locales. It is Tom Thomson's shack, which was moved from Toronto to the grounds of the McMichael to preserve it as a virtual sanctuary dedicated to his memory. Before *First Snow* was removed, one could go to the window of the shack — as I did — and peer inside (see Figure 36). What one could see through the dusty filtered light was an easel with a familiar canvas — *Northern River* — and around that a few bits of furniture and a man's personal belongings, but the man was not there. The room and everything in it were covered in what appeared to be a layer of snow. The room, however, was not empty. In its silence one could almost hear it humming with energy, and the more one strained to see, to pay attention, to hear, the more one's imagination filled in the silence with a storm of memory. But let me change my pronouns, in case you have not yet made this pilgrimage to the shack: *I* filled in the silence because I know the painting. It is a Tom Thomson painting, one of *my* favourites, and it represents a north-country scene of trees and water that I remember from my childhood. In this totally artificial reconstructed spot, with its site-specific installation that was not, after all, really the Thomson painting (it is safe from snow in the National Gallery of Canada), I was in touch again with the landscapes of my youth as created by

FIGURE 36 Panya Clark Espinal, *First Snow* (1998). This site-specific installation for the Tom Thomson shack on the grounds of the McMichael Canadian Art Collection is my favourite invention of Thomson, and I discuss it (and other Thomson-related works by Clark Espinal) in *Inventing Tom Thomson* (165-66). The photograph of the installation, showing a reproduction of Thomson's *Northern River* (c. 1914-15) on his abandoned easel, is reproduced with permission and courtesy of the artist. © Panya Clark Espinal.

one of my country's greatest artists, who taught me how to see my home ground. In this lieu de mémoire, Panya Clark Espinal was telling me that, even if Tom Thomson had vanished, I could continue to see what he had left behind.

Now, this is all rather spooky, if not downright nostalgic nonsense. If I am not careful, I will end up just like that naive Canuck in Charles Pachter's *Mistook North* (Figure 3), mistaking Clark Espinal's invention for the real thing and mistaking both artifacts for an actual Canadian landscape. And yet, the odd thing about this installation piece was that it worked on so many levels to consolidate the iconization of Thomson through his *art* — instead of through his life and death. This painting, in

this site, haunts the memory; it turns Canadians who saw it into voyeurs gazing at a part of the national story; and by making us look and look again, it constructs us as participants in the process of inventing, not just Tom Thomson, but a whole landscape and a story within Canadian history. *First Snow* tells us, through its artistic re-creation of Thomson traces, something beyond words about the art of being Canadian.

Over the past ninety years, Tom Thomson has been made into a vehicle for a number of Canadian fantasies, desires, and memories. Chief among these is his equation with a pristine northern wilderness that is both desired and feared by most Canadians. This idea of North as true, strong, and free defines us, as I argued in my first chapter, and it carries a number of secondary features that have come to be viewed as quintessentially Canadian and that were identified with Thomson right from the start: a cult of outdoors masculinity, of fishing, camping, canoeing, and roughing it in the bush, and the mystique of simple, even innocent, peaceable non-ostentatious manliness and concern for nature. To a degree, as his biographer Joan Murray suggests, Thomson's trees might almost be seen as his self-portraits (see *Tom Thomson: Trees* 16). Thomson has been invented as a kind of martyr to the wild and as a type of Parsifal with deep spiritual purity. This stress on the nexus of nature and spirituality links him in fact with both Riel and Carr. He has also been invented as a natural-born painter, a self-made genius, free of doctrines and schools and the influence of formal training. And from there, it has been a short step to elevate him to our first native-born modernist and prototypical abstractionist. Just because none of this rhetoric about wilderness or untutored genius or abstraction is supported by facts makes little impact on the power of the inventions.

What *is* borne out by the facts is that he died young and under mysterious circumstances. This death is what has contributed most to his iconization because through his death it is possible to mourn a range of losses

— to the nation (like Talbot Papineau) in the Great War, to Canadian art history and national achievement, and to *dreams* of northern wilderness, which are constantly threatened by development, pollution, and climate change. Indeed, Thomson continues to serve us very well in death, as a new interactive website titled Great Unsolved Mysteries in Canadian History makes clear in its webpage "Death on a Painted Lake: The Tom Thomson Tragedy." Dead, he served as an idol for Jackson and the others as they marketed a new Canadian art after the war; dead, he has not been able to disappoint us by failing; dead and silent, he has left us a lot of room to imagine him and, through him, the country. Dead, he has become Canada's most seductive ghost. It is even said that, if you canoe at night on Canoe Lake, you may see him — a lone man wearing a yellowish jacket in a dove-grey canoe who will greet you and then vanish! By repressing or ignoring many of the facts of Thomson's life, we can regularly resurrect him to tell us, in Karen Connelly's words, "How to live / well or badly."

V ON BEING A FEMALE CANADIAN EXPLORER: MINA BENSON HUBBARD

On 27 August 1905, Mina Benson Hubbard recorded in her expedition diary that her "work was done" ("Labrador Expedition Diary" 272). But she had not quite accomplished everything she wanted to do, and her 1905 expedition across Labrador, although successfully completed, would never leave her mind; it had changed her, made her over from a genteel wife and widow into an explorer and an author. Mina Benson was born in the Rice Lake area of Ontario in 1870, and she grew up familiar with the outdoors and eager to do something interesting with her life. As was true for Carr, however, opportunities for a white middle-class woman of the period were limited, but she decided to study nursing in New York. This

step led to Labrador and all that followed because it was in New York that she met and married Leonidas Hubbard Jr., who starved to death in his failed attempt to cross Labrador in 1903. A year later, although still grieving deeply, Mina decided to mount the second Hubbard expedition, hired the Cree Scots guide George Elson, who had been with her husband in 1903, and made meticulous plans for canoes, provisions, and equipment. With three experienced Native men and Elson, she left the tiny fur-trading post of North West River, Labrador, in June 1905 to make the six-hundred-mile trip through the interior and north to the George River Hudson's Bay Company post on Ungava Bay. Approximately eight weeks later, when the expedition was successfully completed and while she waited at the post for the supply ship that would take her back to civilization, she began thinking about her book *A Woman's Way through Unknown Labrador*. As she confided to her diary on 31 August 1905, "Writing to-day. Slow. Hard to decide what to write about ... Wish I knew a bit better what public is interested in."

But if Mina was unsure about what the public of her day wanted, since then the public has had no trouble finding interest in her. The fact that this well-educated, white, middle-class, very attractive single woman of thirty-five set out alone, with four non-white men, on a journey that would take her far away from all the watchful eyes, constraints, prejudices, and taboos of her society has caused no end of speculation, debate, and adulation. In one photograph, reproduced in her book and probably taken by George Elson, she appears happily striding down the trail, rifle in hand, and with Kodak camera around her waist (see Figure 37), but in the formal frontispiece to the book, she appears in an artist's portrait as the demure, lady-like, well-dressed, feminine woman society expected her to be. When I reflect on these two images, I am obliged to wonder who the real Mina was and how the free spirit she found in Labrador managed to squeeze itself back into the corseted decorous lady. The

truth, of course, is that there were several Minas and that she herself discovered, or invented, some of them during her expedition. In fact, the process of invention had begun well before her book appeared in 1908.[28]

Mina would go on inventing herself after her return from Labrador by giving public lectures, writing essays, both scientific and popular, and publishing her book. She remarried in England, raised three children, and worked for the suffragette movement; she returned to Canada frequently (but never permanently) and once, in her sixties, travelled north for a reunion with George Elson. According to her children, she was an austere presence who would regularly set forth on long walks by announcing that she was going off to explore, and it was on the last of these explorations that she was struck and killed by a train, not far from her home in England, at age eighty-six. Today, a commemorative plaque has been erected beside the road in front of the original Ontario farmstead where she was born and grew up, but that is only one visible reminder of who she was.

Mina, I believe, is rapidly becoming a Canadian icon through her many, and ongoing, inventions. There are three critical determinants that shape her story: first, the basic setting concerns *the North*, a vaguely defined, real yet mythical place of enormous symbolic (and practical) value to the country; second, the central figure in the story is a woman on an expedition into a part of the North that remains foreign, mysterious, even exotic to the great majority of Canadians (and explorers' accounts are staple ingredients in the national story of discovery and origins); and third, the verifiable facts of her life include a tragic death, a love story, and a survivor story. A simple summary of the key elements — mysterious North, dangerous expedition, exploration and discovery, young woman, tragic death, faithful love, all set in 1905 — makes it obvious that films will be made about this woman. And they have been, or are being made. One, a docudrama for Radio Canada television called *Mina et Leonidas*

MINA HUBBARD CENTENNIAL
North West River
Labrador, NL, Canada

1905 - 2005

Come Join The Adventure!!!

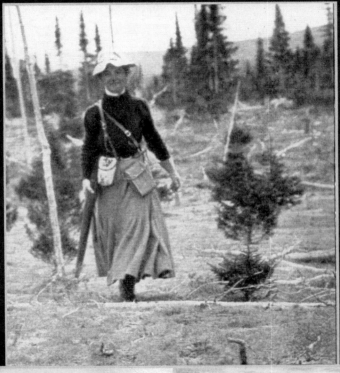

(Shores of North West River 1905) *(Shores of North West River 2005)*

Hubbard: L'amour qui fait voyager (see Figure 38), was aired in March 2007, and at least two others are in production.[29]

With the outbreak of the Second World War, British sales of *A Woman's Way* stopped, and the book went out of print. Outside the tiny community of North West River, Labrador, Mina Benson Hubbard was forgotten for several decades. But attention began to refocus on the 1903 tragedy of the first Hubbard expedition in the 1980s when Davidson and Rugge published *Great Heart: The History of Labrador Adventure* (the epithet "great heart," by the way, was Mina's name, borrowed from *Pilgrim's Progress*, for George Elson). At this point, Mina entered the stage once more, albeit in very minor roles as the pathetic widow, the stubborn and secretive competitor to Dillon Wallace, or the older woman out to seduce the handsome George. Others who have invented Mina include Margaret Atwood (in "The Labrador Fiasco"), Pierre Berton (in his foreword to the 1981 edition of *A Woman's Way*), Clayton Klein (his Mina is a sex-starved widow, and he passes off fictional letters as real ones), the feminist canoeists Carol Iwata and Judith Niemi, who *did* the George River in the early 1980s, and Lynn Noel, who romanticized Mina as a type of Pauline Johnson paddling her own canoe in a 2001 song collection called *A Woman's*

FIGURE 37 (FACING PAGE) The poster for the Mina Hubbard centennial reproduces the famous 1905 photograph of Mina on the trail. This photograph was probably taken by her chief guide George Elson; it appeared in her *A Woman's Way through Unknown Labrador* (1908) and is reproduced in my 2004 edition of the book (67). The image, one of the few of herself that she chose to include in her expedition narrative, has acquired near mythic status as a symbol of the successful female northern explorer. For the community of North West River, Labrador, the 2005 re-enactment of Mina's setting forth in 1905 and the related events of a conference, exhibitions, and the premiere of the play *Mina's Song* allowed local residents to remember and celebrate their history and a woman they revere in memory.

Way, Songs and True Stories of Northern Women Explorers. In 2000 the British journalist Alexandra Pratt attempted to repeat Mina's expedition with an Innu guide, but she failed and had to be airlifted out. Nevertheless, she published her book *Lost Lands, Forgotten Stories: A Woman's Journey to the Heart of Labrador* in 2002. Despite their differences in characterization and invention (from difficult widow to sex-starved seductress, or from occasion for feminist celebration to heroine for the faithful follower-in-the-steps-of who tries to repeat Mina's journey), *all these inventions,* like the most recent ones, including mine in the introduction to my 2004 edition of her book, biographer Anne Hart's, and Randall Silvis' 2004 non-fiction version *Heart so Hungry,* are by southerners, those whom Labradorians and Newfoundlanders label as "from away," American, British, and Canadian. However, in 2005 that changed.

On the centenary of her expedition, the tiny community of North West River (population five hundred), assisted by Memorial University's Centre for Labrador Studies, hosted the Mina Hubbard centennial (see Figure 37). Many of those from away were invited guests, but finally the northerners were going to tell their stories about Leonidas, Mina, Dillon Wallace, and George Elson, and about their own ancestors, who had rescued the 1903 survivors or who had been on Mina's expedition (such as Gilbert Blake). It is these people and their invention of Mina that I want to consider more closely. Mina Hubbard is a legendary figure, along with the men, amongst the "liveyers" (mixed-race settlers, not Innu) of North West, but she is especially cherished because they see her as having respected them in ways that the white men from away rarely did. They also cherish her because of the sensitive manner in which she responded to their beloved Labrador.[30] And, like human beings anywhere, although with what I see as more generosity of spirit, they have to this day a great sympathy for her personal tragedy, her courage, and her tenacity. For many of them, Mina's story is a love story — about *her* husband and about

FIGURE 38 In this still from the tele-film *Mina et Leonidas Hubbard: L'amour qui fait voyager* (2007), Mina holds the telegram that has reached her, many months after the fact, announcing her husband's death from starvation during his 1903 Labrador expedition. In life, as in this film and other fictionalizations of her story, Leonidas' death inspires Mina to undertake her own expedition to complete his work. Mina is played by Catharine Ruel, and this photograph is reproduced with the permission and courtesy of the director Jacques Bouffard. © Jacques Bouffard and Les productions Vic Pelletier.

their northern home. The centennial in June 2005 had four main components: an international conference on Labrador exploration, a re-enactment of Mina's expedition setting forth, an original play by North West River's resident writer June Baikie, and a film. Everything done in the re-enactment was being filmed as it happened, visitors and locals were interviewed during our few days there, and the film crew took considerable footage of the Grand River, the community, and the surroundings. Some guests were also flown by the local airplane company over the rivers that feature so dramatically in Leonidas' death and Mina's success.

Many things impressed me during this northern adventure, my first to Labrador, but the one I found most moving was the staging, in the local community hall, of Baikie's play *Mina's Song*. On this unusual occasion,

I sensed that I had come very close indeed to something emotionally true and symbolically important by *witnessing* this production; this was no professional theatre event, but it was valid and genuinely local. Attending it was a form of fieldwork, for a literary scholar, because I was watching northerners take ownership — which they had never doubted they had — of one of their own stories. Here was a community performing its own myth, creating an icon of this woman who meant so much to it, *living* what Pierre Nora calls a milieu de mémoire. No one from away could do this.

Of course, I am aware of the problematic status of the riverside re-enactment with Martha MacDonald playing Mina, and I acknowledge the *virtual* nature of this representation, just as I recognize the wonderfully imaginative creation of Baikie's Mina. And I shall be fascinated to see what filmmaker Ann Henderson does with all the footage her cameramen got during the event. Nevertheless, the play stands out for me because in it Baikie stayed close to the known facts of Mina's life and death — even to having a train kill her before our (and her attending grandsons') eyes — while at the same time making a powerful contribution to the northern discourse of Labrador. *Her* Mina, who adored her "Laddie," dies because she thinks she is going back to Labrador to explore; her Mina calls out as she steps in front of the train "I am coming Laddie," coming, that is, into the realm of death but also *home* to the northern landscape in which the historical Mina constantly felt and saw her husband's spirit. Through one hundred years of inventing, her self-inventions and her invention by others, Mina illustrates how and why a figure from the past gradually acquires iconic status within the Canadian imaginary. She is being made to represent female success against the most challenging obstacles, not simply of the land, but of public opinion; she has been transformed into a metaphor for what white southern Canadians see as the dangerous, seductive, beautiful but deadly and temperamental North.

As of June 2005, the centennial, the re-enactment, and the play, she has become a symbol — to the northerners, the liveyers of Labrador — of home and of qualities they value highly: reverence for the land, respect for elders, especially Native elders, conjugal love and fidelity, courage without complaint, survival, and community. Through films, notably *Mina et Leonidas Hubbard*, she is being transformed into a *Canadian* love story, not only about two people, but also about the country and its North.

Almost one hundred years ago, in her review of *A Woman's Way*, Jean Graham expressed the hope that, one day, the Canadian public would honour Mina, and we have. We have honoured her *not* by recounting cartographical facts, because her map of Labrador has been superseded; the landscape she travelled has been altered irrevocably, overgrown with dense brush, flooded to build hydro-electric dams, and overflown by military aircraft; and the Innu people have been forced into unhealthy settlements. We honour her by continuing to tell her story, by inventing her as something of a northern icon striding down her Labrador trail, over the hills, and on to the beckoning waters of an imagined Lake Michickamau.

VI ICONS AND THE ART OF BEING CANADIAN

Before I step back to reflect on what the art of being Canadian tells us, I need to pause briefly to consider the lessons of these inventions of Canadians. Riel, Carr, Thomson, and Hubbard, as well as the others I have mentioned, are iconic, rather than heroic, not because of who they were or what they actually did, but because of the ways in which they have been invented. They are not portrayed by biographers and artists in the primary colours of heroism, as victors in a battle, winners in a competition, or as undefeated adventurers conquering a continent to build a nation. They are not seen as stereotypes, fixed once and for all, or so

sacrosanct that their lives, deeds, and works cannot be reinterpreted. And they are not represented as trailing clouds of glory; if they are glorious in some way, it is a reflected glory, a shared glory, and a glory tinged with loss, struggle, and defeat. It has become a bit of a cliché to say that Canadians are suspicious of heroes and self-aggrandizing heroics (see Woodcock on Riel versus Dumont or Atwood in *Survival*). The film *Project Grizzly* is an amusing example of what I mean. In this parodic documentary/feature film, the Canadian hero Roy Hurtubise, stumbling forth to tackle the wilderness in his armoured suit, is a joke.

He is a joke, but he is a very Canadian joke, an ironic image of our efforts to embrace our northern landscape by arming and insulating ourselves against it. However, there is nothing funny about Riel, Carr, Thomson, or Hubbard, who are profoundly *iconic*. To varying degrees and in different ways, their *inventions* serve to tell us what it means to be Canadian because their lives and work represent familiar themes, recognizable struggles, significant achievements, and the ideal (if not always the practice) of shared values: endurance, tolerance, peaceful coexistence with the natural world, an intensely spiritual connection with that world, and a fair measure of humility and self-sacrifice. Riel himself was keenly aware of concepts of nation and nationalism; Carr and Thomson were too, if less overtly and politically; and Hubbard loved Canada deeply but could not bring herself to move home. All four held very regional ideas about the Canadian nation — a vision of being Canadian that continues to resonate across the country — but over decades of invention, their images and stories have proven malleable and easily marshalled to serve pan-Canadian interests.

To ask why Canadian artists return to these historical figures for their own inspiration is to ask a larger, more complex question. One answer is that most of the artists were or are *cultural* nationalists looking for the

stories that give them, the country, and its history meaning. This is certainly the case with Harris, Jackson, and the Group of Seven, R. Murray Schafer, Harry Somers, and Mavor Moore, with Rudy Wiebe, Hugh Mac-Lennan, Joyce Wieland, and with several of the playwrights and poets. But why have these artists devoted so much creative attention to the North and the two wars? The answers to these questions surely must *begin* with the inescapability of both. From the time of explorers, settlers, and national beginnings (in 1867 and before), Canadians recognized their nordicity and sought to transform that unbearable reality into bearable symbols, myths, songs, stories, and tourism. With hindsight, we have come to recognize the formative impact of both world wars on the nation we are today, at the beginning of a new century. Why else?

Listening for the Heartbeat of a Country

You want to know where

where ...

where to put your eye

eye

so you can hear the

heartbeat

of a country ... comin' into bein'

— *Sharon Pollock*, FAIR LIBERTY'S CALL

Instead of providing conclusions or neat answers to questions about identity, I want to keep the process of *being* Canadian open. I want this process of openness, which must not be confused with maturation or conflated with progress, because that is how I see Canada: as always changing, adapting, revising, revisiting its histories; always contesting and redrawing cartographic and cultural boundaries; as always, and productively, unfinished — a work in progress. In reality, of course, I know I must stop, just as the lectures that produced this volume came to an end. Nevertheless, I can easily imagine a next chapter, and another one after that, and I am aware of my exclusions, which, to think of them more productively, are ongoing questions holding out future possibilities of discovery. I believe Desmond Morton was correct when he said that "nations are built from the experience of doing great things together" (145), and there are

many great things still to do. But the question I close with is the one posed by Sharon Pollock in the opening chorus of voices from her play *Fair Liberty's Call*, the voices I have chosen for my final prefacing quotation: where *do* you put your eye to hear the heartbeat of a country coming into being?

In Chapter 2, I promised to return to *Fair Liberty's Call* because I see it as a major representation, not just of war or of life in "the true North strong and free," but of *being Canadian*. The play is set in 1785 in a part of Canada that would soon become New Brunswick. It presents the story of the Roberts family and of other United Empire Loyalists who chose to leave the United States after the Revolution to build new lives in a new country. However, the men in this group refuse to leave the war behind; as the play opens, they are gathering to perform a "Remembrance Ritual" (37) that will keep old wounds fresh, remind them of who they were and what they lost, and strengthen their resolve to replicate on this new soil the society they left behind them. However, they will be foiled in their plans to reinstate their former privileges and hierarchy by the women of the Roberts family, who will unite to undermine and expose the violence, injustice, racism, and greed of the old system. The vision that prevails at the end of the play is symbolized by Joan Roberts, the mother, who, despite her grief and trauma — or perhaps because of it — is able to *hear* "the heartbeat of a country comin' into bein'" (20) and to *see* the spirit of the "red woman with her baby" who will offer the refugee a symbolic "bowl full of earth" (79). In the closing moments of the play, Joan Roberts accepts the bowl and the Mi'kmaq woman's instruction: "Eat, she says. Swallow. And I do" (80). With these words, the remembrance ritual of the men is displaced by a sacrament that celebrates arrival in a new home to be founded on principles of human rights (for all, including the black Loyalist), of liberty, and of mutual acceptance by and of the First Nations who are already here.

These eighteenth-century refugees have come north to escape war and to help build a new kind of nation. What's more, in this new country, there are no individual heroes to worship; instead, there is a community celebrating a foundational communion. Joan Roberts is Pollock's iconic figure of Canada as a mother country that will nurture peace, human rights, and fair liberty. That such a play was commissioned and premiered at Stratford in 1993 carries further significance. Stratford is arguably Canada's most prestigious national theatre site and therefore *the* strategic place to perform a play about the founding of the nation and about the art of being Canadian. Moreover, the 1990s were marked by foreign wars and aggression in Africa, Yugoslavia, and the Middle East, which continue to have serious repercussions. On the home front, the country experienced a series of confrontations (such as the Oka crisis of 1990), fundamental challenges to national unity (as in the 1995 Quebec referendum), and deeply disturbing revelations of past wrongs, one of the most shocking being the abuse of children in the residential schools.

Pollock is always acutely aware of the political scene, at home and abroad, and in *Fair Liberty's Call*, she reminded all who saw the play about what it should ideally mean to *be Canadian* — ideals easily lost sight of but essential to preserve — and of the danger to Canada, and the world, inherent in the ideology of war. When I look to Pollock's mother figure as an embodiment of the country, I see her as more active, more present, and, above all, as more representative of being Canadian than Walter Allward's marble Mother Canada mourning her dead sons at Vimy Ridge. I see her as more representative because, though she appeals for peace, which is what Allward's Mother Canada does and what Jane Urquhart celebrates through her re-creation of the sculptor and his art, Pollock's mother stands on home ground with the terrible benefit of the playwright's hindsight. Pollock wrote her play in the long anterior shadows cast by the Second World War and Vietnam, with the reality of

conflicts in her present (the late 1980s and early 1990s), and with threats of worse to come in the future.[1] Pollock's mother knows what Allward's could not know — that the Great War did not end war — and she says what Allward's cannot: that mothers are co-opted by the state and forced to sacrifice their children, that the words "patriotism" and "liberty" may be lies, and that a mother must do much more than quietly, passively mourn.

Paradoxically, even tragically, wars have always served to define and establish nations, at least as far as those in power are concerned, and Canada is not greatly different in this respect from other modern nation-states, the key exception being that, thus far, it has not started a war of aggression to protect or expand its borders. Perhaps the most significant irony in our coming-of-age-through-war story is that wars have threatened to split the country apart. In the current twenty-first-century context, Canadians continue to be deeply divided, with the greatest opposition to military deployment to Afghanistan coming from Quebec. In many ways, our nordicity is a more powerful, and certainly less problematic, source of real and imagined national unity. The North, wherever we locate it and however we define it, is common to all Canadians and part of all the provinces and territories. Moreover, the North of the Arctic and the Northwest Passage has once more come to southern Canadian attention and not solely because of the dramatic indicators of climate change and environmental degradation found in the North. With the melting of ice in the Arctic and the opening up of the fabled passage that defeated Franklin, Canadian sovereignty is once more a pressing issue.[2] The twenty-first-century version of this old sovereignty debate will shape the Canadian narration of the nation for the foreseeable future and will, no doubt, renew the need for an active Canadian military presence in the North. To meet these environmental and political challenges, Canadians need to act as a united people by voting, by opting for measures to combat climate change, and by formulating and implementing political, scientific, economic, and

cultural policies (as well as military ones) to defend our northernmost border. As Louis-Édmond Hamelin told Canadians decades ago, it is your North too.

We will not act as a united country in the immediate future, however, unless we know our past and listen to the voices of the dead, who tell us how to live. It is my contention that Canadian artists, biographers, historians, and creative writers show everyone who will pay attention — will use their eyes and ears to listen to the heartbeat of the country — what it means to be Canadian through their representations of nordicity and war, and through their inventions of national icons. The meanings and markers of identity are multiple, diverse, complex, and often contradictory, like the examples of iconic figures I have described. These meanings and markers are, moreover, constantly changing and evolving. But while Panya Clark Espinal's *First Snow* lingers in my mind's eye, I will offer one closing reflection. The North, the wars, and our iconic figures all speak to me of ghosts, memory, and commemoration. By remembering where we are, who died before us, and what is signified by those who are dead, we continuously invent ourselves. As Riel prophesied, it is the artists who give us back our spirit. In *First Snow*, Panya Clark Espinal opens windows onto that world of invention, inviting us to enter. In her poem "OH, CANADA," Karen Connelly, my newest, youngest artist, the voice I began with, invites us to listen:

> Not to suggest that a country is a family
>
> but stating it unequivocally
> a country *is* a family
> and this is mine,
> my country
> my family.

I come back to them now
 as water always comes back.
It is the dead
 who teach us how to live,
well or badly, it is the dead
 who teach us how to swim,
well or badly, it is the dead
 who walk among us
 but cannot spell our names. (85)

Notes

INTRODUCTION: ON BEING CANADIAN

1 In some recent studies (see Finlay and Litt), Vincent Massey is portrayed as a privileged elitist prude and as a man whose pride in Canada was coloured by his loyalty to the British Empire. His views about culture were patrician, his understanding of Canadian culture was conservative, and his politics were tainted by anti-Semitism (see Abella and Troper); he was, in short, a man very much of his class and time. However, he shared with contemporary intellectual leaders, like Harold Innis, a vision of the country's future that was grounded in a belief in the importance of secondary education, especially a liberal arts education (history, including Canadian history, literature, philosophy, and languages) and the arts. Massey put his own time, effort, and resources into developing that vision through the creation of Hart House at the University of Toronto, the championing of Canadian artists before and during the Second World War, his commission work, and his years at Rideau Hall as governor general. With Adrienne Clarkson and Michaëlle Jean, the *person* of the governor general has changed dramatically, but the symbolism and responsibility of the position was reinvented as *Canadian* by Massey, and Clarkson and Jean have inherited that tradition.

2 These later reports on the status of the arts examined ongoing questions about funding, about the representation of women in all aspects of theatre (see Fraticelli), and on the financial returns of the arts sector; all contributed to the continuing debate about how best to support Canadian culture.

3 Canadian art has not been known or celebrated for its portraiture, yet many of our best painters have created fascinating portraits and self-portraits. Among photographers, Yousef Karsh is famous, but even in this field, landscape and cityscape remain the dominant subjects, as Ed Burtynsky's and Jeff Wall's work demonstrates. Library and Archives Canada's "Portrait Gallery of Canada/ Musée du portrait du Canada" holds an almost unknown *virtual* collection that to this day lacks a permanent, appropriate, physical home. Over the past twenty-five years, biography and autobiography have flourished in Canada, and insofar as these literary genres complement the work of portraiture, I am tempted to

predict that it will not be long before we gain a clearer appreciation and fuller understanding of the history and complexity of these ways of creating individual and national identity.

4 Despite, or perhaps because of, the weight of such realistic objects as the rug, sculpture, and office interior, and the truthfulness of the likeness of Jean Chrétien, the photograph is a work of art that reminds a viewer of its artfulness in many ways. As a portrait, or self-portrait, it is an illusion of selfhood, an auto-biographical fiction. Its truth claims are deceptive, staged for this occasion to engage a viewer in a dialogue about identity — Chrétien's, the viewer's, Canada's — and about the power of images to construct identities. This question of true identity is one of the most fascinating and problematic issues explored by autobiography, biography, and portraiture. For discussion of these issues, see studies by Timothy Dow Adams, Paul John Eakin, Susanna Egan, Philippe Lejeune, and my "Performing the Auto/biographical Pact."

5 In my current research, I am examining representative works by Canadian artists about the two world wars. I am focusing on the period from 1977 to the present because such a fine body of work — plays, novels, memoirs, other forms of non-fiction, and films — has appeared since Timothy Findley published *The Wars*, and it has not yet received collective interdisciplinary analysis. My discussion of war arts in Chapter 2 is a prelude to the larger study; see also my "'A Different Kind of Theatre': An Introduction."

6 See, for example, Roch Carrier's *La Guerre, Yes Sir!* and Louis Caron's *L'Emmitouflé* (published in translation as *The Draft Dodger*). I discuss the debate between Henri Bourassa and Talbot Papineau over Canada's participation in the First World War and the conscription issue of 1917 in Chapter 2, and almost all commentators on both world wars address the divisions that arose between Canada and the province of Quebec over these wars; see Berton, *Marching as to War*, Egerton, and Gwyn. Despite a general francophone opposition to the wars, and especially to conscription, soldiers from Quebec have always enlisted in the Canadian Armed Forces and have often risen to leading positions.

7 There are a number of important writers and artists who might be included in a chapter on writers-of-colour and First Nations writers, but to the degree that I consider these artists I have decided to incorporate them within the thematic organization of my chapters. Michelle La Flamme has begun the exploration of these authors' works in her PhD dissertation with discussions of, among others, George Elliott Clarke, Lawrence Hill, and Djanet Sears, but much remains to be done.

CHAPTER 1: CREATING A NORTHERN NATION

1 The term "mystic north" was first used by J.E.H. MacDonald (see Nasgaard 3), and Lawren Harris agreed wholeheartedly that the North was the site of spiritual

purity and truth, the place where god resided. Nasgaard borrowed the term for his 1984 Art Gallery of Toronto exhibition and catalogue; see also Larisey and my discussion of Harris in *Canada and the Idea of North.*

2 The European fascination with the North, or with the polar regions, has been constant over the past six hundred years. Efforts to trace this northern interest and its roots in Greek thought are under way among both European and North American scholars. See, for example, Peter Davidson Chapter 1.

3 I discuss this painting and the poem that inspired it at greater length in *Canada and the Idea of North* (104-22).

4 In *A Woman's Way*, Mina Benson Hubbard reproduced many of the photographs she took on her expedition, including images of the land, the Indian people she met, and her guides. She took portrait-style photographs of each guide and published them with their names — an unusual practice at the time. Other travel and expedition narratives tended to focus on landscapes, and if indigenous people were photographed, their images were published as ethnographic illustrations without individual identification.

5 An ice-cream bar once popular in Germany was called a "Nanook," and its packaging perpetuated the idea of the "Eskimo" as a happy, childlike creature. Flaherty's famous film has been extensively studied; see Grace, "Exploration as Construction."

6 Flather and Linklater's play *Sixty Degrees North* was published in Grace, D'Aeth, and Chalykoff, eds., *Staging the North.*

7 Borden endorsed Stefansson's book by writing a preface, and both Pearson and Diefenbaker championed the exploration and development of the North.

8 See his many comments about "the mood and spirit of the North" (51), a term he always capitalized, in *Lawren Harris.* See also Larisey.

9 I discuss this painting at length in *Canada and the Idea of North* (9-11).

10 The series, which comments in many ways upon the notion that Canadians, represented by Fraser, are overly serious, conscientious, and very, very polite, relies on a number of Canadian insider jokes such as the name of Fraser's faithful pooch and possibly even Fraser's own name. The plot takes the young constable from the North to the city of Chicago in search of his father's killers, but as Fraser adjusts to big-city life, he develops an amazing array of uncanny techniques for sniffing out crime. He never succumbs to female flattery (despite many temptations), he never swears, and he typically emerges from various messy scraps looking impeccably clean and shiny. Another popular Canadian television series set in the North was *North of 60*, which ran on CBC from December 1992 to December 1997. However, by comparison with *Due South*, the stories, characters, and issues are much more realistic and socially important. *North of 60* is set in the fictional community of Lynx River with First Nations characters, including a female RCMP officer, Corporal Michelle Kenidi (played by Tina Keeper), who is also a single mum. The problems facing the community — abuse, alcoholism, strained relations with the white community or white

tourists, and a range of common family conflicts — are familiar aspects of Canadian society in general as well as specific challenges faced by northerners and Native peoples. *Sergeant Preston of the Yukon* is available on video and DVD, but the stories now seem clichéd and predictable: they are set in the Yukon, usually in and around Dawson City during the Gold Rush (1896-98), and wicked machinations take place in immoral spots such as the Gold Nugget Saloon.

11 In "'The Idea of North': An Introduction," Gould explains that as a boy he pored over maps of the North, saw reproductions of Group of Seven paintings in "every second schoolroom," and examined "aerial photographs and ... geological surveys" of the North (391).

12 See Grace, *Canada and the Idea of North* (12-15, 271).

13 The plot is simple enough and familiar to anyone who has read about the Gold Rush: Groups of prospectors are making their way north on the Yukon River when an accident befalls one of them. The only survivor is a woman, Mary Potter, who must ally herself with two desperate brothers in order to make it downriver to Dawson City and the chance at a new life there. She will succeed by becoming a dance hall girl, but her male companions will be destroyed by their suspicion and greed.

14 A documentary film with a similar focus but a much more overt political message is *The Road to Nunavut: The Kreelak Story* (1999). Narrated by Martin Kreelak, on the eve of the official recognition of Nunavut, it tells the story of an Inuit family's encounters with white southern institutions and their often painful adaptation to white ways at the cost of their traditional lifestyle. We will accompany them on a return to their traditional summer fishing camp, and we will hear many others' stories in Inuktituk, but the basic message of the film is survival: these Inuit have survived all that civilization can inflict on them, and they have taken control of their own destiny by making this film, by running their own television and radio stations, and by creating Nunavut.

15 The film of *Never Cry Wolf* is closely based on Mowat's memoir by that title. It stars Charles Martin Smith in the role of Tyler (a man who represents Mowat), who is sent into the Keewatin region by the federal government to study wolves. The government assumes that wolves are the main predator destroying the caribou herds, but after a few months on-site, Tyler realizes that man is the chief predator and destroyer of the North. He is obliged to accept his own puny irrelevance in this large wilderness, and he recognizes that, as a human being, he has introduced danger into the lives of the Arctic wolves simply by watching them.

16 *Arctic Mission*, a five-disc DVD series, was produced in 2004. It follows a five-month voyage through the Northwest Passage during which scientists chart the signs of climate change and explain the consequences of melting permafrost and greenhouse gases for the entire globe. In Part 3, *Lords of the Arctic*, it explores the impact of rising temperatures on polar bears and other Arctic fauna and flora. In Parts 4 and 5, it moves into local communities to provide their perspectives on these dramatic changes.

17 Peter Blow made a documentary film, *Village of Widows*, about the impact of uranium mining on the Dene of Deline on Great Bear Lake and the voyage of some Dene to visit the Japanese in Hiroshima for their annual commemorative peace ceremonies on 6 August 1998. Clements has followed the interviews with "uranium widows" and other factual information preserved in the film, but she moves well beyond the film in her treatment of the war.

18 In August 2008 I delivered a keynote lecture to the Nordic Association of Canadian Studies Conference in Norway called "We Stand on Guard: War and the Canadian North." In this paper, and in a version of it presented as the UBC Killam Lecture in September 2008, I explored Marie Clements' play and Peter Blow's film in detail within the context of climate change and the mounting rhetoric of military conflict (by Canada and other nations) in the Arctic. A version of this paper will be published in a book on war and peace, co-edited by myself and Patrick Imbert, and derived from the November 2008 Royal Society of Canada Symposium titled "The Cultures of War and Peace." The year 2008 also saw the publication of two important books on issues of climate change, war, and the Arctic: see *Arctic Front* by Ken S. Coates et al., and *Climate Wars* by Gwynne Dyer.

19 See my introduction to the 2004 edition of Hubbard's *A Woman's Way through Unknown Labrador* for details on her preparations, her photography, and her expedition journal.

20 In the opera, the dream of an earthly paradise in the Arctic is revealed as a deadly illusion, but it conforms to the vision of the Arctic recorded in Mercator's maps, which were contemporaneous with Frobisher's three expeditions in 1576, 1577, and 1578. However, Martin Frobisher was a pirate and a fool: he forced his men to load his ships with tonnes of rock that he thought contained gold, only to be proven wrong when the rocks were tested in London, and he had violent encounters with the Inuit. Frobisher died at home in England, not by disappearing into the frozen wastes of the Arctic, as the young filmmaker Michael wants to think. It is Anna who rejects romantic myths and learns to respect the North.

CHAPTER 2: THEATRES OF WAR

1 This number of the journal, edited and introduced by Pierre de la Ruffinière Du Prey, contains a set of original studies of Allward and his contemporary sculptors, and a number of stunning photographs of the Vimy Memorial. The studies place Allward in an important international context and remind Canadians, not only of his Vimy masterpiece, but of his other works and his general vision — "to express the sadness of war and the gladness of peace" (Du Prey 63). I wish to thank Professor Du Prey for sending me a copy of the journal, which will, I hope, bring more attention to Allward's achievement.

2 Canadians did not legally have citizenship *as Canadians* until the Citizenship Act of 1947.

3 For a good discussion of Cold War politics in Canada, see Cavell.

4 War has been one of the most frequent NFB subjects; another has been the North. Since 1990 a number of NFB films about the First or Second World War have been made: these include *Canada at War* (a four-part series), *John Mc-Crae's War: In Flanders Fields*, and *Far from Home: Canada and the Great War* (a ten-part series). Since 2000 several more films about war have been made, as well as shorts on recent wars, peacekeeping missions, and problems at home.

5 In 1918 John Garvin edited a collection of Canadian poems from the Great War, and some individual poets do focus on war (for example, Birney, Livesay, and Souster), but most anthologies of Canadian poetry do not single out war as a category or topic of interest or study (see Callaghan and Colombo). Raymond Souster has perhaps written more war poetry and other literature about the Second World War than any other Canadian. Souster, who flew with the RCAF from 1941 to 1945, published two novels, a memoir, and an unusual collection of comments from men involved in the raid on Dieppe called *Jubilee of Death*.

6 In 2007 I began a larger study of Canadian representations of the two world wars, and in 2008 I co-edited *Canada and the Theatre of War*, the first volume of Canadian plays about these wars; a second volume will appear in 2009. The number of excellent novels, plays, and other works about the First and Second World Wars continues to grow, so the time seems right for a broad analysis of what these works mean and how they contribute to our understanding of Canada's relationship to past wars and the current position of Canada with regard to global conflict.

7 For an excellent discussion of the poem, see Holmes. In *The Great War and Modern Memory*, Fussell dismisses McCrae and the poem's longevity, but in the NFB film *John McCrae's War: In Flanders Fields*, scholars from Britain and Canada confirm its lasting power to haunt and disturb.

8 Canadian composers often wrote commissioned pieces for Remembrance Day observances, which is what Chatman's setting of "In Flanders Fields" illustrates, but they also wrote other music addressing war: R. Murray Schafer composed "Threnody" (for the victims of Nagasaki, 1970); Irving Glick wrote "I Never Saw Another Butterfly" (1968), based on poems by Jewish children in Terezin concentration camp; Jean Coulthard wrote "Convoy" in 1942 (later retitled *Song to the Sea*), and Louis Appelbaum wrote "Action Stations" in 1942, both of which directly address military manoeuvres. But perhaps the most interesting of these war compositions is John Weinzweig's "Interlude in an Artist's Life" (1943), which is an autobiographical statement in music for string orchestra. On 15 March 2008, the Vancouver Bach Choir premiered John Estacio's "The Houses Stand Not Far Apart," a plea for understanding across the ethnic divides that fuel wars, with libretto by John Murrell.

9 Although Robert Service is best known today for his poems about the Yukon and the Klondike Gold Rush, he wrote and published a number of poems concerning

his experiences in the Great War, many of which are more serious than "A Song of Winter Weather"; see *Rhymes of a Red Cross Man* (1916).

10 Fussell provides an extensive discussion of British war poetry.

11 In *Alex Colville: Diary of a War Artist*, readers can trace Colville's recorded responses to the war scenes he encountered and drew or painted in the Mediterranean, France, Holland, and Germany (at Belsen concentration camp). His comments are more factual and less emotional than those of Charles Comfort in *Artist at War*. He notes at one point that he was very young and saw his job as "essentially to record" (123).

12 Novak provides a thorough treatment of early First World War novels, but she ends her discussion with Findley's *The Wars*; nevertheless, she does suggest that the works she considers have played an important role in shaping both the country and its response to war. These texts, she tells us, "have helped to bring about a fundamental change in the attitudes and feelings of generations of Canadians" by re-creating and condemning "a whole range of traditional responses to war" (165). What she does not stress, however, seems crucial to me — that some of these works address the home front, that they increasingly focus on ethical questions (as does Gwethalyn Graham's *Earth and High Heaven*), and that they gradually demonstrate not only greater literary sophistication but also an increasing self-awareness and narrative complexity. Memory, especially the memory of trauma, national repercussions, and acts of commemoration characterize the most significant Canadian films, novels, memoirs, and plays created since 1977.

13 For other examples of autobiographies, see Bates, Bishop, and Colville, and Mowat's *Otherwise*. The scope of this subject is considerable, with more such accounts being published yearly; most of the documentary films about the two wars also make use of the autobiographical voice through quoted letters and live interviews. The most moving memoir about Newfoundland's First World War experiences is Macfarlane's *The Danger Tree*.

14 Each segment of *The Valour and the Horror* begins with the statement, pronounced by McKenna, that what we are about to see is "the truth." This assertion of truth concerning what had been hidden or lied about led veterans and others to level criticisms at the film. Two playwrights, Kenneth Brown and Stephen Scriver, were angry enough to write a response to the film in the shape of their 1995 play *Letters in Wartime*.

15 *The Death of General Wolfe*, by eighteenth-century Anglo-American artist Benjamin West, presents an imagined scene in the final moments of Wolfe's life during the battle between the French and British forces on the Plains of Abraham at Quebec City, the stronghold of New France, in September 1759. West depicts General James Wolfe receiving word of the British victory just before he dies; the French general, the marquis de Montcalm, died of his wounds the following day. This battle represents the British defeat of France and of its colonial interests in North America during the Seven Years War, and it is seen as a

watershed moment in the history of Canada and of North America. West's painting was immensely popular during the eighteenth century, largely because Wolfe was a celebrated English hero. The painting has received extensive critical discussion of such features as West's use of realistic contemporary uniforms (rather than the conventional robes), the pose and symbolism of the Indian warrior, and the *Pietà*-like position of the dying general. To my twenty-first-century eyes, Wolfe's story is a colonialist melodrama staged (especially in West's painting) on Canadian soil, and to read his victory on the Plains of Abraham as a myth of origins necessitates confronting a complex web of ironies, ambiguities, and contradictions. See discussions of the painting by McNairn and Schama and of Quebec City's historical significance for Canada by Nelles.

16 Since the Second World War, Canada has not officially gone to war, and it did not declare war on Korea, Vietnam, Afghanistan, or Iraq. Its Armed Forces have served as peacekeepers on several fronts until recently, when their role shifted from peacekeeping to anti-terrorist combat in Afghanistan. As this book goes to press in the summer of 2009, public opinion about Canada's role in Afghanistan remains divided, but some (including Stephen Harper and top soldiers in the Armed Forces) link Canada's capacity to fight with a renewal of national identity and of enhanced stature on the world stage. For an illuminating analysis of how Canada became involved in Afghanistan, see Janice Stein and Eugene Lang's *The Unexpected War: Canada in Kandahar.*

17 Due to legal entanglements, this film is not available on video or DVD; however, I saw it when it was first released and on two special occasions since, and it represents one of the best film scripts yet made from a Canadian novel. Findley's novel was adapted for the stage by David Garnhum, but the 2007 script offered a sanitized version of *The Wars.*

18 Although Ryan is a British filmmaker, *Going Home* is a tragic *Canadian* story with a largely Canadian cast starring Nicholas Campbell. Other feature films dealing with Canada and war include *Map of the Human Heart, 49th Parallel* (see note 21), and *The Snow Walker. Map of the Human Heart* is the story of an Inuk bomber pilot in the Second World War and a white southern Canadian woman; the two fall in love, but after the war she marries a white man, and he returns, broken-hearted and alone, to Baffin Island where he leads a damaged and lonely life. The war plays a minor but significant role in *The Snow Walker* because the male protagonist, a former war pilot, now flies planes in the Canadian Arctic, but his volatile temper is linked to PTSD through vivid flashbacks of his traumatic memories of fighting.

19 The position of women in post-Second World War Canada was complex. They gained the federal vote in 1918, won the right to vote provincially by 1922 (except in Quebec, where they did not get the franchise until 1940), and were declared "persons" in 1929, but many professions were still closed to them, and the general social pressure on women to relinquish jobs outside the home and return to a subservient domestic role was intense (see Cavell).

20 Along with an increase in the number of memoirs and autobiographies being published, several survivor narratives have also appeared. See, for example, Kahn, Raab, and Shandler, and the remarkable story *Hana's Suitcase* by Levine.

21 This film is a full-blown example of war propaganda in which a group of Nazis reaches the undefended Canadian Arctic by submarine, makes land after their boat is spotted and sunk, and then treks southward murdering hapless Canadians as they go or, and this is more interesting, defecting to join groups of German-speaking Canadians whom they meet along the way. By the film's end, only the German commandant is still a Nazi and still crossing Canada, but he is finally captured by an unarmed Canuck who sees through his duplicity. The British-made film, which starred famous English actors of the day (Leslie Howard, Laurence Olivier) and Canadian Raymond Massey, would be merely comic now if not for the fact that rumours about German invasions from the North, coupled with the internment of German Canadians as enemy aliens during the war, were parts of the war frenzy and prejudice whipped up by such propaganda.

22 The father in the film will burn his First World War uniform in an extremely moving scene after he has been coerced into signing voluntary repatriation (to Japan) papers, and one of the white men in the town, who cannot feel anything but hatred for these "Japs," will strip off his eye patch to remind the others of what he lost in the war. Wheeler has created a film that balances the complex competing claims of prejudice, loyalty, fear, and compassion without slipping into romantic sentimentality or simple accusation. For reasons of rights and distribution, this extraordinary film is available only through the museum in New Denver, BC, and thus not widely accessible to Canadian audiences. I would like to thank Wheeler for screening the film for me and my students in February 2005.

23 Blow interviewed members of Sahtu Dene families, who had worked for the Canadian government in transporting uranium ore, and widows from Deline, NWT. He intersperses their present comments and memories with archival footage of government and industry praise for the mining carried out during the 1940s.

24 In his biography of Innis, Watson suggests that the impact of his war experiences were formative for the man and scholar Innis would become. The dust jacket features a photograph of Innis in his uniform, staring at the camera with a grim, almost shell-shocked expression.

25 Early in the war, Talbot Papineau's cousin Henri Bourassa, founder and editor of *Le Devoir*, decided that the war was a foreign, imperialist affair in which Canada, and especially French Canadians, should not be involved. By the time of the 1917 election, with its conscription platform, Bourassa was passionately opposed to the war and was using his public voice to arouse Quebec nationalist and anti-anglophone sentiments over the treatment of francophone Canadians. For his part, Talbot Papineau was equally passionate about the larger nationalism

of Canada, which he saw emerging from the war. In 1916 he wrote a long letter to the editor in which he accused Bourassa of arrogating to himself the term "nationalist," and he insisted that "if you were truly a Nationalist ... surely you would have recognized this war as [Canada's] moment of travail and tribulation. You would have felt that in the agony of her losses in Belgium and France, Canada was suffering the birth pangs of her national life" (quoted in Gwyn 319).

26 Bayefsky describes his war experiences and their impact on his life during an interview for the film *Canvas of War.*

27 These advertisements have appeared in First Nations newspapers such as *Windspeaker.* Readers are invited to go to the website or to e-mail the Dominion Institute for further information.

28 An interview with Kearns, illustrated with colour reproductions of her canvases, appeared in the *Toronto Globe and Mail;* see Ross. Kearns was embedded with the Canadian forces for five weeks, but the military and the War Museum have shown some reluctance about displaying her work. As this book goes to press, Thauberger is preparing to spend time in Kandahar photographing Canadian soldiers, but for several months in 2008, her massive site-specific photograph of Canadian soldiers on training exercises hung in the university library at the University of British Columbia. Viewers' responses were mixed, with some protesting the display of such work in a library, a place they felt should be reserved for undisturbed study, and others praising the capacity of the art to challenge viewers and provoke thought and debate.

29 Canadian troops who fought in Korea in 1950 went under the aegis of the United Nations.

30 Supposedly, the final dreamlike sequence shows Papineau/Trudeau appearing on the verdant lawns of what looks like the family home at Montebello (where he had earlier visited his beloved mother, Caroline) to meet his Beatrice, and the film ends with the couple locked in a passionate embrace. But the image is confusing for at least two reasons: first, we have already been told that he died at Passchendaele, so his healthy appearance at the end is at best a romantic fantasy and at worst a syrupy distortion of the truth; and second, the lush green setting for this scene closely resembles earlier scenes in which Papineau is seen in close, fond communion with his youthful, attractive mother and in which she walks through the grounds alone, dreaming of her absent son. We know that Papineau wrote regularly to both women, but they almost seem to be conflated in this final sequence to suggest that mother Canada has not forgotten her beloved son and that he will always return to her arms. The Freudian overtones of the scene are obvious.

31 Susan Aglukark's "I'm Dreaming of Home" was featured in the 2005 film *Joyeux Noël* about the 1914 Christmas fraternizations among troops along the western front and the terrible consequences of that show of simple fraternity and humanity for the soldiers on both sides.

32 This term, which is Pierre Nora's, suggests a place, space, or physical site of re-membrance; however, it does not necessarily refer to the best possible conjunc-tion of memory and history, which, for Nora, would be a *milieu de mémoire*, that is, an environment or place for the shared experience of remembering. But it strikes me that, during its creation and later at its 1936 and 2007 dedications, with living Canadians gathered to participate actively and communally in re-membrance, Allward's monument is at least a lieu de mémoire and that it comes close to fulfilling Nora's ideal state of milieu.

CHAPTER 3: INVENTING ICONIC FIGURES

1 The writing of biography and autobiography in Canada has not yet received sufficient scholarly attention, and Canadians have been slow to write biograph-ies of intellectuals and artists, but biography in its many forms (from newspaper obits to encyclopedias, and from edited series to substantial monographs) con-tributes enormously to the development of national identity. This is not the place to undertake a discussion of life-writing, but I do wish to stress my view that biography is a narrative creation, a story about a biographee, and that, as such, biography invents a life by deploying factual information and data; for example, photographs are not unmediated real objects but staged images *used* by a writer to interpret a life and to support a version of the life story. I discuss some of these issues in *Inventing Tom Thomson* and in my introduction to *Mak-ing Theatre: A Life of Sharon Pollock*.

2 Franklin continues to be the subject of literary representation and archaeologic-al searches. This fascination may not abate until traces are found of his ships and explanations agreed upon for the failure of his third expedition; see Grace, "Re-inventing Franklin."

3 Bishop is one of the hometown heroes celebrated on billboards and plaques in Owen Sound, together with Tom Thomson and Norman Bethune.

4 Rightly or wrongly, Canadian soldiers are rarely celebrated as heroic, although Dallaire may, with time, prove the exception to this Canadian reluctance to transform military men into icons. A film based on his memoir, *Shake Hands with the Devil*, appeared in 2007, other films and books are in process, and, through his public lectures, he has become a champion of urgent causes such as the plight of child soldiers. In her play about the historical figure of Major James Walsh of the North-West Mounted Police, Sharon Pollock portrays the man as a moral failure rather than as a hero; the hero of her play, if there is one, is Sitting Bull.

5 The most widely known of these representations is the 1990 film *Bethune*, star-ring Donald Sutherland in the title role. Rod Langley and Ken Mitchell have written plays about Bethune called *Bethune* and *Gone the Burning Sun*. By far the most fascinating invention of Bethune to date is the man created through an imagined autobiography in Bock's novel. Perhaps Bethune is not yet a *Canadian*

icon because so much of his heroic work took place outside the country, in Spain and China, where he is revered as a national hero and where he died. However, it may also be — as Bock's title insists — because of his political beliefs. Can it be that Canadians will deny a person iconic status, regardless of his or her achievements, on the grounds of being a communist?

6 A special *livre d'artiste* limited edition of Atwood's poems, with illustrations by Charles Pachter, was published in 1997. Moodie has been much written about by biographers, documentary filmmakers, and editors; her main Canadian books are still in print.

7 I am aware of at least two plays on Aquash — Sharon Pollock's *The Making of Warriors* and Yvette Nolan's *Annie Mae's Movement* — and a recent NFB documentary film *The Spirit of Anna Mae.* See also La Flamme, "Indigenous Women Living beyond the Grave."

8 I see Hubbard as a more convincing site for invention than either Johnson or Aquash for several reasons: her story has a good mix of elements (adventure, sensation, danger, gender transgression, gossip); her class and race make her less controversial than either Aquash or Johnson; and her connection with the lore of masculine northern exploration puts her on the margins of a perennially topical subject. Nevertheless, once the opera about Pauline Johnson has been premiered, this state of things could shift quickly; Johnson-as-icon is still a work in progress.

9 See biographies by Bazzana and Friedrich, as well as fictional treatments by Wynne-Jones and Young. The most evocative and inventive of the documentary films is *Glenn Gould Hereafter*, which, as its title suggests, constructs its portrait of Gould with future iconicity in mind.

10 *The Rocket*, Binamé's feature film on the life of Maurice Richard (1921-2000), has enshrined Richard as the emblem of Quebec in rebellion against anglophone Canada. In 1955, when Richard was suspended for the entire season by then NHL president Clarence Campbell, a riot broke out in the Montreal Forum. This so-called Rocket Richard Riot has come to be seen as the symbolic start to the Quebec nationalist movement. The most delightful fictional treatment of Richard is Roch Carrier's famous short story "The Hockey Sweater."

11 I disagree in some respects with Woodcock's assessment of the icons or heroes we choose. Although I agree that Canadians "distrust heroes" and prefer "martyrs" (10), I am not convinced that our choice of Riel over Dumont can be fully explained in this way. Riel is the more complex, ambiguous, and mysterious figure, and in these respects, he has much in common with Carr and Thomson. I believe that, unlike American heroes who swagger and exist in black and white, Canadian icons are mutable, flexible, and three-dimensional; we can take pride in them without being dominated by them, and they can be invented to serve a variety of purposes.

12 This biography may well bring Riel to the attention of a whole new generation of Canadian readers. My students tell me that one can get Riel comic-strip

T-shirts based on this book and that Riel is becoming the Che Guevara of Canada. Time will tell if this is so and, if it is, what view the Métis might hold of the phenomenon.

13 Brown was interviewed on CBC radio *Arts Tonight* by Eleanor Wachtel on 25 January 2005 in conjunction with her discussion of the McGill University School of Music's revival of Harry Somers' opera *Louis Riel*.

14 In the context of my discussion, 1930 stands out as an important date because, during that year, Massey gave his lecture on art and nationality, Voaden published his manifesto for Canadian theatre, and the Labine brothers discovered uranium ore at Great Bear Lake. But 1977 is unparalleled for the number of important Canadian books that appeared that year, including Findley's *The Wars*, Robertson's *A Terrible Beauty*, and Wiebe's *The Scorched-Wood People*.

15 Creighton stressed the importance of the St. Lawrence River and the eastward trading connection with European markets as the definitive conditions of Canadian history and life, but Morton saw the West and the North as equally, if not more, important to the identity of the country.

16 In their study of this opera, Linda and Michael Hutcheon find it ironic that Riel was chosen as a centennial subject and suggest that the opera provides a basically ironic view of Canada as a nation. In my view, Riel, the man, embodied many of the struggles still faced in this country, and the opera's "Riel" represents the complexity and ambiguity (possibly also the irony) that defines it.

17 These comments and descriptions are quoted from the extensive notes provided with the full libretto that accompanies the recording of the work made at the 1975 revival produced at the Kennedy Center in Washington, DC. Canadian tenor Bernard Turgeon sang the role of Riel.

18 All art has the potential to evoke and utilize ambiguity, but it seems to me that twentieth-century Canadian art is especially characterized by the productive uncertainties that I read as ambiguity.

19 Other sculptures, by John Nugent, have been made of Riel; they were commissioned for the Saskatchewan legislature. See Mattes, *Rielisms* 28-29.

20 In her dissertation, La Flamme develops the concept of "soma text" to explain how this process functions in a number of works by biracial writers and playwrights.

21 Several plays have been written about Carr; see Nothof.

22 See studies by Blanchard, Laurence, Shadbolt, and Tippett, and Carr's autobiographical works in *The Complete Writings*. Various fictional treatments of Carr have been written (see Barton, Braid, and Vreeland). The name of the Victoria street on which Carr lived, and where the Carr family home still stands, has been changed from Carr to Government Street, and the sign outside the house itself is small and undistinguished. There is no indication that she was an artist of distinction, let alone of national reputation.

23 Udall sees Carr's trees as forms of self-portraiture, and Murray makes a similar suggestion about Tom Thomson's trees.

24 See Little's 1970 book and my discussion of his efforts in *Inventing Tom Thomson* (37-48).

25 In stressing the general context of the First World War as the background and source of possible motivation behind Thomson's death, Poling notes Thomson's efforts to enlist (although these claims have been disputed). In addition, he reminds us that Billy Bishop, that other Owen Sound boy, was gaining fame in the summer of 1917 as a fighter pilot, and he describes Mark Robinson, the park ranger who was wounded at Vimy and returned home still limping. Then he concludes that "the war would have been the major topic of discussion on the evening of July 7th, 1917" (54) — the night when a group of men, including Thomson, Shannon Fraser, and Martin Bletcher Jr., were drinking and arguing in a cabin at Canoe Lake, and the night before Thomson disappeared.

26 See Nora and my discussion of this term in Chapter 2.

27 Clark Espinal covered the floor of the room with potted narcissus, and along the walls she hung framed pages from the Town and Silcox book. The total effect was commemorative and uncanny, real (in the sense that the plants and images were recognizable and *real*) and yet totally non-real or constructed.

28 Even before she left on her expedition, the newspapers of the day were publishing sensational reports about her plans and motivations; she was described as the suspicious widow out to prove foul play and as the frail little woman trying to compete with Dillon Wallace (who had been with Leonidas on the first fatal expedition and survived). She was, in short, not taken seriously and was criticized for undertaking such an unfeminine task as northern exploration. When she returned claiming success, she was not believed at first, and then, when her success was irrefutable, the task itself was downplayed to a canoeing holiday. I have discussed the reception and context for Mina's 1905 expedition and the attention she continued to receive once the book appeared in my introduction to the 2004 edition of *A Woman's Way*.

29 As I write, at least three films are being made about Mina Benson Hubbard. The 2007 film about Mina and Leonidas Hubbard, directed by Jacques Bouffard, aired as episode 12 of the Radio Canada series *Canada en Amour*.

30 During my visit to North West River, I was impressed with the strong sense of community identity and pride evident among both the settler and indigenous populations. Many of the liveyers spoke eagerly about their memories of Mina and their views about her character and place in their history. They were welcoming to those of us from away, but they were also patiently skeptical about our ability to understand Labrador or to appreciate the full significance of their history.

EPILOGUE: LISTENING FOR THE HEARTBEAT OF A COUNTRY

1 Pollock has written several plays that address war and genocide, beginning with *Walsh* in 1973 and, most recently, with *Man Out of Joint*, which premiered in

2007 and explores the efforts of a Canadian lawyer to help prisoners in Guantanamo Bay. In her radio play *Sweet Land of Liberty*, she dramatizes the trauma and suicide of a Vietnam veteran seeking refuge in Canada, and in her powerful monologue play *Getting It Straight*, her autobiographical character Eme remembers the Second World War and warns against the destruction of the world through a renewed arms race and global nuclear aggression. Pollock never simply points an accusatory finger, however. She always develops her stories to provide historical contexts and Canadian relevance; thus, for example, the lawyer in *Man Out of Joint* is haunted by the ghostly voice of his Italian Canadian father, who reminds him about the profiling of Italian Canadians as "alien enemies" and the internment of average Canadian citizens during the Second World War. Pollock's point is that Canada once more runs the risk of falling into the trap of prejudice and racial profiling — this time against Canadian Muslims.

2 Debates over control of the North are as old, and older, than Canada itself. I discuss this history in *Canada and the Idea of North* but note here that the tensions over American influence in the Yukon during the 1890s gold rush, the US military presence in the Yukon (and elsewhere) during the Second World War, and the continuing activities of the Americans across the Canadian North during and after the Cold War (exemplified by the DEW Line) are once again heating up as the United States continues to dispute control over the waters of the Beaufort Sea; see also *Arctic Front* by Coates et al. In response to this looming threat, the Canadian government has already stepped up military exercises and presence in the North, and has increased funding for scientific research across the Arctic archipelago.

Bibliography

Abella, Irving, and Harold Troper. *None Is Too Many*. Toronto: Lester and Orpen Dennys, 1982.

Adams, Timothy Dow. *Light Writing and Life Writing: Photography in Autobiography*. Chapel Hill and London: University of North Carolina Press, 2000.

Alexei, Robert. *Porcupines and China Dolls*. Toronto: Stoddart, 2002.

Aquin, Benoit. "Lethal Beauty." *Canadian Geographic* 118.2 (March-April 1998): 30-35.

Atwood, Margaret. *The Blind Assassin*. Toronto: Random House, 2000.

—. "Introduction." Farley Mowat, *High Latitudes*. ix-xi.

—. *The Journals of Susanna Moodie*. Toronto: Oxford University Press, 1970. Rpt. with artwork by Charles Pachter. Toronto: Macfarlane Walter and Ross, 1997.

—. "The Labrador Fiasco." *Turn of the Story: Canadian Short Fiction on the Eve of the Millennium*. Ed. Joan Thomas and Heidi Harms. Toronto: Anansi, 1999. 1-13.

—. *Survival: A Thematic Guide to Canadian Literature*. Toronto: Anansi, 1972.

—. "To Be Creative Is, in Fact, Canadian." *Writers' Union of Canada Newsletter* 36.3 (2008): 22-23.

Baikie, June. "Mina's Song." Unpublished play script, 2005.

Barton, John. *West of Darkness/L'ouest de l'ombre*. Trans. Arlette Francière. Ottawa: BuschekBooks, 2006.

Bates, Maxwell. *A Wilderness of Days: An Artist's Experiences as a Prisoner of War in Germany*. Victoria: Sono Nis, 1978.

Bazzana, Kevin. *Wondrous Strange: The Life and Art of Glenn Gould*. Toronto: McClelland and Stewart, 2003.

Beattie, Owen, and John Geiger. *Frozen in Time: Unlocking the Secrets of the Doomed 1845 Arctic Expedition*. New York: Plume, 1987.

Beissel, Henry. *Cantos North*. Moonbeam, ON: Penumbra, 1982.

Berton, Pierre. "Foreword." *A Woman's Way through Unknown Labrador*. By Mina Benson Hubbard. St. John's, NF: Breakwater Books, 1981. n.p.

—. *Hollywood's Canada: The Americanization of Our National Image*. Toronto: McClelland and Stewart, 1975.

—. "Introduction." Robert Shipley, *To Mark Our Place*. 7-10.

—. *Marching as to War*. Toronto: Doubleday, 2001.

—. *Prisoners of the North*. Toronto: Doubleday, 2004.

—. *Vimy*. Toronto: McClelland and Stewart, 1996.

Beynon, Frances. *Aleta Day*. 1919. Peterborough, ON: Broadview Press, 2000.

Birney, Earle. "The Road to Nijmegen." *The Mammoth Corridors*. Okemas, MI: Stone Press, 1990. 10-11.

—. *Turvey*. 1949. Toronto: McClelland and Stewart, 1989.

Bishop, William. *Winged Warfare*. 1919. Toronto: McArthur, 2002.

Blanchard, Paula. *The Life of Emily Carr*. Vancouver: Douglas and McIntyre, 1987.

Bock, Dennis. *The Communist's Daughter*. Toronto: HarperCollins, 2006.

Bourdieu, Pierre. *Distinction: A Social Critique of the Judgment of Taste*. Trans. Richard Nice. Cambridge, MA: Harvard University Press, 1984.

Boyden, Joseph. *Three Day Road*. Toronto: Viking, 2005.

Braid, Kate. *To This Cedar Fountain*. Vancouver: Polestar, 1995.

Brandon, Laura. *Art or Memorial? The Forgotten History of Canada's War Art*. Calgary: University of Calgary Press, 2006.

Braz, Albert. *The False Traitor: Louis Riel in Canadian Culture*. Toronto: University of Toronto Press, 2003.

Brown, Chester. *Louis Riel: A Comic-Strip Biography*. Vancouver: Raincoast Books, 2003.

Brown, Kenneth, and Stephen Scriver. *Letters in Wartime*. 1995. *The West of All Possible Worlds: Six Contemporary Canadian Plays*. Ed. Moira Day. Toronto: Playwrights Canada Press, 2004. 331-81.

Buchanan, Roberta, Anne Hart, and Bryan Greene. *The Woman Who Mapped Labrador: The Life and Expedition Diary of Mina Hubbard*. Montreal and Kingston: McGill-Queen's University Press, 2005.

Byrne, Nympha, and Camille Fouillard, eds. *It's Like the Legend: Innu Women's Voices*. Charlottetown: Gynergy Books, 2000.

Callaghan, Barry, and Bruce Meyer, eds. *We Wasn't Pals: Canadian Poetry and Prose of the First World War*. Toronto: Exile Editions, 2001.

Campbell, Rebecca. "We Gave Our Glorious Laddies." Master's thesis, University of British Columbia, 2007.

Caron, Louis. *The Draft Dodger*. Trans. David Toby Homel. Toronto: Anansi, 1980. Trans. of *L'Emmitouflé*. 1977.

Carr, Emily. *The Complete Writings of Emily Carr*. Introduction by Doris Shadbolt. Vancouver: Douglas and McIntyre, 1997.

Carrier, Roch. *La Guerre, Yes Sir!* Toronto: Anansi, 1968.

—. *The Hockey Sweater*. Trans. Sheila Fischman. Toronto: Tundra Books, 1985.

Cavell, Richard, ed. *Love, Hate, and Fear in Canada's Cold War*. Toronto: University of Toronto Press, 2004.

Chamberlin, Edward J. *If This Is Your Land, Where Are Your Stories? Finding Common Ground*. Toronto: Alfred Knopf, 2003.

Chatman, Stephen. *In Flanders Fields*. Corvallis: Earthsongs, 1998.

Cherney, Brian. "Notes." *North Country: Four Movements for String Orchestra*, by Harry Somers. On *The Spring of Somers*. CBC Records, SDMC5162, 1996.

Clark, Sally. *Wanted*. Vancouver: Talonbooks, 2004.

Clarke, George Elliott. *Beatrice Chancy*. Victoria: Polestar, 2004.

Clarkson, Adrienne. "On Being a Northern Country." Interview with Tom Strickland. *On Site Review* 11 (Spring 2004): 6-7.

Clements, Marie. *Burning Vision*. Vancouver: Talonbooks, 2003.

Coates, Donna, and Sherrill Grace, eds. *Canada and the Theatre of War*. Vol. 1. Toronto: Playwrights Canada Press, 2008.

Coates, Ken S., P. Whitney Lackenbauer, William Morrison, and Greg Poelzer. *Arctic Front: Defending Canada in the Far North*. Toronto: Thomas Allen, 2008.

Coghill, Joy. *Song of This Place*. Toronto: Playwrights Canada Press, 2003.

Colombo, John Robert, and Michael Richardson, eds. *We Stand on Guard: Poems and Songs of Canadians in Battle*. Toronto: Doubleday, 1985.

Colville, Alex. *Alex Colville: Diary of a War Artist*. Comp. Graham Metson and Cheryl Lean. Halifax: Nimbus, 1981.

Comfort, Charles. *Artist at War*. 1956. Pender Island, BC: Remembrance Books, 1995.

Connelly, Karen. "OH, CANADA." *Conversations: A Publication of the Green College Society*. Vol. 4. Vancouver: Green College, University of British Columbia, 2004. 85. Rpt. *Walrus* 4.8 (2008): 75.

Coulter, John. *Riel, a Play in Two Parts*. Hamilton: Cromlech Press, 1972.

—. *The Trial of Louis Riel*. Ottawa: Oberon Press, 1978.

Creighton, Donald. *Dominion of the North: A History of Canada*. Toronto: Macmillan, 1957.

Crummey, Michael. *The Wreckage*. 2005. Toronto: Anchor, 2006.

Dallaire, Roméo. *Shake Hands with the Devil: The Failure of Humanity in Rwanda*. Toronto: Random House, 2003.

Dault, Julia. "How We See Ourselves." *National Post* [Toronto] 4 March 2004: B6.

Davey, Frank. *Back to the War*. Vancouver: Talonbooks, 2005.

Davidson, James West, and John Rugge. *Great Heart: The History of a Labrador Adventure*. Montreal and Kingston: McGill-Queen's University Press, 1997.

Davidson, Peter. *The Idea of North*. London: Reaktion, 2005.

Deverell, Rex. *Beyond Batoche*. *Canadian Drama* 11.2 (1985): 378-427.

Dingle, Adrian. *Nelvana of the Northern Lights*. Toronto: Triumph-Adventure Comics, 1941-47.

Dominion Institute. "The Memory Project." 2001. http://www.thememoryproject.com.

Du Prey, Pierre de la Ruffinière. "Allward's Figures, Lutyens's Flags and Wreaths." *Journal of the Society for the Study of Architecture in Canada* 33.1 (2008): 57-64.

Dulani, Mario. *The City without Women: A Chronicle of Internment Life in Canada during the Second World War*. Trans. Antonino Mazza. Oakville, ON: Mosaic Press, 1994.

Dyer, Gwynne. *Climate Wars*. Toronto: Random House, 2008.

—. *War*. 1985. Toronto: Vintage, 2005.

Eakin, Paul John. *How Our Lives Become Stories: Making Selves*. Ithaca: Cornell University Press, 1999.

Egan, Susanna. *Mirror Talk: Genres of Crisis in Contemporary Autobiography*. Chapel Hill: University of North Carolina Press, 1999.

Egerton, George. "Entering the Age of Human Rights: Religion, Politics and Canadian Liberalism." *Canadian Historical Review* 85.3 (2004): 251-79.

Emily Carr: New Perspectives on a Canadian Icon. Vancouver: Douglas and McIntyre, 2006.

English, John. *Citizen of the World: The Life of Pierre Elliott Trudeau, 1919-1968*. Vol. 1. Toronto: Knopf, 2006.

Estacio, John, and John Murrell. *Filumena*. Calgary Opera Company. Jubilee Auditorium, Calgary. 1 February 2003.

—. *Frobisher*. Calgary Opera Company. Jubilee Auditorium, Calgary. 27 January 2007.

Findley, Timothy. *Can You See Me Yet?* Vancouver: Talonbooks, 1977.

—. *Famous Last Words*. Toronto: Clarke Irwin, 1981.

—. *The Wars*. Toronto: Clarke Irwin, 1977.

Finlay, Karen A. *The Force of Culture: Vincent Massey and Canadian Sovereignty*. Toronto: University of Toronto Press, 2004.

Flanagan, Thomas. *Riel and the Rebellion: 1885 Reconsidered*. Saskatoon: Western Producer Prairie Books, 1983.

Flather, Patti, and Leonard Linklater. *Sixty Below*. *Staging the North*. Ed. Grace, D'Aeth, and Chalykoff. 435-501.

Fraticelli, Rina. "The Invisibility Factor: Status of Women in Canadian Theatre." *Fuse* September 1982: 112-24.

French, David. *Soldier's Heart*. Vancouver: Talonbooks, 2002.

Friedrich, Otto. *Glenn Gould: A Life and Variations*. New York: Random, 1989.

Fussell, Paul. *The Great War and Modern Memory*. New York: Oxford University Press, 1975.

Garay, Kathleen. "John Coulter's *Riel*: The Shaping of a Myth for Canada." *Canadian Drama* 11.2 (1985): 293-309.

Garvin, John, ed. *Canadian Poems of the Great War*. Toronto: McClelland and Stewart, 1918.

Gaucher, Dominique. *On the Surface of Things*. Vancouver: Douglas Udell Gallery, 2006.

Gould, Glenn. *The Idea of North*. 1967. *The Solitude Trilogy: Three Sound Documentaries*. CBC Records, PSCD 2003-3, 1992.

—. "'The Idea of North': An Introduction." Ed. Tim Page. 391-94.

Grace, Sherrill. "Afterword." Robert Kroetsch, *The Man from the Creeks*. 335-41.

—. *Canada and the Idea of North*. 2001. Montreal and Kingston: McGill-Queen's University Press, 2007.

—. "'A Different Kind of Theatre': An Introduction." *Canada and the Theatre of War*. Vol. 1. Ed. Coates and Grace. iii-ix.

—. "Exploration as Construction: Robert Flaherty and *Nanook of the North*." *Representing North. Essays on Canadian Writing* 59 (Fall 1996): 123-46.

—. "From Emily Carr to Joy Coghill ... and Back: Writing the Self in *Song of This Place*." *BC Studies* 137 (Spring 2003): 103-24.

—. *Inventing Tom Thomson: From Autobiographical Fiction to Fictional Autobiography*. Montreal and Kingston: McGill-Queen's University Press, 2004.

—. *Making Theatre: A Life of Sharon Pollock*. Vancouver: Talonbooks, 2008.

—. "'Mina's Song' and the Invention of Mina Benson Hubbard." *Canadian Theatre Review* 128 (Fall 2008): 115-20.

—. "Performing the Auto/biographical Pact: Towards a Theory of Identity in Performance." *Tracing the Autobiographical*. Ed. Marlene Kadar et al. Waterloo, ON: Wilfrid Laurier University Press, 2005. 65-79.

—. "Re-introducing Canadian 'Art of the Theatre': Herman Voaden's 1930 Manifesto." *Canadian Literature* 135 (Winter 1992): 51-63.

—. "Re-inventing Franklin." *Canadian Review of Comparative Literature* 22.3-4 (1995): 707-25.

—. "We Stand on Guard: War in the Canadian North." Unpublished paper, 2008.

Grace, Sherrill, Eve D'Aeth, and Lisa Chalykoff, eds. *Staging the North: Twelve Canadian Plays*. Toronto: Playwrights Canada Press, 1999.

Graham, Gwethalyn. *Earth and High Heaven*. 1944. Toronto: McClelland and Stewart, 1969.

Graham, Jean. "Woman's Sphere." *Canadian Magazine* 31 (September 1908): 468-71.

Granatstein, J.L. *Canada's Army: Waging War and Keeping the Peace*. Toronto: University of Toronto Press, 2004.

Gray, John, and Eric Peterson. *Billy Bishop Goes to War*. Vancouver: Talonbooks, 1981.

Great Unsolved Mysteries in Canadian History. "Death on a Painted Lake: The Tom Thomson Tragedy." http://www.canadianmysteries.ca.

Griffiths, Linda. *Maggie and Pierre*. Vancouver: Talonbooks, 1980.

Gwyn, Sandra. *Tapestry of War: A Private View of Canadians in the Great War*. Toronto: HarperCollins, 1992.

Hamelin, Louis-Édmond. *Canadian Nordicity: It's Your North Too*. Trans. William Barr. Montreal: Harvest, 1979.

Hamilton, John David. *Arctic Revolution: Social Change in the Northwest Territories, 1835-1994*. Toronto: Dundurn, 1994.

Harris, Lawren. *Lawren Harris*. Ed. Bess Harris and R.G.P. Colgrove. Toronto: Macmillan, 1969.

Harrison, Charles Yale. *Generals Die in Bed*. 1930. Hamilton: Potlatch, 1975.

Hart, Anne. "The Life of Mina Benson Hubbard Ellis: Finding Her Way, 1906-1956." Buchanan, Hart, and Greene. 351-438.

Hatzis, Christos. *Footprints in New Snow*. 1996. CBC Records, MVCD 1156.2, 2002.

Hay, Elizabeth. *Late Nights on Air*. Toronto: McClelland and Stewart, 2007.

Hayes, Adrian. *Pegahmagabow: Legendary Warrior, Forgotten Hero*. Huntsville, ON: Fox Meadow, 2003.

Hendry, Tom. *Fifteen Miles of Broken Glass*. Vancouver: Talonbooks, 1975.

Hill, Charles. *The Group of Seven: Art for a Nation/Le group des sept: L'émergence d'un art national*. Ottawa: National Gallery of Canada, 1995.

Hille, Veda. *Here Is a Picture (Songs for E. Carr)*. SOCAN VH114, 1997.

Hodgins, Bruce, Jamie Benedickson, and George Rawlyk, eds. *The Canadian North: Source of Wealth or Vanishing Heritage?* Scarborough, ON: Prentice-Hall, 1977.

Hodgins, Jack. *Broken Ground*. Toronto: McClelland and Stewart, 1998.

Holmes, Nancy. "'In Flanders Fields' — Canada's Official Poem: Breaking Faith." *Studies in Canadian Literature* 30.1 (2005): 11-33.

Hubbard, Mina Benson. "Labrador Expedition Diary, 16 June-27 December 1905." Ed. Roberta Buchanan. Buchanan, Hart, and Greene. 105-349.

—. *A Woman's Way through Unknown Labrador*. 1908. Ed. Sherrill Grace. Montreal and Kingston: McGill-Queen's University Press, 2004.

Hunt, William R. *Stef: A Biography of Vilhjalmur Stefansson*. Vancouver: UBC Press, 1986.

Hutcheon, Linda, and Michael Hutcheon. "Otherhood Issues: Post-national Operatic Narratives." *Narrative* 3.1 (1995): 1-17.

Innis, Harold. *The Fur Trade in Canada: An Introduction to Canadian Economic History*. New Haven: Yale University Press, 1930.

Iwata, Carol, and Judith Niemi. "Women's Ways in Labrador." *Woodswomen's News* 2.1 (1983): 6-7.

Jeffery, Lawrence. *Who Look in Stove*. Toronto: Exile Editions, 1993.

Jenkins, McKay. *Bloody Falls of the Coppermine: Madness, Murder, and the Collision of Cultures*. Toronto: Random House, 2004.

Johnson, Chris. "Guest Editorial." *Canadian Drama* 11.2 (1985): 291-92.

Kahn, Leon. *No Time to Mourn: The True Story of a Jewish Partisan Fighter*. Vancouver: Ronsdale Press, 2007.

Kerr, Kevin. *Unity (1918)*. Vancouver: Talonbooks, 2002.

Klein, Clayton. *Challenge the Wilderness: The Legend of George Elson*. Fowlerville, MI: Wilderness Adventure Books, 1988.

Kogawa, Joy. *Obasan*. Toronto: Lester and Orpen Dennys, 1981.

Kordan, Bohdan S. *Enemy Aliens, Prisoners of War: Internment in Canada during the Great War*. Montreal and Kingston: McGill-Queen's University Press, 2002.

Kroetsch, Robert. *The Man from the Creeks*. 1998. Toronto: McClelland and Stewart, 2008.

La Flamme, Michelle. "Indigenous Women Living beyond the Grave: From Pollock to Pechawis." *Sharon Pollock*. Ed. Sherrill Grace and Michelle La Flamme. Toronto: Playwrights Canada Press, 2008. 160-75.

—. "Living, Writing, and Staging Racial Hybridity." PhD diss., University of British Columbia, 2006.

Langley, Rod. *Bethune*. Vancouver: Talonbooks, 1975.

Larisey, Peter. *Light for a Cold Land: Lawren Harris's Work and Life — An Interpretation*. Toronto: Dundurn, 1993.

Laurence, Robin. "Our Emily: Locating Ourselves in a National Icon." *Canadian Art* 22.1 (2005): 64-68.

Lawson, Mary. *The Other Side of the Bridge*. Toronto: Knopf, 2006.

Leacock, Stephen. "I'll Stay in Canada." *Funny Pieces: A Book of Random Sketches*. New York: Dodd, Mead, 1936. 284-92.

Lejeune, Philippe. "The Autobiographical Pact (Bis)." *On Autobiography*. Ed. Paul John Eakin. Trans. Katherine Leary. Minneapolis: University of Minnesota Press, 1989. 119-37.

Lepage, Robert, with Ex Machina. *Seven Streams of the River Ota*. London: Methuen, 1996.

Levine, Karen. *Hana's Suitcase*. Toronto: Second Story Press, 2006.

Library and Archives Canada. "Portrait Gallery of Canada/Musée du portrait du Canada." http://www.portraits.gc.ca.

Lill, Wendy. *The Occupation of Heather Rose*. *Staging the North*. Ed. Grace, D'Aeth, and Chalykoff, 299-330.

Lindsay, Oliver. *The Battle for Hong Kong, 1941-1945: Hostage to Fortune*. Montreal and Kingston: McGill-Queen's University Press, 2006.

Litt, Paul. *The Muses, the Masses, and the Massey Commission*. Toronto: University of Toronto Press, 1992.

Little, William T. *The Tom Thomson Mystery*. Toronto: McGraw-Hill, 1970.

Livesay, Dorothy. "Autumn: 1939." *Collected Poems: The Two Seasons*. Toronto: McGraw-Hill Ryerson, 1972. 104.

MacDonald, Gayle. "Tragedy at the Top of the World." *Globe and Mail* [Toronto] 18 March 2006: R1, R5.

Macfarlane, David. *The Danger Tree: Memory, War, and the Search for a Family's Past*. Toronto: Vintage, 2000.

MacGregor, Roy. *Canoe Lake*. Toronto: McClelland and Stewart, 2002.

MacLennan, Hugh. 1941. *Barometer Rising*. Toronto: McClelland and Stewart, 1989.

—. *The Watch That Ends the Night*. Toronto: Macmillan, 1959.

Major, John. *No Man's Land*. Toronto: Doubleday, 1995.

Malvern, Sue. *Modern Art, Britain and the Great War: Witnessing, Testimony and Remembrance*. New Haven and London: Yale University Press, 2004.

Massey, Vincent. "Art and Nationality in Canada." *Transactions of the Royal Society of Canada*. Vol. 24. Ottawa: Royal Society of Canada, 1930. 59-72.

—. *On Being Canadian*. London and Toronto: J.M. Dent, 1948.

Massicotte, Stephen. *Mary's Wedding*. Toronto: Playwrights Canada Press, 2002.

Mattes, Catherine. "Rielisms." *Rielisms*. Winnipeg: Winnipeg Art Gallery, 2001. 12-22.

McCrae, John. *In Flanders Fields and Other Poems.* Toronto: William Briggs, 1919.

McDougall, Colin. *Execution.* 1958. Toronto: McClelland and Stewart, 2004.

McNairn, Alan. *Behold the Hero: General Wolfe and the Arts in the Eighteenth Century.* Montreal and Kingston: McGill-Queen's University Press, 1997.

Michaels, Anne. *Fugitive Pieces.* Toronto: McClelland and Stewart, 1996.

Mitchell, Ken. *Gone the Burning Sun.* Toronto: Playwrights Canada Press, 1984.

Monk, Katherine. *Weird Sex and Snowshoes, and Other Canadian Film Phenomena.* Vancouver: Raincoast Books, 2001.

Morton, Desmond. *A Military History of Canada.* Edmonton: Hurtig, 1985.

Morton, Desmond, and J.L. Granatstein. *Marching to Armageddon: Canadians and the Great War, 1914-1919.* Toronto: Lester and Orpen Dennys, 1989.

Morton, W.L. *The Canadian Identity.* 1961. 2nd ed. Madison: University of Wisconsin Press, 1972.

Mouawad, Wajdi. *Scorched.* Trans. Linda Gaboriau. Toronto: Playwrights Canada Press, 2005.

Mowat, Farley. *And No Birds Sang.* Toronto: McClelland and Stewart, 1979.

—. *High Latitudes.* Toronto: Key Porter, 2002.

—. *Never Cry Wolf.* Toronto: McClelland and Stewart, 1963.

—. *No Man's River.* Toronto: Key Porter, 2004.

—. *Ordeal by Ice: The Search for the Northwest Passage.* Toronto: McClelland and Stewart, 1989.

—. *Otherwise.* Toronto: McClelland and Stewart, 2008.

—. *People of the Deer.* Toronto: McClelland and Stewart, 1952.

—. *The Polar Passion: The Quest for the North Pole.* Toronto: McClelland and Stewart, 1967.

—. *The Snow Walker.* Toronto: McClelland and Stewart, 1975.

Moyles, R.G. *British Law and Arctic Men: The Celebrated 1917 Murder Trials of Sinnisiak and Uluksuk, First Inuit Tried under White Man's Laws.* Saskatoon: Western Producer Books, 1979.

Munro, Alice. "The Bear Came over the Mountain." *Hateship, Friendship, Courtship, Loveship, Marriage.* Toronto: Penguin Canada, 2001. 279-327.

Murray, Joan, ed. *Letters Home: 1859-1906. The Letters of William Blair Bruce.* Moonbeam, ON: Penumbra, 1982.

—. *Tom Thomson: Trees.* Toronto: McArthur, 1999.

Murrell, John. "Frobisher: Program Notes." *Calgary Opera,* 2006-07. Calgary: Winter-Spring Program, 2006. 25.

—. *Waiting for the Parade.* Vancouver: Talonbooks, 1980.

Nasgaard, Roald. *The Mystic North: Symbolist Landscape Painting in Northern Europe and North America, 1890-1940.* Toronto: University of Toronto Press, 1984.

Nelles, H.V. *The Art of Nation-Building: Pageantry and Spectacle at Quebec's Tercentenary.* Toronto: University of Toronto Press, 1999.

Nelson, Joyce. "Home Front, 1942." Heather Robertson, *A Terrible Beauty.* 188.

Nemni, Max, and Monique Nemni. *Young Trudeau: Son of Quebec, Father of Canada, 1919-1944.* Trans. William Johnson. Toronto: McClelland and Stewart, 2006.

Noel, Lynn E. *A Woman's Way, Songs and True Stories of Northern Women Explorers.* 2001. http://home.att.net/~lynnoel/programs/AWW_Biblio.html. Page now discontinued.

Nolan, Yvette. *Annie Mae's Movement.* Toronto: Playwrights Canada Press, 2006.

Nora, Pierre. "Between Memory and History: *Les Lieux de Mémoire.*" Trans. Marc Roudebush. *Representations* 26 (Spring 1989): 7-25.

Nothof, Anne. "Staging a Woman Painter's Life: Six Versions of Emily Carr." *Mosaic* 31.3 (1998): 83-109.

Novak, Dagmar. *Dubious Glory: The Two World Wars and the Canadian Novel.* New York: Peter Lang, 2000.

Nowlan, Alden. "Ypres, 1915." *Selected Poems.* Toronto: Anansi, 1996. 63.

Oliver, Dean F., and Laura Brandon. *Canvas of War: Painting the Canadian Experience, 1914 to 1945.* Vancouver/Ottawa: Douglas and McIntyre/Canadian War Museum, 2000.

Ondaatje, Michael. *The English Patient.* Toronto: McClelland and Stewart, 1992.

Osler, E.B. *The Man Who Had to Hang: Louis Riel.* Toronto: Longmans Green, 1961.

Page, Tim, ed. *The Glenn Gould Reader.* Toronto: Lester and Orpen Dennys, 1984.

Poling, Jim. *Tom Thomson: The Life and Mysterious Death of the Famous Canadian Painter.* Canmore, AB: Altitude, 2003.

Pollock, Sharon. *Fair Liberty's Call. Sharon Pollock: Collected Works.* Vol. 2. Toronto: Playwrights Canada Press, 2006. 359-418.

—. *Getting It Straight. Sharon Pollock: Collected Works.* Vol. 2. 227-62.

—. *Kabloona Talk. Sharon Pollock: Collected Works.* Vol. 3. Toronto: Playwrights Canada Press, 2008. 305-65.

—. *The Making of Warriors. Sharon Pollock: Collected Works.* Vol. 3. 227-54.

—. *Man Out of Joint. Sharon Pollock: Collected Works.* Vol. 3. 259-99.

—. *Sweet Land of Liberty. Sharon Pollock: Collected Works.* Vol. 1. Toronto: Playwrights Canada Press, 2005. 177-212.

—. *Walsh. Sharon Pollock: Collected Works.* Vol. 1. 33-95.

Poole, Michael. *Rain before Morning.* Madeira Park, BC: Harbour, 2006.

Pratt, Alexandra. *Lost Lands, Forgotten Stories: A Woman's Journey to the Heart of Labrador.* Toronto: HarperCollins, 2002.

Raab, Elisabeth M. *And Peace Never Came.* Ed. Marlene Kadar. Waterloo: Wilfrid Laurier University Press, 1997.

Racette, Sherry Farrell. "Metis Man or Canadian Icon: Who Owns Louis Riel?" Catherine Mattes, *Rielisms.* 42-53.

Ralph, Joel. "Vimy Revisited." *Beaver* April-May 2007: 36-41.

Report: Royal Commission on National Development in the Arts, Letters, and Sciences, 1949-1951. [Massey-Lévesque Commission] Ottawa: Edmond Cloutier, 1951.

Richler, Mordecai. *Solomon Gursky Was Here*. Harmondsworth: Penguin, 1990.

Roberts, Charles G.D. "Going Over (the Somme, 1917)." *The Collected Poems of Sir Charles G.D. Roberts: A Critical Edition*. Ed. Desmond Pacey. Wolfville: Wombat, 1985. 304.

Robertson, Heather. *A Terrible Beauty: The Art of Canada at War*. Oshawa and Ottawa: James Lorimer and the Robert McLaughlin Gallery, 1977.

Rogers, Stan. *Northwest Passage*. Fogarty's Cove Music, FCM 004D, 1981.

Ross, Val. "Scenes from the Front." *Globe and Mail* [Toronto] 28 August 2006: R1-R2.

Roy, Gabrielle. *La Montagne secrète*. Montreal: Beauchemin, 1961.

Schafer, R. Murray. "Program Note." *North/White*. *On Canadian Music*. Bancroft, ON: Arcana Editions, 1984. 62-63.

—. *North/White*. London and Toronto: Universal, 1980.

Schama, Simon. *Dead Certainties (Unwarranted Speculations)*. New York: Knopf, 1991.

Scott, D.C. "To a Canadian Aviator Who Died for His Country in France." *The Poems of Duncan Campbell Scott*. Toronto: McClelland and Stewart, 1926. 306-7.

Service, Robert. "Men of the High North." *The Best of Robert Service*. 1940. Toronto: McGraw-Hill Ryerson, 2001. 34-35.

—. "The Shooting of Dan McGrew." *The Best of Robert Service*. 11-14.

—. "A Song of Winter Weather." *Rhymes of a Red Cross Man*. New York: Barse and Hopkins, 1916. 45-46.

Shadbolt, Doris. *The Art of Emily Carr*. Vancouver: Douglas and McIntyre, 2003.

Shandler, Rhodea. *A Long Labour: A Dutch Mother's Holocaust Memoir*. Vancouver: Ronsdale Press, 2007.

Shanly, Charles. "The Walker of the Snow." *Atlantic* Monthly 3.19 (May 1859): 6341-42. Sherrill Grace, *Canada and the Idea of North*. 107-9.

Sherman, Jason. *None Is Too Many*. *A Terrible Truth: An Anthology of Holocaust Drama*. Vol. 2. Ed. Irene N. Watts. Toronto: Playwrights Canada Press, 2004. 81-155.

Shipley, Robert. *To Mark Our Place: A History of Canadian War Memorials*. Toronto: NC Press, 1987.

Siggins, Maggie. *Riel: A Life of Revolution*. Toronto: HarperCollins, 1994.

Silvis, Randall. *Heart so Hungry: The Extraordinary Expedition of Mina Hubbard into the Labrador Wilderness*. Toronto: Knopf, 2004.

Somers, Harry. *Louis Riel*. Opera. Libretto by Mavor Moore and Jacques Languirand. Toronto: Canadian Opera Company, 1967.

—. *North Country: Four Movements for String Orchestra*. 1948. *The Spring of Somers*. CBC Records, SMCD5162, 1996.

Souster, Raymond. "The Dresden Special." *Selected Poems of Raymond Souster*. Ottawa: Oberon, 1972. 108.

—. *Jubilee of Death: The Raid on Dieppe*. Ottawa: Oberon, 1984.

Stacey, Robert. "Tom Thomson: 'Deeper into the Forest.'" *OKanada*. Ottawa: Canada Council, 1982. 70-79.

Stanley, George F.G. *Louis Riel*. Toronto: Ryerson Press, 1963.

Stefansson, Vilhjalmur. *The Friendly Arctic: The Story of Five Years in Polar Regions*. New York: Macmillan, 1922.

Stein, Janice, and Eugene Lang. *The Unexpected War: Canada in Kandahar*. Toronto: Penguin, 2007.

Sturken, Marita. "Personal Stories and National Meanings: Memory, Re-enactment, and the Image." *Seductions of Biography*. Ed. Mary Rhiel and David Suchoff. New York and London: Routledge, 1996. 31-41.

Thiessen, Vern. *Vimy*. Toronto: Playwrights Canada Press, 2008.

Thomson, R.H. *The Lost Boys*. Toronto: Playwrights Canada Press, 2002.

Tibballs, Geoff. *Due South: The Official Companion*. New York: Titan, 1998.

Tippett, Maria. *Emily Carr: A Biography*. Toronto: Oxford University Press, 1979.

Todd, Paula. "Series Makes the Connection." *Globe and Mail* [Toronto] 5 April 2008: D6.

Town, Harold, and David P. Silcox. *Tom Thomson: The Silence and the Storm*. Toronto: McClelland and Stewart, 1977. Rpt. Toronto: Firefly Books, 2001.

Udall, Sharyn Rohlfsen. *Carr, O'Keefe, Kahlo: Places of Their Own*. New Haven: Yale University Press, 2000.

Urquhart, Jane. *The Stone Carvers*. Toronto: McClelland and Stewart, 2001.

Van Camp, Richard. *The Lesser Blessed*. Vancouver: Douglas and McIntyre, 1996.

Vance, Jonathan. *Death so Noble: Memory, Meaning, and the First World War*. Vancouver: UBC Press, 1997.

Vanderhaeghe, Guy. *Dancock's Dance*. Winnipeg: Blizzard, 1996.

—. *The Englishman's Boy*. Toronto: McClelland and Stewart, 1996.

Voaden, Herman. *Six Canadian Plays*. Toronto: Copp Clark, 1930.

—. *A Vision of Canada: Herman Voaden's Dramatic Works, 1928-1945*. Ed. Anton Wagner. Toronto: Simon and Pierre, 1993.

Vreeland, Susan. *The Forest Lover*. Toronto: Penguin, 2004.

Wagner, Colleen. *The Monument*. Toronto: Playwrights Canada Press, 1993.

Watson, Alexander John. *Marginal Man: The Dark Vision of Harold Innis*. Toronto: University of Toronto Press, 2006.

Wiebe, Rudy. *A Discovery of Strangers*. Toronto: Knopf, 1994.

—. *Playing Dead: A Contemplation concerning the Arctic*. 1989. Edmonton: NeWest, 2003.

—. *The Scorched-Wood People*. Toronto: McClelland and Stewart, 1977.

Willson, Beckles. *Redemption*. New York: Putnam, 1924.

Woodcock, George. *Gabriel Dumont*. Edmonton: Hurtig, 1975.

Wynne-Jones, Tim. *The Maestro*. Toronto: Groundwood Books, 1995.

Young, David. *Glenn*. Toronto: Coach House, 1992.

Youssef, Marcus, and Guillermo Verdecchia. *A Line in the Sand*. Vancouver: Talonbooks, 1997.

FILMS

Ararat. Dir. Atom Egoyan. Miramax and Alliance Atlantis, 2002.

Arctic Dreamer: The Lonely Quest of Vilhjalmur Stefansson. Dir. Peter Raymont. White Pine Pictures and National Film Board of Canada (NFB), 2003.

Arctic Mission. Dir. Jean Lemire. NFB and Glacialis Productions, 2004.

Atanarjuat (The Fast Runner). Dir. Zacharias Kunuk. Igloolik Isuma Productions, 2001.

Away from Her. Dir. Sarah Polley. Film Farm, 2006.

Back to God's Country. Dir. Nell Shipman. 1919. Restored, Idaho Film Collection, 1996.

Bethune: The Making of a Hero. Dir. Phillip Borsos. Filmline International, 1990.

Bye Bye Blues. Dir. Anne Wheeler. Alberta Motion Picture Development Corporation, NFB, and Téléfilm Canada, 1989.

Canada at War. Dir./Prod. Donald Brittain, Stanley Clish, and Peter Jones. NFB, 2005.

Canada Remembers. 3 vols. Dir. Terence Macartney-Filgate. NFB, 1995.

Canada's War in Colour. Dir. Karen Shopsowitz. CBC, 2005.

Canvas of War: The Art of World War II. Dir. Michael Ostroff. Narrated by R.H. Thomson. Sound Venture Productions, 2000.

Days of Glory (Indigènes). Dir. Rachid Bouchareb. Tessalit Productions, 2006.

Due South. Dir. George Bloomfield et al. Alliance Atlantis and CBS, 1994-96.

The Englishman's Boy. Dir. John N. Smith. CBC, 2008.

Far from Home: Canada and the Great War. Dir./Prod. Richard Nielson. NFB, 1999.

The Far Shore. Dir. Joyce Wieland. 1976. Liberty, 1978.

49th Parallel. Dir. Michael Powell. General Film, 1941.

Glenn Gould Hereafter. Dir. Bruno Monsaingeon. Idéale Audience and Rhombus Media, 2005.

Going Home. Dir. Terence Ryan. CBC/BBC Wales, 1987.

The Great War. Dir. Brian McKenna. NFB/CBC, 2007.

John McCrae's War: In Flanders Fields. Dir. Robert Duncan. NFB, 1998.

The Journals of Knud Rasmussen. Dirs. Zacharias Kunuk and Norman Cohn. Igloolik Isuma Productions, 2006.

Joyeux Noël. Dir. Christian Carion. Sony Pictures, 2005.

Map of the Human Heart. Dir. Vincent Ward and Louis Nowra. Miramax Films, 1993.

March of the Penguins. Dir. Luc Jacquet. Warner Independent, 2006.

Mina et Leonidas Hubbard: L'amour qui fait voyager. Canada en Amour, episode 12. Dir. Jacques Bouffard. Les productions Vic Pelletier, 2007.

Nanook of the North. Dir. Robert Flaherty. Pathé, 1922.

Never Cry Wolf. Dir. Carroll Ballard. Walt Disney Pictures, 1983.

North of 60. Exec. Prod. Robert Lantos. CBC, 1992-97.

Passage. Dir. John Walker. NFB, 2008.

Passchendaele. Dir. Paul Gross. Rhombus and Alliance Atlantis, 2008.

Perfect Pie. Dir. Barbara Willis Sweete. Odeon Films, 2002.

Project Grizzly. Dir. Peter Lynch. NFB, 1996.

The Road to Nunavut: The Kreelak Story. Dir. Ole Gjerstad and Martin Kreelak. NFB, 1999.

The Rocket. Dir. Charles Binamé. Alliance Atlantis and Odeon, 2005.

Rose-Marie. Dir. W.S. Van Dyke. MGM, 1936.

Sergeant Preston of the Yukon. Series. Rhino Video Distributors, 1989.

Shake Hands with the Devil. Dir. Roger Spottiswoode. Seville Pictures, 2007.

Shake Hands with the Devil: The Journey of Roméo Dallaire. Dir. Peter Raymont. California Newsreel Productions, 2005.

The Snow Walker. Dir. Charles Martin Smith. Lions Gate Films, 2004.

The Spirit of Anna Mae. Dir. Catherine Anne Martin. NFB, 2002.

Thirty-Two Short Films about Glenn Gould. Dir. François Girard. By François Girard and Don McKellar. Rhombus Media, 1993.

Through These Eyes. Dir. Charles Laird. NFB, 2004.

Trudeau. Dir. Jerry Ciccoritti. CBC, 2002.

The Valour and the Horror. Dir. Brian McKenna. NFB, 1992.

Village of Widows: The Story of the Sahtu Dene. Dir. Peter Blow. Lindum Films, 1999.

The War between Us. Dir. Anne Wheeler. Troika, 1994.

A War Story. Dir. Anne Wheeler. NFB, 1981.

Wedding in White. Dir. William Fruet. Cinépix Film, 1972.

The White Planet. Dir. Thierry Piantanida and Thierry Ragobert. Bac Film International, 2006.

Index

A Discovery of Strangers, 43, 48, 108, 116. *See also* Wiebe, Rudy

"A Song of Winter Weather," 64-65. *See also* Service, Robert

A Terrible Beauty: The Art of Canada at War, 58-59, 68. *See also* Robertson, Heather

A Terrible Truth, 79

A War Story, film, 70, 77. *See also* Wheeler, Anne

A Woman's Way through Unknown Labrador, 28, 49, 144, 147, 151, 162 n4, 164 n19. *See also* Hubbard, Mina Benson

"AFTERWORD: SELF-PORTRAIT," 127. *See also* Braid, Kate; *To This Cedar Fountain*

Aglukark, Susan, 35, 104

Alexei, Robert, 38, 54

Allward, Walter, 13, 56, 60, 97, 104-5, 156, 157, 164 n1

Aquash, Anna Mae Pictou, 109, 171 n7

Aquin, Benoit, 27

Arctic Mission, film, 44-45

"Art and Nationality in Canada," 4. *See also* Massey, Vincent

Art or Memorial? The Forgotten History of Canada's War Art, 69. *See also* Brandon, Laura

Artist at War, 60, 69-70. *See also* Comfort, Charles

Atanarjuat, film, 28, 42. *See also* Kunuk, Zacharias

Atwood, Margaret, 2, 31, 55, 63, 101, 108, 109, 131, 147, 152

Back to the War, 66-67. *See also* Davey, Frank

Baikie, June, 149-50

Barometer Rising, 67-68. *See also* MacLennan, Hugh

Batoche–Louis David, 121. *See also* Boyle, John

Bayefsky, Aba, 95

Beaumont-Hamel, 103

Beattie, Owen, 38

Beissel, Henry, 43

Benyon, Frances, 67

Berton, Pierre, 11, 14, 23, 29, 30, 31, 32, 33, 41, 55, 60, 147

Bethune, film, 170-71 n5

Bethune, Norman, 108

Beyond Batoche, 119-21. *See also* Deverell, Rex

Billy Bishop Goes to War, 65, 81-82, 84, 108. *See also* Murrell, John

Birney, Earle, 7, 60, 65, 66, 67, 81

Bishop, William, 81, 84, 96, 108

Blake, Gilbert, 148

Bletcher Jr., Martin, 135

Blind Assassin, The, 55, 63, 101. *See also* Atwood, Margaret

Blow, Peter, 89, 164 n17
Bobak, Molly Lamb , 87, 95
Bock, Dennis, 108
Bourassa, Henri, 93, 161n6, 168-69 n25
Bourdieu, Pierre, 43
Boyden, Joseph, 48, 87, 88, 96, 104
Boyle, John, 113, 121, 124
Braid, Kate, 125-29, 131
Brandon, Laura, 69, 83
Braz, Albert, 111, 124
Broken Ground, 90, 91-92. *See also*
 Hodgins, Jack
Brown, Chester, 113-15
Bruce, Blair, 25-26, 28, 33, 37
Burning Vision, 46-47, 89-90. *See also*
 Clements, Marie
Bye Bye Blues, film, 75, 77-78. *See also*
 Wheeler, Anne

Campbell, Nicholas, 14, 76
Can You See Me Yet?, 57, 58, 75, 78.
 See also Findley, Timothy
Canada and the Idea of North (Sherrill
 Grace), 12, 18, 26, 35
Canada and the Theatre of War (ed.
 Donna Coates and Sherrill
 Grace), 80
Canada Remembers, film, 68, 87
Canada's War in Colour, film, 68, 70
Canoe Lake, 137-38. *See also*
 MacGregor, Roy
Canvas of War, exhibition and
 catalogue, 11, 59, 94-95, 99
Canvas of War: The Art of World War II,
 film, 95
Caron, Louis, 58, 88
Carr, Emily, 12, 13, 108, 110, 112, 120,
 123-33, 142, 143, 151, 152
Carver, Brent, 75
Chamberlin, Edward, 2
Chatman, Stephen, 64
Cherney, Brian, 35
Chrétien, Jean, 8-10

Clark, Paraskeva, 65
Clark, Sally, 29, 41-42, 47
Clarke, George Elliott, 13
Clarkson, Adrienne, 17, 32
Clements, Marie, 14, 29, 46, 47, 54, 79,
 89, 96
Coghill, Joy, 13, 125, 129-31
Colville, Alex, 60, 66, 72, 95
Comfort, Charles, 60, 69-71, 72
Connelly, Karen, 3-4, 6, 109, 131, 143,
 158
Coulter, John, 117, 119
Creighton, Donald, 116
Crummey, Michael, 63, 80, 87
Currie, Sir Arthur, 108

Dallaire, Roméo, 96, 97, 108
Danushevsky, Andrew Danson, 8-9
Dault, Julia, 8, 9
Davey, Frank, 66, 67
Days of Glory (Indigènes), film, 88-89
Death of General Wolfe, The, 72-73, 166
 n15. *See also* West, Benjamin
"Death on a Painted Lake: The Tom
 Thomson Tragedy," website, 143
"Deep Woods," 125. *See also* Braid,
 Kate; *To This Cedar Fountain*
Deverell, Rex, 119-20
Diefenbaker, John, 34
"Dresden Special, The," 58. *See also*
 Souster, Raymond
Due South, film, 34
Dumont, Gabriel, 110, 114, 115, 116-17,
 152

Elson, George, 50, 144, 145, 147, 148
*Emily Carr: New Perspectives on a
 Canadian Icon* (exhibition
 catalogue), 124
English, John, 94, 109
English Patient, The, 69, 80. *See also*
 Ondaatje, Michael
Espinal, Panya Clark, 137, 140-41, 158

Estacio, John, 13, 48
Execution, 57, 67, 69. *See also*
 McDougall, Colin

Fafard, Joe, 124
Fair Liberty's Call, 79, 101, 154, 155-56.
 See also Pollock, Sharon
Famous Last Words, 75. *See also*
 Findley, Timothy
Far Shore, The, film, 8, 136. *See also*
 Wieland, Joyce
Feore, Colm, 36, 109
Findley, Timothy, 12, 13, 57, 58, 72-75,
 79, 80, 96, 97, 100
First Snow, 137, 140-42, 158. *See also*
 Espinal, Panya Clark
Flaherty, Robert, 28, 29
49th Parallel, The, film, 85
Franklin, Sir John, 38, 48, 108, 157
Fraser, Shannon, 135
French, David, 60, 95
Friendly Arctic, The, 30. *See also*
 Stefansson, Vilhjalamur
Frobisher, Sir Martin, 48, 49, 52-53
Frobisher, opera, 52-53. *See also*
 Estacio, John; Murrell, John
"From Emily Carr to Joy Coghill," 129

Gaucher, Dominique, 54
Generals Die in Bed, 57, 67. *See also*
 Harrison, Charles Yale
Girard, Francois, 36, 37, 109
Glenn Gould Hereafter, film, 171 n9
Going Home, film, 75-77, 78-79, 92
Goldhammer, Charles, 95
Gould, Glenn, 13, 19, 36-37, 38, 54, 75,
 109
Graham, Gwethalyn, 57
Graham, Jean, 151
Granatstein, J.L., 11
Gray, John, 65, 81, 82
Great War, The, film, 70, 94, 101-3, 109
Griffiths, Linda, 109

Gross, Paul, 34, 60
Group of Seven, 15, 18, 29, 39, 132, 133,
 153
Group of Seven: Art for a Nation, The
 (exhibition), 39
Gwyn, Sandra, 56, 92-94, 96, 97, 103,
 105

Hamelin, Louis-Édmond, 15, 17, 38,
 158
Harper, Stephen, 103, 104
Harris, Lawren, 16, 18-19, 29, 32-33,
 132-33, 153, 161-62 n1
Harris, Lawren P., 99
Harrison, Charles Yale, 57, 67
Hatzis, Christos, 14, 54, 109
Hay, Elizabeth, 48
Henderson, Ann, 150
Here Is a Picture (Songs for E. Carr),
 131-33; "Meeting the Group of 7,"
 132-33. *See also* Hille, Veda
Hille, Veda, 125, 131-32
Hodgins, Jack, 60, 77, 80, 90, 91-92
Holocaust Remembrance Day, 80
Hornby, John, 30, 48
Hubbard Jr., Leonidas, 49, 144, 148, 149,
 150
Hubbard, Mina Benson, 12, 28, 38, 48,
 49-51, 53, 108, 109, 110, 112, 120, 133,
 143-51, 152

Idea of North, The, 19, 37. *See also*
 Gould, Glenn
"I'll Stay in Canada," 18. *See also*
 Leacock, Stephen
"In Flanders Fields," 63-64, 90, 104. *See
 also* McCrae, John
Innis, Harold, 16, 93
Inventing Tom Thomson (Sherrill
 Grace), 136, 141
*It's Like the Legend: Innu Women's
 Voices* (ed. Nympha Byrne and
 Camille Fouillard), 38

Iwata, Carol, 147

Jack Pine, The, 134, 136. *See also* Thomson, Tom
Jackson, A.Y., 18, 133, 135, 143, 153
"Jean Chretien, 1985: Self-Portrait," photograph, 9-10
Jeffery, Lawrence, 48
Jenkins, McKay, 51
John McCrae's War: In Flanders Fields, film, 165 n7
Johnson, Pauline, 108-9, 147, 171 n8
Journals of Knud Rasmussen, The, film, 45-46
Journals of Susanna Moodie, The, 108, 131. *See also* Atwood, Margaret
Joyal, Miguel, 121-22

Kabloona Talk, 52, 53. *See also* Pollock, Sharon
Kearns, Gertrude, 97, 169 n28
Klein, A.M., 79
Klein, Clayton, 147
Klondike Gold Rush, 40-41, 47
Kogawa, Joy, 63, 77, 80
Kroetsch, Robert, 40-41, 42, 47
Kunuk, Zacharias, 28, 42, 45-46

La Flamme, 123, 161 n7
Languirand, Jacques, 117, 119
Lawson, Mary, 48, 80
Le Roux, Father, 48-49, 51
Leacock, Stephen, 18
Lemay, Marcien, 113, 121-22
Lepage, Robert, 63
Lévesque, Georges-Henri, 5
Lill, Wendy, 19-20, 29
Lindsay, Oliver, 63
Lismer, Arthur, 39, 133
Little, William, 135
Livesay, Dorothy, 65
Lost Boys, The, 77, 80-81, 90-91. See also Thompson, R.H.

Louis Riel, opera, 117-19. *See also* Moore, Mavor; Somers, Harry
MacDonald, J.E.H., 133, 135, 161n1
MacDonald, Martha, 150
MacGregor, Roy, 137-38
MacLennan, Hugh, 58, 67-68, 108, 153; *Barometer Rising*, 67-68
Magnetic North Mask, 17. *See also* Proch, Don
Major, John, 95
Malvern, Sue, 2
Man from the Creeks, The, 40. *See also* Kroetsch, Robert
Man Out of Joint, 173-74 n1. *See also* Pollock, Sharon
Map of the Human Heart, film, 167 n18
Massey, Vincent, 4-7, 12, 17
Mattes, Catherine, 121
McClung, Nellie, 108
McCrae, John, 57, 63, 64, 65, 90, 101, 108
McDougall, Colin, 57, 67, 69
McKenna, Brian, 68, 70, 94, 101-2, 103, 105
McKenna, Terence, 68, 70
"Meeting the Group of 7." *See Here Is a Picture (Songs for E. Carr)*
"Memory Project, The," 96-97
Men in Scarlet, radio serial, 33, 34, 36
Mercator, Gerardus, 21, 24
Michaels, Anne, 80
Mina et Leonidas Hubbard: L'amour qui fait voyager, film, 145, 147, 149, 151
Mina Hubbard Centennial, 50-51, 146-51
Mina's Song, 147, 149-50. *See also* Baikie, June
Mistook North, The, 15, 16, 141. *See also* Pachter, Charles
Moodie, Susanna, 108, 131
Moore, Mavor, 14, 117-18, 119, 153

Morton, Desmond, 11, 154
Morton, W.L., 116
Mowat, Farley, 14, 23, 29, 30-31, 32, 43-44, 69, 163 n15
Moyles, R.G., 51
Murphy, Emily, 108
Murray, Joan, 142
Murrell, John, 13, 48, 52-53, 65, 77, 82, 85

Nanook of the North, film, 28, 29. See also Flaherty, Robert
National Film Board of Canada, films by, 44-45, 58
Nelvana of the Northern Lights, comic series, 34-35, 36
Nelson, Joyce, 65
Nemni, Max and Monique, 94
Never Cry Wolf, 31, 44, 163 n15. See also Mowat, Farley
Nevinson, C.R.W., 82-83, 94
Niemi, Judith, 147
Noel, Lynn, 147-48
None Is Too Many, 79. See also Sherman, Jason
Nora, Pierre, 150, 170 n32
North Country, 14, 35. See also Somers, Harry
North of 60, television series, 162-63 n10
Northern Encounters Festival, 39-40
Northern River, 134, 140-41. See also Thomson, Tom
North/White. See Schafer, R. Murray
Novak, Dagmar, 67
Nowlan, Alden, 65, 66
Nunavut, 24-25, 38, 51

Obasan, 63, 77, 78, 80. See also Kogawa, Joy
Occupation of Heather Rose, The, 20. See also Lill, Wendy
"OH, CANADA," 3, 4, 6, 158-59. See also Connelly, Karen

"On Being a Northern Country," interview, 32. See also Clarkson, Adrienne
On Being Canadian, 4. See also Massey, Vincent
Ondaatje, Michael, 69, 80
Other Side of the Bridge, The, 48, 80. See also Lawson, Mary

Pachter, Charles, 15-16, 18, 20, 43, 141
Papineau, Talbot, 13, 93-94, 96, 103, 105, 143, 161 n6, 168-69 n25
Parker, Molly, 13
Passage, film, 48. See also Walker, John
Passchendaele, film, 60. See also Gross, Paul
Pegahmagabow, Francis, 88
Peterson, Eric, 65, 81-82, 84
Phantom Hunter, The, 25. See also Bruce, Blair; Shanly, Charles
Pinsent, Gordon, 13-14
Playing Dead, 14. See also Wiebe, Rudy
Poitras, Jane Ash, 113, 122-23
Poling, Jim, 136
Pollock, Sharon, 14, 48, 52, 79, 101, 154, 155, 156-57
Poole, Michael, 48, 80, 87, 88
Pratt, Alexandra, 148
Prisoners of the North, 30, 41. See also Berton, Pierre
Proch, Don, 17-18
Project Grizzly, film, 152

Racette, Sherry Farrell, 123
Rain Before Morning, 88. See also Poole, Michael
Ralph, Joel, 101-2
Rasmussen, Knud, 45-46
Report: Royal Commission on National Development in the Arts, Letters and Sciences, 5
Richard, Maurice, 13, 109, 171 n10
Richler, Mordecai, 43, 79, 108

Riel, Louis, 108, 110-23, 124, 133, 142, 151, 152, 158

Riel Reality, 122-23

Rielisms, exhibition catalogue, 123

"Road to Nijmegen, Holland, The," 66. See also Birney, Earle

Road to Nunavut: The Kreelak Story, The, film, 163 n14

Roberts, Charles G.D., 65

Robertson, Heather, 58, 68

Rogers, Stan, 14, 35, 108

Rouvière, Father, 48, 51

Roy, Gabrielle, 43

Ryan, Terence, 75

Schafer, R. Murray, 14, 19, 153

Schama, Simon, 74

Scorched-Wood People, The, 114, 116-17. See also Wiebe, Rudy

Scott, D.C., 65

Sergeant Preston of the Yukon, television series, 33-34, 35, 162-63 n10

Service, Robert, 30, 40, 41, 48, 64

Seven Streams of the River Ota, 63. See also Lepage, Robert

Shake Hands with the Devil, 97, 170 n4. See also Dallaire, Roméo

Shanly, Charles, 25-26, 28, 33

Sherman, Jason, 79

Shipley, Robert, 59

"Shooting of Dan McGrew, The," 40. See also Service, Robert

Siggins, Maggie, 112, 114

Silence and the Storm, The, 140. See also Espinal, Panya Clark

Sinnisiak, 51-52

Snow Walker, The, film, 44. See also Mowat, Farley

Soldier's Heart, 60, 77, 95. See also French, David

Solomon Gursky Was Here, 43, 79, 108. See also Richler, Mordecai

Somers, Harry, 14, 35, 117, 118, 119, 153

Song of This Place, 129-31. See also Coghill, Joy

Souster, Raymond, 58, 65, 66

Stacey, Robert, 133

Stefansson, Vilhjalmur, 28, 29-30, 31, 33

Stone Carvers, The, 55-56, 90, 91. See also Urquhart, Jane

Sturken, Marita, 106

Tapestry of War: A Private View of Canadians in the Great War, 92-94. See also Gwyn, Sandra

Thauberger, Althea, 97, 169 n28

Thiessen, Vern, 98-100, 104

Thirty-two Short Films about Glenn Gould, film, 36-37, 109

Thompson, R.H., 80, 90-91, 95

Thomson, Tom, 15, 35, 39, 107, 108, 110, 112, 120, 121, 124, 133-43, 151, 152

Three Day Road, 88. See also Boyden, Joseph

To This Cedar Fountain, 125-29; "AFTERWORD: SELF-PORTRAIT," 127-29; "Deep Woods," 125-26, 128. See also Braid, Kate

To Mark Our Place: A History of Canadian War Memorials, 59. See also Shipley, Robert

Todd, Paula, 106

Tom Thomson Murder Mystery, The, party game, 136

Tom Thomson: The Life and Mysterious Death of the Famous Canadian Painter, 136. See also Poling, Jim

Trainor, Winnifred, 135, 137-38

Trudeau, Justin, 94, 96, 103, 109

Trudeau, Pierre Elliott, 13, 94, 109

Turvey, 67, 81. See also Birney, Earle

Uluksuk, 51-52

Urquhart, Jane, 55-56, 60, 80, 96, 97, 105, 156

Valour and the Horror, The, film, 68, 70, 87

Van Camp, Richard. 54

Vance, Jonathan, 11

Varley, Frederick, 6, 57, 72, 94, 95, 99, 100

Village of Widows, film, 89, 164 n17. *See also* Blow, Peter

Vimy, play, 98-99, 101. *See also* Thiessen, Vern

Vimy Memorial, 13, 56, 96, 105. *See also* Allward, Walter

Vimy Ridge, 11, 56, 60, 98, 100, 101, 105, 156; re-dedication ceremony at, 103-5

Voaden, Herman, 28-29, 33

Wainman-Goulet, Brenda, 139

Waiting for the Parade, 65, 77, 81, 82, 85. *See also* Murrell, John

Walker, John, 48

"Walker of the Snow, The," 26. *See also* Shanly, Charles

Wallace, Dillon, 147, 148

Walsh, James, 108

Wanted, 41-42. *See also* Clark, Sally

War between Us, The, film, 87. *See also* Wheeler, Anne

Wars, The, 71-75, 76, 79. *See also* Findley, Timothy

Wedding in White, film, 58

West, Benjamin, 72-74

West Wind, The, 134, 139. See also Thomson, Tom

Wheeler, Anne, 14, 63, 70, 75, 77-79, 87

White Planet, The, film, 45

Wiebe, Rudy, 14, 15, 23-24, 43, 48, 108, 114-17, 153; *Playing Dead,* 14, 15, 23

Wieland, Joyce, 8, 10, 136-37, 138, 153; *The Far Shore,* 8

Willson, Beckles, 67

Winter Comes to the Arctic from the Temperate Zone, 32-33. *See also* Harris, Lawren

Woodcock, George, 110, 152

Wreckage, The, 87-88. *See also* Crummey, Michael

"Ypres, 1915," 66. *See also* Nowlan, Alden